# THE BIG ARCHIVE

# THE BIG ARCHIVE

art from bureaucracy

sven spieker

THE MIT PRESS
CAMBRIDGE, MASSACHUSETTS
LONDON, ENGLAND

MIT Press books may be purchased at special
quantity discounts for business or sales
promotional use. For information, please email
special_sales@mitpress.mit.edu or write to
Special Sales Department, The MIT Press,
55 Hayward Street, Cambridge, MA 02142.

This book was set in Filosofia and Helvetica Neue
by Graphic Composition. Printed and bound in Spain.

Library of Congress Cataloging-in-Publication Data
Spieker, Sven.
The big archive : art from bureaucracy / Sven Spieker.
p. cm.
Includes bibliographical references and index.
ISBN 978-0-262-19570-6 (hardcover : alk. paper)
1. Art, Modern—20th century. 2. Collective memory.
3. Art and history.
I. Title.
N6490.S646 2008
709.04—dc22
2007039872

10 9 8 7 6 5 4 3 2 1

# CONTENTS

# Acknowledgments

Over the years this project has been in the making, I have incurred debt of all sorts with many friends and colleagues. Finally, I want to thank at least some of them. Russell Coon, Martha Buskirk, Michael Fehr, Maria Gough, and Walid Raad kindly read portions of the book and shared their opinions. I thank Elisabeth Weber, Ann Adams, Bruce Robertson, Laurie Monahan, Hans-Christian von Herrmann, Mai Wegener, Richard Polt, Bernhard Dotzler, Louis-Philippe Martim, Wolf Kittler, Michael Molnar, Jackie Spafford, Igor Smirnov, Wolfgang Ernst, Marco Codebò, and my colleagues on the *ARTMargins* editorial board who shared their knowledge and time. At the MIT Press, Roger Conover saw merit in this project at an early stage and accompanied its completion with warmth and critical curiosity. Also at the Press, Marc Lowenthal answered my e-mails faster than I could even send them, and Paula Woolley and Matthew Abbate edited the manuscript with great precision. I thank Margarita Encomienda for her masterful design of this book. Two anonymous reviewers helped me rethink parts of the book in unexpected ways. (I now know that they were Ulrich Baer and Rubén Gallo, and I thank them warmly.) My students in two graduate seminars on archives in twentieth-century art put my ideas to a rigorous test at an early stage, and an international conference on art and archives at the University of California, Santa Barbara ("Packrats and Bureaucrats: Study in the Archive") brought together artists and scholars whose work was crucial to the project. Ilya and Emilia Kabakov, Boris and Vita Mikhailov, Andrea Fraser, Susan Hiller, Walid Raad, Michael Fehr, Markus Krajewski, James Putnam, Richard Polt, and Sally Smith kindly shared reproductions of their work or opened their collections. For his dedication to securing images and the rights to their reproduction I thank Will Scilacci. My project benefited greatly from two fellowships, one at the Stanford Humanities Center and the other at Berlin's Literaturzentrum. I am grateful to the staff of UCSB's History of Art and Architecture department and the Comparative Literature Program/Department of Germanic, Slavic, and Semitic Studies for their help with many critical tasks. Without a grant from UCSB's Academic Senate I would not have been able to recover the considerable cost of image reproduction. As always, thanks go to Russell E. Coon for his unwavering support and sustained affection.

# SIXTEEN ROPES

L

Ilya Kabakov

IN ILYA KABAKOV'S INSTALLATION *SIXTEEN ROPES* (1984), NUMEROUS PIECES OF GARBAGE DANGLE AT REGULAR INTERVALS, ROUGHLY AT EYE LEVEL, FROM SIXTEEN PARALLEL ROPES THAT ARE SUSPENDED A METER AND A HALF FROM EACH OTHER AND THE SAME DISTANCE FROM THE FLOOR. Written labels attached to the objects by pieces of string contain text and fragments of phrases. ("Look what we took out of the library!" "We'll read it this evening.") Although it may not be immediately apparent, *Sixteen Ropes* represents an archive. In fact, such "stringing up" of objects was one of the most ancient forms of filing, and the English word "file," which is derived from the French *fil* (string), originally meant "to line something up on a piece of string." The question posed by *Sixteen Ropes*, then, is whether its strings can deliver what archives promise us, a sense of (and in) time.

Archives contain paperwork that no longer circulates in the bureaucracy, paperwork that has lapsed and become garbage. The crux of *Sixteen Ropes* is the way in which it provides garbage in a literal sense—from cigarette butts to wrappers,

scraps of paper, and railway tickets—with the archive's formal trappings, such as strings, labels, ropes, knots, and written words, all functioning to tame the trash by turning it into documents of culture and history. The most important of the tools designed to bring about this conversion, the horizontal ropes and the vertical strings to which the labels are attached, form a three-dimensional grid on which the suspended garbage is caught. But can this formal grid sufficiently reduce the heterogeneity of the trash, its utter difference, so that a coherent story, and hence history, can emerge?

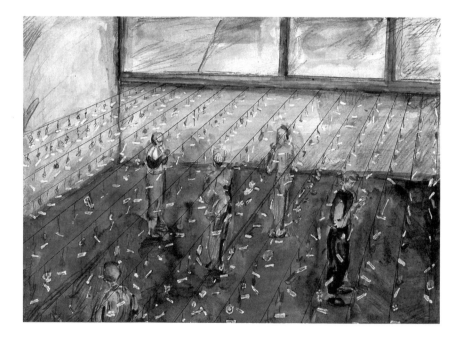

0.1
Ilya Kabakov, *Sixteen Ropes*
(1984 installation). Watercolor and
pen on paper (1993). Courtesy
Ilya and Emilia Kabakov. © 2007
Artists Rights Society (ARS),
New York.

The other question Kabakov's installation poses, a question that is perhaps even more insistent than the first and even more difficult to answer, is whether we ought to think of this grid, ideally empty and exempt from time, as preceding the trash that is caught in it, or conversely whether the garbage dangling from the ropes precedes the grid that organizes it. A third possibility, the one explored in this book, is that the grid and its trash, the archive and what it stores, emerge at the same time so that one cannot easily be subtracted from the other. In this archive, the objects stored and the principles that organize them are exempt neither from time nor from the presence of the spectator. Never quite selfsame, the archive oscillates between embodiment and disembodiment, composition and decomposition, organization and chaos.

Using a term from cybernetics, we could describe Kabakov's overlaying of trash with a grid as a form of feedback.[1] "Feedback" describes a self-regulating system's ability to control its output through internal control mechanisms without interrupting its activity. Norbert Wiener, the father of cybernetics, famously (and problematically) extended the term to contexts that had little or nothing to do with machines, especially to the problem of historical awareness. While the East Coast American Wiener believed that the historical consciousness of New Englanders took the form of class consciousness, he thought that in more recently settled areas such as the Midwest historical consciousness could result only from feedback:

> When a Yankee basketmaker will show you in his shed the tools which his great grandfather forged from bog iron and which he learned to use after the custom of the Indian to split the annual rings of the red ash and make his splints, he will do so with a guileless sense of the contemporaneity of the past, which is very far removed from the pride of the New England aristocrat in his genealogy. His past lies in his barn with its bins, its tools and its baskets.[2]

In this example, the basketmaker derives feedback from the collection of family tools that alleviates his lack of historical (class) consciousness, allowing him to extend his life in a backward direction. However, crucially (and unnoticed by Wiener), this feedback has as its prerequisite not only the collected objects themselves but also the living voice of the basketmaker who shows the visitor his

ancestors' tools, matching words with things, and who guarantees the authenticity of this match through his presence in the barn.

In *Sixteen Ropes*, the living voice has been replaced by the written labels, in themselves nothing but trash, that are attached to the pieces of garbage.[3] These labels may imitate living voices, but they fail to connect with their objects in any meaningful way. On some labels we read what sounds like written voice recordings ("and I thought he would call before leaving"), sometimes in the form of an obscenity.[4] Where in Wiener's example successful feedback is predicated upon the presence of the basketmaker-collector who authoritatively connects the objects in the barn with the daily practice of which they were once a part, in Kabakov's installation the archive itself takes over the function of the basketmaker's voice, refracting it into myriads of more or less incoherent written labels that fail resoundingly to connect words with things. The switch inherent in this operation—from the living voice to the archival medium of writing—makes all the difference. Where in Wiener's example the differences among the collected objects are sublated, tamed, neutralized through living commentary, the absence of such a voice from Kabakov's written labels throws their cacophonous difference into even greater relief. Visually, the archive's failure to establish what Wiener calls historical consciousness manifests itself in the fact that the ropes and strings do such a poor job of alleviating the overwhelming impression of messiness and disorder created by the installation.

Traditionally the records stored in archives fulfilled a legal function. However, over time archives changed from being legal depositories to being institutions of historical research. By the end of the nineteenth century, finally, the archive had morphed into a hybrid institution based in public administration and historical research alike: "There was often talk of the archives' Janus head, a head with two faces of which one looks to the administration and the other to research, and it was and still is a matter for debate where the emphasis should come to lie."[5] As they enter the archive, the papers of which offices rid themselves are resurrected as sources that historians consult in their efforts to write history. From the historian's point of view these papers stand as quasi-objective correlatives of the living past.[6]

Rather than endorsing the efficacy of the archive's transformational powers—garbage into culture—*Sixteen Ropes* dramatizes its resounding failure, as Kabakov's archive fails to establish a sense of history—understood as an orderly succession of events—due to failing feedback. Instead of turning into correlatives

of history, the items in the installation remain what they are, garbage. In no small degree this failure stems from the fact that Kabakov's archive collects quite literally everything. When an archive has to collect everything, because every object may become useful in the future, it will soon succumb to entropy and chaos. Wiener stressed that there are cases when feedback does not produce a higher degree of stability but, on the contrary, leads to chaos. In such cases the system begins to swing back and forth so violently that it finally collapses. This, precisely, is the state of affairs dramatized in *Sixteen Ropes*, a state of entropy that symbolizes, more generally, the archive's precarious position between order and chaos, between organization and disorder, between the presence of the voice and the muteness of objects.

Archives do not record experience

1

# INTRODUCTION

⌐

THIS BOOK LOOKS AT THE WAY IN WHICH THE BUREAUCRATIC ARCHIVE SHAPED ART PRACTICE IN THE TWENTIETH CENTURY, FROM DADAIST MONTAGE TO LATE-TWENTIETH-CENTURY INSTALLATION. More specifically, I contend that the use of archives in late-twentieth-century art reacts in a variety of ways to the assault by the early-twentieth-century avant-gardes on the nineteenth-century objectification (and fetishization) of linear time and historical process. In the process I hope to find tentative answers to some questions posed by Allan Sekula in his essay "The Body and the Archive": "To what degree did self-conscious modernist practice accommodate itself to the model of the archive? To what degree did modernists consciously or unconsciously resist or subvert the model of the archive?"[1] The archive Sekula invokes is frequently viewed as a cipher for the modern dream of total control and all-encompassing administrative discipline, a giant filing cabinet at the center of a reality founded on ordered rationality. I hope, among other things, to unpack an alternative to this prevalent

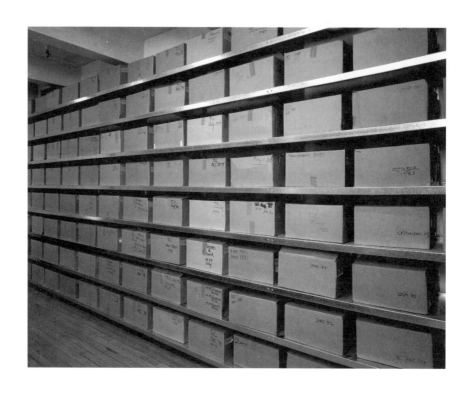

1.1
Andy Warhol, 138 *of Andy Warhol's 610 Time Capsules.* Courtesy The Andy Warhol Museum, Pittsburgh. © 2007 Artists Rights Society (ARS), New York.

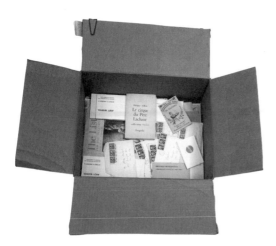

1.2
Andy Warhol, *Time Capsule #13* (late 1970s). Courtesy The Andy Warhol Museum, Pittsburgh. © 2007 Artists Rights Society (ARS), New York.

view, an alternative that exposes the irrational underside of modernism's archival connection and that gives that underside its necessary historical traction.

At an exhibition in Paris a few years ago I saw a few of Andy Warhol's *Time Capsules*, a serial work consisting of 610 standard-sized cardboard boxes which, beginning in 1974, he filled and then sent off to storage in another location. To Warhol, these boxes were an extension of the drawers in his desk; they contained the various types of paperwork—from dinner invitations, personal correspondence, and printed matter to photographs and travel souvenirs—that passed, more or less unnoticed, through his studio daily. Archivizing these objects meant depositing them into a box conveniently placed next to his desk. When the box was full, it would be sealed and a new box put in its place. In Warhol's factory, which at least in this instance looked more like a crammed archive, documents went into the box not because they were important, valuable, or otherwise memorable, but because they were "there," on the desk, just as a photograph records what is "there" at a certain time, in a certain place. The boxes seemed to me like so much clutter and background noise—until, that is, I was suddenly struck by a small collection of Concorde memorabilia (napkins, tickets, dinner knives) that Warhol had brought back with him from one of his flights across the Atlantic. A few weeks before I visited the exhibit, a Concorde had crashed on an airfield near the French capital, killing all passengers aboard. Eerily, it was as if the presence of these articles in Warhol's archive only a week or so after the fatal crash commemorated an event, a trauma—that of those killed on the plane some three decades later—that had not yet occurred when the archive was put together. What the archive records, my experience with Warhol's boxes seemed to indicate, rarely coincides with what our consciousness is able to register. Archives do not record experience so much as its absence; they mark the point where an experience is missing from its proper place, and what is returned to us in an archive may well be something we never possessed in the first place. Is there a part of the archive that escapes from the archivist's control, a "beyond the archive" that remains inaccessible to its finding tools? Such a beyond might be described as *unheimlich*, a term whose etymology (from German *Heim* [home] and *heimlich* [secret, hidden]) links it to the archive in more ways than one.[2] In Freud's reading, the uncanny marks the unexpected return of a record we recognize as familiar despite its being missing from our file registers. Not surprisingly, such a return of a purloined file is indexed by a sense of fright and unease.[3] When files return to take their place in an archive we think of as being complete—with every record in its appointed place, fully indexed and

accounted for—the modernist project of reality-founded rationality and order collapses: the archive becomes literally a haunted place.

Archives do not simply reconnect us with what we have lost. Instead, they remind us, like Warhol's boxes, of what we have never possessed in the first place. If that is a paradox, it is perhaps the paradox of modernism itself, if by modernism we mean a set of protocols that govern the production and transmission of culture from a place that is by definition not the place of the subject, not simply *our* place. The *arkheion*—the archive's material base or substratum—is not simply a home for memories. According to Yosef Hayim Yerushalmi, "Memory is not an archive, nor is an archive a memory bank. The documents in an archive are not part of memory; if they were, we should have no need to retrieve them; once retrieved, they are often at odds with memory."[4] Where nonarchival collections offer a dwelling place to their owners (in Walter Benjamin's words, "ownership is the most intimate relationship that one can have to objects. Not that they come alive in him; it is he who lives in them"),[5] archives rarely offer such shelter. François Lyotard has described the difference between the *domus* as a home (a collection) of memories and the archive with great precision. To him, the space of the *domus* is homey and primordial, a space organized by the rhythms of oral tales that organize culture as personal experience. The *domus* is Lyotard's shorthand for human life lived within the fold of nature: "narratives are like gestures, related to gestures, places, proper names." In the *domus,* "there are stories: the generations, the locality, the seasons, wisdom and madness. The story makes beginning and end rhyme, scars over the interruptions."[6] The counterplace to the *domus* is the urban official residence (the *arkheion*) where houses are not homes but archives, offices, and agencies and where the transmission of culture has become a matter not of narratives but of lists. In the city, where the domicile replaces the *domus* as the place for the transmission of culture, the ancient "domestic monads" are dispersed. The domicile is the place were the people, objects, and animals that populate the *domus* are subject to cataloguing, inventory, and administration by letters and by numbers. Here, counting takes the place of recounting, and identification takes the place of gestures. The domicile is the cipher for an age of archivization where memory is the domain of the technical media, of signs, of more or less systematic storage, or, in Lyotard's phrase, "the anonymity of archives."[7]

In late-twentieth-century art and art criticism, the archive became the trope of choice for a dazzling variety of activities. Still, there seems to be little consensus as to what an archive is, how it might be distinguished from other types of

collections, and, most importantly, how its relationship with earlier twentieth-century art, most notably with the historical avant-gardes, might be framed.[8] Central to my project is a diachronic perspective on the archive, one that also takes account of the fact that while archives have existed ever since humans started to administrate their lives, the technical modalities of archival storage have changed greatly over time.[9] Among the archive technologies whose use in twentieth-century art I deal with at some length are the typewriter, the card index, and files. These technologies are at the core of what James Beniger famously referred to as a "control revolution" in the period 1880–1930, a reaction to the "loss of economic and political control ... at ... local levels of society during the Industrial Revolution. Before this time, control of government and market had depended on personal relationships and face-to-face interactions; now control came to be reestablished by means of bureaucratic organization, the new infrastructures of transportation and telecommunications, and system-wide communication via the new mass media."[10] The control revolution became a reality, according to Beniger, by means, first, of the rationalizing modern bureaucracy and, second, of communications technologies developed at around the same time. However, the technological means through which that control was established also carried with them an increased, yet largely unacknowledged, risk of an uncanny loss of control. The problem was that the office machines that came into widespread use between 1870 and 1920—from typewriters to card indexes—not only processed existing records at record speed, but also produced record amounts of new data. For instance, with the introduction of carbon copies, the typewriter, arguably one of the most effective tools in bringing about the control revolution, was transformed into a remarkably efficient copying machine that intensified the crisis it was designed to conquer.[11] I view early-twentieth-century modernism as a reaction formation to the storage crisis that came in the wake of Beniger's revolution, a giant paper jam based on the exponential increase in stored data, both in the realm of public administration and in large companies whose archives were soon bursting at the seams.

The archive I focus on in this book is not that of the eighteenth century, with its classificatory tables, empty grids, and abstract schemes for the organization of knowledge. What separates the eighteenth-century archive from its nineteenth-century successor? In short, its trust in the possibility of registering contingent time in the form of discrete traces (records), the hope that the present moment—contingency itself—might become subject to measurement and registration. In

the nineteenth century, the role of archives changed from being depositories of legal titles to places where historians hoped to find the sediments of time itself. Not history, I hasten to add, but time in flux and ongoing. This concern with the contingent, with the present moment, and with the possibility of their archivization had important consequences. Obsessed with the idea that there was nothing in either nature or culture that could not be explained without recourse to time, the nineteenth century not only expanded considerably the definition of what constitutes a record, it also widened considerably the scope of the archive charged with collecting such records.

If it can be argued that nonarchival collections are tied to the order of what Lacan called the Imaginary, and the library of books to the Symbolic, then the nineteenth-century archive with its ambition to record contingent time aligns itself with the order (the disorder) of the Real.[12] Crucially, the nineteenth-century belief that archives had the ability to register what eludes symbolic representation has its basis in the reality that they were compiled for reasons—mostly legal—that were different from those that motivated historians to visit them.[13] When one of the nineteenth century's most prominent historians, Leopold von Ranke, remarked that he wanted to "as it were erase my own Self in order to let only things speak,"[14] his statement reflected the confidence that in an archive, the historian, duly confining himself to more or less complete passivity, confronted the sediments of forces and processes whose authority was underwritten by the fact that they were not recorded there. Such confidence in heterotopy—the idea that a record's evidentiary power is a reflection of its origin in a place other than the archive that preserves it—was not limited to historians; in the sciences too there was a widespread belief that the archivization of the forces of nature could become a reality only if (mechanical) methods of registration were found that successfully bypassed symbolic representation, so that the "other place"—in the last resort, time itself—could be induced to create its own archive (Marey; Anschütz).

The nineteenth-century archive across a variety of disciplines—from historiography to the natural sciences—had a lasting impact on early-twentieth-century art. Rather than endorsing the nineteenth century's confidence in the registration of time, however, members of the twentieth-century avant-gardes critiqued and ultimately dismantled that confidence: first, by pointing out that contingency and chance may affect the archive's operations literally at every level (Marcel Duchamp); second, by compiling collections of moments of rupture that elude the archive (early Surrealism); and third, by challenging the Newtonian

underpinnings of the archive's topography and its optical correlatives by way of film (El Lissitzky, Sergei Eisenstein). In all these instances, the archive functions both as a laboratory for experimental inquiries into the nineteenth century's irrational underside and as an elaboration of a type of visuality to which archivization is key. As Rosalind Krauss has contended, any assessment of the avant-garde's attack on the autonomy of art—and, specifically, on the art museum—would be incomplete if it did not consider that autonomy's visual and cognitive corollaries.[15] Modernist vision is often identified with an ideally empty, nonarchival gaze that knows no objects and no subjects, described by Foucault as the "bright, distant, open naivety of the gaze."[16] To assess the avant-gardes' attack on this kind of nonarchival autonomy—which, according to Krauss, reached its apex in impressionism and neoimpressionism—is to confront a model of seeing to which the archive is relevant not as an ideally empty grid waiting to be filled with objects but as a place to which these objects return ready-made.[17] In this reading the untrammeled purity of modernism, its devotion to origin as an absolute departure—the famous "clean slate"—can function only to the extent that we marginalize the archive on which it is founded.

A crucial challenge to the nineteenth-century archive was Dada montage (collage, assemblage, photomontage). When Francis Picabia smashed a Swiss clock, dipped its parts in ink, and imprinted their outline on paper (*Alarm Clock I*, 1919), he not only changed order into disorder, he also transformed a functioning mechanism into a collection of its parts by means of reproduction, thus enabling these parts to enter into new sets of relations. That these relations did not simply mimic those of the functioning clock—of time measured and tamed by regularity—is hardly surprising. Picabia's procedure has crucial implications for timekeeping, a task with which archives, and clocks, are associated. If clocks are invested in an understanding of time as a linear progression of moments, Picabia's collection of reproduced mechanical parts suggests an archive based on return and reproduction. As such it may well be emblematic of the Dadaists' approach to archivization more generally. Dadaist montage dramatizes the central tension that characterizes the modern archive, its precarious oscillation between narrative and contingency. As abstractions that treat the items nailed or glued to the picture plane as so many elements of a formal language of abstraction, Dadaist collage and montage belong squarely in the nonarchival sphere. However, as investigations into the relationship between image and picture plane, both form

part of an archive-based modernism—not because they endorse the nineteenth-century archive, but because they critique and subvert it.

Made of recycled trash—pieces of cloth, found wood, newspaper clippings, reproduced photographs, playing cards—stacked up on a supporting base in a pseudo-archaeological fashion, Dadaist montage functions as an anti-archive that not only reacts to the traumatizing paper jam that occurred in the wake of the First World War (no other event in history generated as much paperwork), but also refuses to endorse the nineteenth-century archive's conversion of garbage into culture. Walter Benjamin has referred to this operation as an effect of the Dadaists' realization that the establishment of order has become an impossibility: "They mounted old rags, tram tickets, pieces of glass, buttons, matches and were saying: You can no longer handle reality. Not this little pile of garbage and not the troop movements, the flu epidemic and the banknotes."[18] If according to Benjamin Dadaist montage challenges the call to order, the general mathesis that underlies enlightened rationality (and traditional art) in the destructive context of the First World War, in the process it also challenges the view that in the midst of such general disorder artistic production can be anything other than a form of archivization, an appeal to the fragmentary presence of material objects without regard for the past or future.[19]

As a form of reproduction that relies on the archivization of fragments of reality that are taken out of their customary context, then stored and redistributed, Dadaist montage can be viewed as an instance of Heideggerian revealing (*Entbergen*). In his lecture "The Question Concerning Technology," Heidegger separated creation as a form of revealing from absolute creation (*poiesis*), linking the former to modern technology. Unlike *poiesis*, which implies a direct shift from absence to presence, *Entbergen* uncovers and transforms what is already present yet invisible.[20] However, if Dadaist montage is revelatory in one sense, it is obscurantist in another. For instance, the layers of carefully cut and arranged shapes in many works by Kurt Schwitters—who viewed post office documents as the "ultimate" form of reality and derived the sounds of his *Ursonate* from the abbreviated words on company signs and office letterhead[21]—all point to the same supporting base, a substratum without which no archive could exist. Yet in pointing to it, these shapes also obscure that base at every step, making us wonder what is ground and what is image. At times, Schwitters even used one of his own paintings as the supporting base for his collages and assemblages, a procedure designed to thwart further our expectation that the supporting base, much like an empty canvas, could be conceived as a kind of virgin soil or grid on which an image comes to rest. By ensuring that its images are irreparably broken, the irregularly "stacked" montage not only progressively obscures its base but also promotes individual elements on which new objects come to be fixed to the status of new, local bases. As every element on the picture plane potentially becomes the local support for another, Dadaist montage refracts and redoubles the (unbroken) base plane with numerous (broken) rival planes, highlighting the fact that in an archive the relationship between the substratum, the archival base or medium, and what it stores is never simply a given. This has important consequences for our reception of these works, for our gaze is never quite at rest as it moves constantly (and erratically) between images and text, base layer and surface, in a movement that resolutely resists contemplation.

Dadaist montage promotes the archive of broken parts as a disruption of the means-ends rationality that governs social and political reality. Beyond that, it provides a crucial link with a medium that embodies the modern archive's claim to the Real like no other: film.[22] As Dorothea Dietrich writes in her discussion of Schwitters's *Cherry Picture (Merzbild 32A)* (1921), "the eye constantly shifts between deciphering a text and taking in an image, much the way the eye moves from the image of the cherry on the flash card to the identifying words

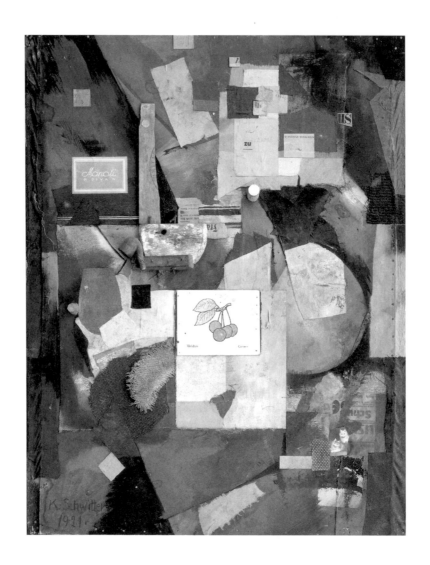

1.4
Kurt Schwitters, *Cherry Picture
(Merzbild 32A. Das Kirschbild)*
(1921). Collage of colored
papers, fabrics, printed labels and
pictures, pieces of wood, etc.,
and gouache on cardboard
background, 36⅛ x 27¾ in.
© The Museum of Modern Art /
Licensed by SCALA / Art Resource,
NY. © 2007 Artists Rights Society
(ARS), New York.

underneath, and there shifts between the two languages only to move back again to the image. Our eye ... [moves] backward and forward on a track between different reading options."[23] Dietrich points out that this process, unfolding as it does over time, owes a debt to reading because the image is consumed like a text. However, we might claim with equal justification that the way in which our glance moves back and forth between the different elements is more similar structurally to viewing a film. Unlike John Heartfield's photomontages, which, as Peter Bürger has pointed out, combine image and text linearly in the manner of ancient emblems, in Schwitters's montages the relationship between image and text is mostly disjointed, as images and words rarely seem to match exactly.[24] What this means is that although we can read the fragments of text that dot many of Schwitters's works, such a reading never manages to fully integrate the text with its image. Where linear reading presupposes concentration and the ability to "hold the line," the broken surfaces of Dadaist montage, much like montage film, encourage a receptive mode characterized by distraction, a lack of linear direction, and repeated fading in and out. And here, precisely, lies their importance for the Dadaist elaboration of the (anti-) archive. Works such as *Cherry Picture* are archival not only in the sense that they constitute sites of storage for the discarded, alienated fragments of a shattered symbolic order; they are also analytical of the relationship between the archival base and what the archive stores. Dadaist montage hints that it is the relationship between these two strata, or rather their persistent interference and oscillation—our inability to tell the one from the other—that dooms the nineteenth-century project of integrating the archive with contingent time.

In its attack on the foundations of the nineteenth-century archive, Dadaist montage marks a dynamic first moment in the elaboration of a type of modernism to which the archive is key. In late-twentieth-century (postwar) art, which I consider in the last two chapters of this book, the archive is marked in formerly Communist Eastern Europe by the manipulations of the Stalinist era and the inertia that followed it, and in the West by the social encoding of widespread amnesia through the commercial mass media. In the countries of the former eastern bloc, the media of technical reproduction and archivization, which the historical avant-garde had viewed as so many emancipatory organs of a newly mechanized collective social body, were declared state monopolies—in the former Soviet Union, even the personal ownership of typewriters was regulated by the state—transforming the archivizing, collective social subject envisioned

by the avant-garde (to everyone his camera) into the fragmented, archivized object of near-ubiquitous audiovisual surveillance.

Artists from the mid 1960s and 1970s onward—a period often associated with the rise of information in or as art—amplify the avant-garde's critique of nineteenth-century historicism by conceiving of the archive as the rules and protocols that are basic to art's production, roughly in the vein of Michel Foucault's historical a priori. The archive Foucault outlines in many of his early works is neither a grammar of abstract rules and paradigms nor an inventory of actual records; it is an archive whose rules constitute themselves together with (at the same time as) that which they help formulate. The rules specified in Foucault's historical a priori are not imposed from the outside; they emerge from the archive itself, "caught up in the very things that they connect."[25] Like the historical a priori, the archive in works by artists from Susan Hiller and Gerhard Richter to Walid Raad and Boris Mikhailov is neither simply a grammar of abstract rules nor a storehouse of information; rather, it is a grammar (a model) whose rules constitute themselves together with the statements they help formulate. Robert Morris's *Card File: July 11–December 31, 1962* is a case in point. Consisting of an industrially produced, hand-operated Cardex file with a layered, quasi-archaeological arrangement, its individual pages reflect the process of its own production.

1.5
Robert Morris, *Card File:*
*July 11–December 31, 1962*
(1962). Metal and paper,
68.5 x 27 x 4 cm. Courtesy
CNAC/MNAM/Dist. Réunion
des Musées Nationaux/
Art Resource, NY. Photo:
Philippe Migeat. © 2007 Artists
Rights Society (ARS), New York.

In the way that it connects words with the storage of process, *Card File* is as much an archive as a self-referential guide for the production of art. For instance, the page with the tab "decision" contains a list of the file's first pages and the dates when they were created, while the section marked "errors" lists the orthographic mistakes on the other pages. Other pages include "title," which lists the work's title, and "signature," which contains the artist's signature.

The fact that Morris establishes his file's relation with time ("July 11–December 31, 1962") through the use of words links his archive both to eighteenth-century efforts to establish archival order on the basis of language and to the nineteenth-century critique of that endeavor. As Foucault has demonstrated, in the nineteenth century language no longer served as an instrument of classification as it did in the eighteenth, when the archive as a system of formal discursive categories was used to classify the world. Instead language became an object of inquiry in its own right. With the rise of philology in the nineteenth century, language acquired its privileged status as the dense, opaque murmur of life whose sustained questioning by scientists, philologists, and philosophers—from Nietzsche to Marx to Freud—afforded a glimpse of what enables us to speak in the first place: "The truth of discourse is caught in the trap of philology. Hence the need to work one's way back from opinions, philosophies, and perhaps even from sciences, to the words that made them possible, and, beyond that, to a thought whose essential life has not yet been caught in the network of any grammar."[26] Treating words as "so many objects formed and deposited by history"[27]—in short, as an archive—nineteenth-century philology pitted the archive against the eighteenth-century order of grammar and linguistic organization, so that the archive's secret—"a thought whose essential life has not yet been caught in the network of any grammar"—was to be found nowhere if not in the flow of time itself.

Do Morris and late-twentieth-century art more generally continue the questioning of the archive of words that Foucault views as the nineteenth century's center of gravity? Returning to *Card File*, it is curious that its effect as an archive derives at least in part from the way it makes use of both the eighteenth- and nineteenth-century paradigms without finally endorsing either one of them. In its use of words as tabs for the purposes of classification, Morris's file bypasses nineteenth-century archival metaphysics (the archive transcribing the murmur of time itself), reverting instead to the eighteenth-century use of language for the purposes of formal classification. Yet in its insistence on archaeological layering and the preservation of process, *Card File* also confirms that paradigm—with one

important twist. Even though the layered industrial layout recalls the archaeological model that characterizes the nineteenth-century archive, what is stored in Morris's file has no evidentiary power beyond the process of its own production. This, however, amounts to no less than the banishment from the archive of what had constituted its essential *Lebenskraft* in the nineteenth century, the idea that archives connect us with time itself by catching it unawares. As addresses, the verbal tabs that organize Morris's *Card File* no longer have the power to testify either to the order and organization of eighteenth-century discourse or to the nineteenth-century notion of history as infinite process. What Robert Smithson in a 1972 interview remarked about his *Enantiomorphic Chambers* (1964) may therefore apply to Morris as well: "And I think that it [*Enantiomorphic Chambers*] was the piece that really freed me from all these preoccupations with history; I was dealing with grids and planes and empty surfaces. The crystalline forms suggested mapping."[28] It is precisely the map that comes to rival the nineteenth-century archive in late-twentieth-century art.

· · ·

Occasional loops notwithstanding, the chapters in this book follow each other in chronological order. I begin with an introduction to the nineteenth-century archive and then analyze some facets of avant-garde archival practice before turning to the uses of archives in contemporary art practice. In the second chapter, I explain some of the scientific, administrative, and aesthetic assumptions of the nineteenth-century archive. Next I examine one of the more elaborate efforts to deal with the consequences of the archive's radical expansion in the nineteenth century, Freudian psychoanalysis. My interest in this chapter lies in Freud's administration of psychoanalysis and in his elaboration of a model of the psyche that shares important characteristics with the archive of nineteenth-century historicism, in particular the hope that the archive may give access, within the confines of the present moment, to "another territory."

In the fourth chapter, I consider Marcel Duchamp's preparation and amplification of the Dadaist critique of the nineteenth-century archive, focusing on the possibility that contingency—chance and accident—may affect the fabric of the archive itself. Duchamp's readymades, which are often interpreted as little more than investigations into the power of naming, claim that contingency and the possibility of accident lie at the very center of any effort to record and measure time, and that the incursion of chance affects the archive at every level. Where

nineteenth-century archives commonly act as cumulative storage facilities for an ever-increasing amount of evidence, the readymades counter this model with a pronounced tendency to thin and diminish—Duchamp's is a radically anemic archive.

In chapter 5, I analyze early Surrealism's critique of the nineteenth-century archive's focus on provenance and original order. Where the nineteenth century considered everything *sub specie historiae*, the Surrealists establish an archive of lapses from history, an archive of what falls out of time. Taking as my departure point the archive opened by the Surrealists in 1924 in the heart of Paris, I show that the project of early Surrealism is aimed at the disruption of nineteenth-century archival metaphysics.

In the mid 1920s, the Soviet futurist El Lissitzky designed two galleries to exhibit the new abstract art. In chapter 6, I argue that Lissitzky's Demonstration Rooms function as extensions of the avant-garde's ambition to transform the traditional art museum into an archive. Aimed at breaking the link between the museum's architecture and its contemplative visual regime, the Demonstration Rooms also provide a crucial link to film, a media technology that exemplifies the modern archive's ambition to register time in more ways than one. Apart from taking on film, Lissitzky's transposition of the administrative archive into the museum travels by way of nineteenth-century research into binocular vision and mechanical precursors to film such as the stroboscope and the phenakistoscope.

My consideration of the archive in postwar art in chapter 7 begins with photography. Looking at compilations of photographs by postwar artists in the East and West—Susan Hiller, Gerhard Richter, Hans-Peter Feldmann, Walid Raad, Boris Mikhailov—I explore the transition from a model of the archive dominated by the nineteenth century's concern with registration and contingent time to database-like forms that eschew the nineteenth-century emphasis on chronological arrangement and linear reading. I further argue that, beyond reacting to the nineteenth century, the archive/database in postwar photography also responds to the avant-garde's critique of that archive and to the neohistoricist monumentalization of the nineteenth-century archive that marked the late 1920s and 1930s. The last chapter inquires into the ways in which postwar artists question the production of archival objects in an anthropological, cognitive, and institutional context. The notion of the "archive at play" is designed to intervene in the prevalent view of the modern archive as being merely an instance of technology, a technical memory whose functioning is guaranteed by its rational foundations.

so much as its absence;

2

# 1881
# MATTERS OF PROVENANCE
# (PICKING UP AFTER HEGEL)

L

It is always the case that what we experience
in one moment, whole and unquestioning,
becomes incomprehensible and confused when
we seek to bind it to our enduring ownership.
Robert Musil, *Young Törless*

**I WANT TO BEGIN WITH A DATE AND A PLACE.** In 1881, the so-called *Provenienzprinzip* or
principle of provenance (PP) was introduced at the Privy State Archive in Berlin.[1]
It stipulated that archival files were to be arranged in strict accordance with the
order in which they had accumulated in the place where they had originated *before*
being transferred to the archive: "The arrangement of the Privy State Archive is
carried out according to the provenance of its materials."[2] The PP does not merely
place the specific *origin* of the archival record—its provenance—above everything
else, it also excludes or limits its arrangement by subject matter: "Whenever
records are brought together originally in relation to action, they should not be
rearranged according to subject. A subject arrangement is alien to their nature."[3]
Oriented topographically rather than semantically, the archive arranged accord-
ing to the PP collects not what exists in an extra-archival outside but what has
already been collected, arranged, and organized *in another place*. From the PP's
point of view, the archive is not a grid or a principle, not a concept, an empty

category, or a series of such categories. The records kept in an archive based on the PP refer their users back to the conditions under which they emerged (in the other place), the media that helped produce them, the business of which they once were a part, the techniques and technologies that were critical for their emergence; and it is these conditions—this place—rather than meaning (or history) that the nineteenth-century archive aims to reconstruct: not simply content, but the formal (administrative) and technical conditions for its emergence.

2.1
Files at the Privy State Archive (year unknown). © Geheimes Staatsarchiv Preussischer Kulturbesitz, G'S"tA PK, IX.HA Bilder, II, Nr. 236916

The PP reminds us that in an archive, it is never just a question of what is being stored but rather of what is being stored *where*. Archival storage has something to do with topology, and the authority of the archivist derives from his or her ability to interpret texts in relation both to their place in the archive and to the place from which they emerged: "The significance of archives lies not only in the matter of each document, but also in the interrelationship of documents within a group: the student needs to appreciate this in his researches, but, even more important, the custodian must understand and carefully preserve the original interdependence of documents if their evidence is not to be confused or falsified."[4] The unspoken assumption here is that the archive's physiognomy is a function of the confluence of two distinct orders, the present order of the archive ("the matter of each document") and the past order of the agency or individual that first accumulated its records ("the original interdependence of documents"). The idea that the evaluation of records has to proceed with an eye both to the present (the archive) and to a topographically concrete (past) beyond which can only be reconstructed by taking that very present as a departure point is of considerable importance for the modernist mindset. Its archaeological logic

still permeates Walter Benjamin's definition of "authentic memories" (*wahrhafte Erinnerungen*): "For authentic memories, it is far less important that the investigator report on them than that he mark, quite precisely, the site where he gained possession of them."[5] With his emphasis on the materially concrete site where memories are acquired, Benjamin, in the spirit of the principle of provenance, takes issue with the Kantian idea that spatial concreteness (*Räumlichkeit*) is not a necessary condition for cognition and knowledge,[6] insisting that the authenticity of memories is moored in the topography of the present rather than the elusive past.[7] Such mapping, whose element is the present and whose most emblematic figure is the archive with its insistence on spatial concreteness and its privileging of formal relations over semantics ("The significance of archives lies not only in the matter of each document, but also in the interrelationship of documents within a group"), has antecedents in the use nineteenth-century scientists made of provenance. For instance, Rudolf Virchow, one of the pioneers of anatomical pathology, argued that there could not be an abstract understanding of disease, since the pathological nature of a given tissue was not to be found in the tissue itself but in the place where it occurred; disease, in Virchow's formulation, was the appearance of cells in the wrong place at the wrong time. A recognized archaeologist who excavated with Heinrich Schliemann in Troy, Virchow treated pathological tissue in exactly the way that an archaeologist treats a fragment he finds in the ground or the way a nineteenth-century philologist treated words: as discrete, isolated pieces of evidence that can be understood only in the context of the place (and the time) where they were detected, a place where they lie side by side with other discrete objects in specific constellations.

Where even cells are treated as context-bound clues that derive their meaning from the topography in which they are found—their provenance—the difference between facts of nature and facts of culture is no longer categorical. In his *Cellular Pathology* (1858), Virchow compared an organism composed of cells with a well-administered state, "complete with junior and senior officials."[8] If physical bodies can be studied like social organisms, we can no longer see the difference between nature and culture in the fact that cultural phenomena are historical while those of nature are not. To Virchow, and to nineteenth-century scientists more generally, *every* phenomenon, to the extent that it emerged from a specific topography or context, was historical: "All knowledge of facts is historical ... because ... we know accurately only what we know through history. The naked facts are doubtful weapons."[9]

Where Virchow treated the facts of nature like so many historical objects, nineteenth-century archivists, conversely, treated the records stored in archives as a form of life, frequently comparing them to "organic wholes" and living bodies composed of organic cells.[10] The idea behind such archival vitalism was that the strict adherence to the PP would reveal a preexisting organic "archive body" whose "single files and records represent the cells of a living body flooded by a life force [*Lebenskraft*]."[11] The nineteenth-century archive was much more than a facility for storing discarded paperwork; it was in a sense the anatomy—a kind of administrative skeleton—of life itself. Rather than being simply "natural," life's anatomical deep structure is, in the nineteenth-century reading, analogous to the bureaucracy, its archives and filing rooms. In the words of Friedrich Meinecke, "every single administrative registry … [becomes] an organism in and of itself, with its own vital principle."[12] According to such vitalist archivistics, whenever the archival body falls ill—whenever, in other words, a registry is missing files—the archivist intervenes like a surgeon to repair the damage. As one archivist writes: "Certainly the organism grows, but in the end what grows may be pathological and unorganic. And should we conserve what is pathological at all cost?"[13] The author's eugenicist terminology, which the editors of his archive manual call "rather awkward," highlights the tension between a view of the archive as an instrument to register time in the form of discrete "cells" or files and the urge to create a healthy, beautiful body—in short, the tension between the archive on the one hand and aesthetics on the other.

If the nineteenth-century archive establishes a relationship with otherness, it does so with a decisive twist. For as I mentioned above, the other sphere to which the archive alludes, its beyond, is not an extra-archival outside but another collection, the site where records accumulate before their transfer to the archive. Not coincidentally, nineteenth-century administrative archives in continental Europe adopted not single records but series of documents that had already been collected in the so-called *Registraturen* (registries), instances of a prearchival accumulation of records that helped agencies and larger companies control paperwork while it was still in circulation and before it was transferred to the archive proper. Like modern registries, the earliest archives known had involved chronological lists that stored ongoing business and correspondence in chronological order. With the increasing availability of paper and the increasing accumulation of records in public offices, the archive and the registry became separate institutions. While the registry stored paperwork that was still in

circulation, still part of ongoing business, the archive confined itself to the storage of those records that had been taken out of circulation because they were no longer needed for the dispatch of ongoing business.[14]

The registry is crucial for my purposes here not only because its name evokes registration, the idea of producing an analogue recording of ongoing activities, but also because it represents the middle element in a triad that has had a formative influence on what we have come to define as modern: the office, where records are produced; the registry, where they are kept as long as they circulate; and the archive itself, where they are stored in perpetuity. In altered form, this triad returns in the Freudian psychic apparatus—modernism's most formidable archive gadget—where its separate elements connote different mnemonic functions.[15]

The relationship between the registry and the archive was thought to be supplementary; the documents that were meticulously entered on a registry's ledger frequently bore call marks that were identical to those the same files would bear after their consignment to the archive. This meant that already in the registry, papers were classified with a view to their future place in the archive itself. As the former director of Berlin's Privy State Archive, Georg Winter, noted: "Those files that are still [in the registry] and those that have already been deposited in the Privy State Archive belong together according to their arrangement like two … *cartae dentatae*, or like two tools produced by a metal worker, one of which was carved out of the other."[16] If archives store archives—series of records that have accumulated in the registry—it is also true that whatever is consigned to the registry emerged from the very beginning with the archive in mind.[17] This indicates that records do not simply come to the archive (nor does the archive, like a library, choose them); they *return* there. Or, in other words, the paperwork that circulates in an office or agency is touched or structured by its demise or death—its withdrawal from circulation—from the moment it is produced. This in turn hints at the possibility that every act of original registration may already be archival, a conclusion that comes tantalizingly close to Freud's analysis, roughly at the time when the PP was first introduced, of registration inside the psyche. Here, too, whatever is stored in the psychical apparatus—in the archive—first has to be withdrawn from circulation (from consciousness); such withdrawal, which is tantamount to forgetting, was for Freud the prerequisite for all permanent storage.

In her essay on eighteenth-century police archives, Arlette Farge claims that archives may give rise to the "naive but profound feeling of tearing apart a veil, of cutting across the opaqueness of knowledge, and of entering, as if after a long and uncertain journey, the essence of beings and things."[18] What Farge calls the archive's "effect of the real" (*effet du réel*) is the idea that the documents read, the images seen in archives confront us with a presence that seems purely accidental, as if the archive recorded life itself, focusing on what seems utterly insignificant and random and what is, therefore, all the more haunting.[19] But if, in one sense, the archive's "effect of the real" is linked to the fact that it stores what was never meant to be stored, in another, much of what enters the archive would never have come into existence without the archive in mind. Of course, to the extent that the police reports Farge studied at the Bastille were part of a regulated investigation, and to the extent that they were filed and recorded according to procedures that were more or less well established, using media and discursive formations that had their own rules and that generated their own forms of control and surveillance, these reports were destined for the archive the moment they were spoken.

In the eighteenth century, archives were often celebrated as the messages history itself dispatched in order to give away some of its best-kept secrets. In the preface to his *Archival Side-Products and News of Different Kinds Together with Original Documents* (1783), Philipp Ernst Spiesz explains with great enthusiasm that his volume of accidental discoveries in various archives "consists for the most part either in the discovery of a new historical circumstance or in the eradication of an error, or in the illumination of various obscure matters."[20] Spiesz's exploration of the archive leaves everything to chance; what is collected in his book finds its place to the extent that it may become useful in an unspecified future— by chance. In a sense, the nineteenth century's obsession with the historicity of all facts only draws the inevitable consequence from Spiesz's approach: if we cannot know what will or will not be useful in the future, then archives have to preserve *all* the paperwork. However, where archives have to collect everything, because everything may become useful in the future, their storage capacities are soon exhausted. Not surprisingly, anxiety over disorder and entropic chaos is a staple of nineteenth-century writing about archives. More often than not, such anxiety was articulated in terms that identified chaos and disorder with women and order with men. If archives and registries were strictly male domains, the reason was that messy registries in which nothing could be found were routinely

associated with women's intrinsic inability to keep order. While in the nineteenth century the *production* of paperwork became increasingly the task of women, its arrangement, preservation, and protection in the registry were the undisputed prerogative of men:

> That registry work has a definitely male character is tacitly assumed.... He must be intelligent and must have a good memory and mature judgment, because if he lacks these virtues disorder and confusion will predominate in the registry. He should have a quiet, calm, and well-poised mind, since a sanguine and fickle temperament would not be compatible with the profession. He must not be talkative, but must have his tongue in his heart and not his heart upon his tongue. He should have adequate fundaments and should in general talk very little lest he blab out the secrets of his registry.[21]

The need to separate women from men (by shutting them out of the registry) not only came from the fear that women might not keep the archive's secrets; it was also a displaced symptom of the increasing difficulties nineteenth-century archivists experienced in separating records from garbage. In the post-Hegelian world the boundary that once separated *Fall* from *Abfall*, fact from garbage, was no longer easily drawn. Whereas in Hegel's time data that were deemed worthy of entering the archive of culture had been limited to those that reflected in some way the systematic workings of the *Weltgeist*, now literally everything—including *Abfall*, which in German means both "garbage" and "heresy"—was considered historical and thus worthy of being archivized, preserved, documented.[22] Indeed, the archivist's fear of women, which here as elsewhere translates into a fear of the masses more generally, cannot be separated from the fear that the archive might drown in masses of paperwork if women were admitted into it. The archive's code of ethics, a litany of virile virtues ranging from punctiliousness to patriotism and higher *Bildung*, functioned like an armor that shielded both registry and archive from the office, where women were becoming more and more common. In late modernity, the archive, much like the army, helped shore up a male ego that was feeling increasingly vulnerable.

The nineteenth-century historian's most fundamental fantasy consisted of the successful integration of sets of data with hermeneutic reading, of contingent

time with historiography, and of the discreteness of records with an overarch-ing *Gestalt*. In Philip Rosen's words, "the ambition of the historian is to be able to discover and authoritatively transmit the actuality of the past.... A perfect historian would have to be out of time, able to be in at least two different times simultaneously—past and present."[23] Indeed historians treated the records preserved in archives as the quasi-spontaneous transcripts of contingent time itself, crediting them with a degree of authenticity denied to documents pro-duced explicitly for the record: "Human beings cannot express the exact truth about matters.... But if, when performing some action, they record information, and are unaware of its historical importance, then such information is more likely to be impersonal and impartial."[24] The enunciation of the "exact truth," in matters of administration, does not have consciousness as a prerequisite. On the contrary, the truth of a given record, or a series of such records, was viewed as inversely proportional to the historical awareness that went into its production. Wherever records were produced "in the process of accomplishing some definite administrative, legal, business, or other social end" rather than with a view to their historical importance, such records were thought to be impartial and could be consigned to the archive.[25]

The German term for the files stored in archives, *Akten*, is derived from the neuter form of the passive past participle of the Latin verb *agere* (to act) and could be translated as "that which has been acted upon."[26] Written memories not so much of the contents of a decision, its "final copy," but rather of the process that led to its adoption, *Akten* come into being when several documents that share a com-mon subject are combined by either physically tying them together in a binder of some sort or grouping them as a loose collection.[27] Such a collection—itself a kind of archive—contains all the notes, sketches, and drafts that pertain to an administrative decision, but that would not be contained in the final document or letter. In other words, what is present in the file is what the final document ex-cludes. Nineteenth-century historians thought of the files stored in archives as primary—in other words, not part of culture—because they viewed them as tran-scriptions of activities of which they were themselves a part. Ranke for instance treated *Akten* as recordings of past events that were in perfect sync with the process of these events' unfolding: "It is a general conviction that we can observe things even more precisely in their flow ... especially if we have occasion to sort through the archives where the most original knowledge is laid down in the correspon-dence that accompanies the events."[28] As Siegfried Kracauer and others have

remarked, the approach to files adopted by historians such as Ranke shows many parallels with an idea of photography.[29] With its ability to archivize even the most inconspicuous details, while at the same time stripping these details of any index of the past in which they once belonged, photography, together with the *Akten* found in archives, represents the backbone of nineteenth-century historiography. Consider the following passage from Johann Gustav Droysen's *Historik*:

> Finally there are the remnants of the written process of various public as well as private transactions as they present themselves in the files kept in archives, reports, evaluations, correspondences, bills, etc. What is characteristic of these materials is that they were moments of transactions in process, accidentally and partially preserved moments from the continuity of these transactions but not the transactions themselves.[30]

As "moments" torn from the continuity of past actions, the traces preserved in archival files, much like the details caught by a photographic image, function as indices whose power to testify to the past is directly linked to their accidental preservation. The belief that archival records register what eludes summary symbolic representation ("not the transactions themselves") has its basis both in their "unconscious" mode of production and in the reality that they were compiled for reasons different from those that motivate historians to consult them.[31]

If, as Mary Ann Doane has noted, modernism was obsessed with "the contradictory desire of archiving presence,"[32] the most compelling testimony to this desire is the "documents, remains, survivals, ruins and edifices, fossils—in short, indexical traces that attest to a past by emerging into the present from it."[33] Since these materials exist as discrete elements in an archive in the present, the historian has to realize that the only entryway into the past is that very present. As Droysen notes, "even if historical narrative relates the occurrence of things from a certain origin [*Anfangspunkt*] by imitating the development of things by means of representation …, true historiography goes the opposite way…. It remains conscious of the fact that it deals with material that stands in the present."[34] Refusing to turn on this material the melancholy gaze of the *flâneur*, nineteenth-century historians aimed to produce accounts of history where not the past but the archive (the present) would serve as departure point, a point Ranke referred to as "the correct standpoint" (*der richtige Standpunkt*).[35] Doane is right to point

out that the nineteenth century's claim to create archives of the present is contradictory because "what is archivable loses its presence, becomes immediately the past."[36] Yet the historian's insistence on "material in the present" (Droysen) was designed, precisely, to wrest historiography away from metaphysics. To Droysen and his colleagues, the often fragmentary traces the historian finds in an archive function as reminders that whatever is kept in an archive, to the extent that it is a material remnant in the present, is likely to be incomplete or fragmented, as some parts of the past survive while others are lost. Droysen's phrase "material in the present" may be taken to mean that the past we come to inspect in an archive is fully contingent on the conditions (and constraints) of the process of archivization itself, and that to take note of this is to acknowledge the difference between historiography and fiction. Much as a photograph shows us the isolated fragments of a past whose existence is inextricably tied to the specific modalities of the technical image, so archives too confronted the nineteenth-century historian not with the past as such but with its remediation in the present. Nineteenth-century archives therefore function not unlike technical media, if by this term we mean, as did the modernists, a set of framing protocols or conventions whose (self-) reflection is central to their mission, the reproduction of a past in the present.

Understood as medium, the nineteenth-century archive informs Walter Benjamin's discussion of photography and film in his essay on the "Work of Art in the Age of Mechanical Reproduction" (1935–1936). To Benjamin, both media function as collections of traces at a time when the original to which these traces once belonged has long since disappeared. In the era of technical reproduction, it is the gathering and visual deployment of formerly site-bound traces by a mobile medium such as photography or film (enabling the original "to meet the recipient halfway")[37] that assume the function of originality formerly associated with the "original in its place." This operation is closely linked to time. Where the auratic original in its place was not only removed from technical reproduction but also shielded in its essence from the effects of time—remaining selfsame and authentic no matter how long it remained in its traditional place—technical, process-bound image (re-) production refracts that original into a series of individual shots that show it from a variety of different perspectives. The fact that film and photography, in Benjamin's examples, often leave their objects unrecognizable because they reproduce only parts of them or because they reproduce them at very close range ("enlargement not merely clarifies what we see

indistinctly 'in any case,' but brings to light entirely new structures of matter")[38] is equivalent to the presence of fragmentary remnants of the past in an archive. Like the latter, photography and film take as their departure point not the past original but a series of fragmentary traces in the present, suggesting that any access to that original has to proceed from an archive of such fragments.

As is the case with photography, the efficacy of archives as media that allow for the perception of the past within the context of the present is tied to the transformation of temporal relationships into spatial ones. As Wolfgang Ernst has written, "historiography means the transformation of the archive's space into the effect of a [temporal narrative]."[39] As I mentioned earlier, Droysen suggested that the point in time we call the "present" is actually part of a series of such moments—each one of them static in itself—in which it merely occupies the central position. Only by adopting one such moment as the starting point for historiography can the historian hope to make the present the starting point for his endeavor to write history. In a similar vein, Wilhelm Wundt, the founder of the modern discipline of psychology, had located the origin of our idea of time (*Zeitvorstellung*) in a series of discrete moments—not coincidentally designated by the letters of the alphabet—with the present moment at its center: "The elements *a b c d e f* in a temporal series can appear to us as one single complex once the series has reached the letter *f*; yet they can also appear to us as a series of points in space. However, while [a series of points in space] ..., due to the ... eye's reflex movements, is always ordered according to the central point of vision, which can alternate between any of the external impressions *a* to *f*, when it comes to the idea of time, it is the actually present impression toward which all the others orient themselves."[40] Where the perception of a series of points in space is anchored in a central yet variable point that shifts with the movement of our eyes (any point can serve as center), for a *Zeitvorstellung* to arise there has to be a stable point of origin, the central letter in the series whose task is to mark the present moment. To Wundt, the present is that point toward which past and future points gravitate, and the order of their elements cannot be changed without the entire series changing in the process: "Similar to the spatial ones, temporal entities ... are characterized by the fact that the elements into which they can be divided show a certain unchanging order, so that if this order changes, the given entity ... becomes a different one."[41] Such spatialization of time—embodied by the archive—became crucial to modernist efforts to make time productive, consumable, and maximally profitable. In Wundt's spirit, Frank and Lillian

Gilbreth—one of whose first important clients was the typewriter manufacturer Remington & Sons[42]—divided practical tasks such as bricklaying or typing into sets of elementary variables ("variables of the worker," "variables of the surroundings," "variables of the motion") that function as equivalents to Wundt's series of letters.[43] These sets of variables, which in turn were broken down into smaller and smaller segments, allowed the Gilbreths to focus on single moments in the present, one step at a time. (Frank Gilbreth's methods led him straight to photography, which he used to break down each motion into smaller and smaller segments in the way Etienne-Jules Marey and Ottomar Anschütz had done with the help of chronophotography.)

Nineteenth-century historiography was caught between the lure of fiction, on the one hand, and the complete abandonment of the symbolic order for the sake of the synchronicity of the "moment" on the other. This latter scenario, whereby historiography fragments into a random collection of discrete moments without coherence—as we will see, this is Duchamp's model—was powerfully dramatized in Jorge Luis Borges's short story "Funes the Memory Artist." Set in the 1880s—the decade when the principle of provenance was introduced in Berlin—the story focuses on Funes's inability to forget anything he has ever seen, heard, or felt. At the age of nineteen, Funes falls from a horse and is gravely injured.[44] After this incident he has an almost unbearably sharp consciousness of the present, which is to say that he remains conscious of everything he has perceived at any time in the past as if it were the present: "In Funes's overstuffed world there was nothing except details, almost immediate ones."[45] If Funes looks at the same leaf a dozen times, his mind produces precisely a dozen records of each individual perception.[46] Behind these details, all summary concepts disappear: "Not only did he have trouble understanding that the general symbol dog encompasses so many individual creatures of varying sizes and varying forms; it bothered him that the dog of 3 o'clock 14 minutes (which he saw in profile) should carry the same name as the dog of 3 o'clock 15 minutes (which he had seen from the front)."[47]

His inability to establish similarities between moments in time except by juxtaposing them on a chronological axis (one thing after another) links Funes to the archival impulse of his age, the compulsion to privilege differences in space (and time) over summary concepts such as words. The opposition between words—a summary shorthand for what unfolds over time and defies summary—and the archive as a series of discrete, differentiated moments was a matter of

sharp debate in the 1880s, and Borges's story seems to allude to this debate. In his *Contributions to the Analysis of the Sensations* (1886), Ernst Mach had argued that even though we use the same word "table" in both cases, there is no reason to assume that the table we see at a certain point in time is the same table we see, under different light conditions and from a different perspective, at another.[48] To Mach nothing exists beyond discrete sensations and the attributes on which they are based. If this general decomposition without an organizing center (a subject) suggests a general archive, it is an archive without objects in which the only principle of organization is accumulation over time, one sensation after another. A passage from the beginning of Rilke's novel *The Notebooks of Malte Laurids Brigge* (1910) may illustrate Mach's point:

> Electric street-cars rage ringing through my room. Automobiles run their way over me. A door slams. Somewhere a window-pane falls clattering; I hear its big splinters laugh, its little ones snicker. Then suddenly a dull, muffled noise from the other side, within the house. Someone is climbing the stairs. Coming, coming incessantly.... And again the street. A girl screams. Ah tais-toi, je ne veux plus. An electric car races up excitedly, then away, away over everything. Someone calls. People are running, overtake each other. A dog barks. What a relief: a dog.[49]

Many if not all of the signals that reach Malte from outside consist of noise, more or less meaningless fragments to which he attaches equally random thoughts.[50] The scene demonstrates what happens when there is literally nothing but the "presence of materials" of which nineteenth-century historians dreamed, without the retrospective, ordering, past-creating, focalizing activity of a subject-agent.[51]

Malte, and Funes, comprise but the reverse side of a coin presented by Nietzsche's acerbic critique of the nineteenth century's archival ambitions. In the second of his *Unfashionable Observations* ("On the Utility and Liability of History for Life," 1874), Nietzsche expressed his distaste for an epoch in which everything, even the present itself, was treated as historical: "Before the war is even over, it has already been transformed into a hundred thousand pages of printed paper, it has already been served up as the latest delicacy to the exhausted

palates of the history-hungry."[52] Incapable of forgetting anything, the nineteenth-century subject measures any future action against the past actions it resembles, persuading himself that to act is to repeat the monumental activities of the past: "But he also wondered about himself and how he was unable to learn to forget and always clung to what was past; no matter how far or how fast he runs, that chain runs with him."[53] Nietzsche found the archival ambitions of his age deeply suspicious: *The Ego wants everything.—*It seems that the sole purpose of human action is possession: this idea is, at least, contained in the various languages, which regard all past action as having put us in possession of something ('I *have* spoken, struggled, conquered': that is to say, I am now in possession of my speech, struggle, victory). How greedy man appears here! He does not want to extricate himself even from the past, but wants to continue to *have* it!"[54] Like the nineteenth-century archive more generally, Nietzsche's "Ego" not only wants to "have" the past—a will that manifests itself in the very structure of its language, which can express a relation to past action only in terms that imply possession—it wants to possess it as the continuing, contingent process it once was (it "wants to continue to *have* it!"). Where Funes clings to time as a realm of difference, Nietzsche's "historical man" clings to history as a realm of similarity and resemblance; where Funes produces discrete sets of data, *der historische Mensch* turns life into a narrative modeled on existing texts. Nietzsche's nineteenth-century man is unable to act because he sees the present as a province of the past (everything he does is in emulation, and imitation, of past deeds). Funes on the other hand regards the past as a province of the present (in the spirit of Ranke and Droysen, yet without their hermeneutic zeal): he cannot conceive of the past, as every detail of it remains acutely present to him. His inability to treat the word "dog" as a fitting pointer to a concept beyond and above its concrete incarnations in space and time, and his refusal to organize perceptions in any other way than according to the sequence in which they occurred, are vivid testimony to this mindset. While Nietzsche's *historischer Mensch* is obsessed with a will to possess the past, Funes represents that will in a state of radical dispossession—where everything is stored, nothing is possessed. What we witness in Funes is remembering as an autonomous agency that pledges no allegiance whatsoever to subjects or objects (its institutional outlet is the archive)—the very autonomy that will come under attack by the early-twentieth-century avant-garde.

The nineteenth-century archive is founded on the suspicion that, to the extent that they could be treated as the material traces of an obscure beyond—

time, history, life itself—whose limitations were profoundly unknown or unknowable, literally anything could be or become a clue. In a speech given in 1862, Hermann von Helmholtz provided eloquent testimony to this mindset, positing that since Hegel's time science had been confronted with an exponential increase in the amount of data at its disposal: "The philologists of earlier centuries kept themselves sufficiently busy studying Greek and Latin; only for immediately practical purposes did they learn, perhaps, other European languages.... Now, every lost fragment by an ancient writer, every note taken by a pedantic grammarian or by a Byzantine court poet, any broken gravestone of a Roman official that might be found in some dark corner of a forest in Hungary, Spain, or Africa might contain a message or proof [*eine Nachricht oder ein Beweisstück*] that could become important in its own right."[55] The increase in available data is due to the fact that a large number of objects that up to that point may have been regarded as insignificant have now—in an age of ever-expanding possibilities for technical observation—become worthy of attention ("every lost fragment by an ancient writer").[56] As Giovanni Morelli demonstrated by bypassing a painting's *Gestalt* to determine its author on the basis of unsystematic clues, the best (art) historian or scientist may well be the detective (or, in Freud's case, the psychoanalyst).[57] In the age of the clue, whatever is latent and unconscious is progressively brought into the purview of consciousness, where it helps in detecting the ways in which the unknowable past—in the last resort, death—is woven into the present.

The question is whether and how the potentially infinite growth of such an archive of clues might come to an end, rescuing it from the inescapable fate of entropic chaos. According to Helmholtz, only the bold formulation of "laws and causes" (*Gesetze und Ursachen*) may impose limits on a potentially boundless archive of scientific facts. Helmholtz argues that it is not enough to gather and organize knowledge; the point is to formulate general laws on the basis of this data that will make any further accumulation unnecessary: "It is not enough to know the records; science comes into being only at that point where the law and the causes of these records reveal themselves."[58] Once data have revealed their "law and causes," any future expansion of the archive is unnecessary, from a scientific point of view. As inductions that emerge directly from the records to which they are thought to apply, the "law and causes" do not, like Goethe's *Urpflanze*, preexist their individual existence, even though they establish legislative power over information that has not yet been gathered ("this law does not only comprise those cases that we or other people have already observed, but we will also not

hesitate to extend it to cases that have not yet been observed"). Helmholtz's laws are summaries (*Zusammenfassungen*), a kind of shorthand for the records of nature. The general concept (*Begriff*) found by the scientist "comprises within itself a multitude of particulars and represents them in our thinking."[59] The German word Helmholtz uses here is *vertreten* ("vertritt sie in unserem Denken"), a term that, not coincidentally, is also used to describe political representation by elected officials in a democratic state. The concepts and rules that reveal themselves after data collection "represent" these records, but they do not precede them, let alone replace them, the way a metaphysical category might be said to precede its material embodiment. Helmholtz thus finds a way of limiting the potentially infinite accumulation of data, a happy endgame of data collection that results in a kind of data democracy.

The opposite scenario of an archive that never finds its end is most eloquently described in Flaubert's novel *Bouvard and Pécuchet*, which was published in 1881, the year the principle of provenance was introduced. Since, to Flaubert's two protagonists, nothing—literally nothing—can be dismissed because literally everything has to be collected and inventoried, even the slightest omission might cause the entire edifice to collapse: "To judge impartially they would have to read all the histories, all the memoirs, all the journals, and all the manuscript documents, for the slightest omission may cause an error which will lead to others *ad infinitum*."[60] The two heroes have no mechanism for dispensing with knowledge, for ridding themselves of what is inessential for their project, a fact that in turn means that the positivity of their collection remains, to them, forever elusive and unformulated. There simply is no discourse or organizing principle that could be adequate to their project as long as their goal is to encompass everything: "Others who claim simply to narrate are no better; because one cannot say everything, there must be some choice. But in choosing documents a certain spirit will prevail, and it varies according to the writer's conditions. History will never be fixed."[61]

The problem Bouvard and Pécuchet face is that the number of recorded facts had become so large by the late nineteenth century that their totalizing representation within one archive seemed increasingly impossible. To the two protagonists literally every object that surrounds them has the potential to be or to become a historical record, even literary prose. For isn't the realist novel's claim to existence tied to its ambition to include everything? Bouvard and Pécuchet seem to endorse this idea: "What they objected to in all these books was that they said nothing about the background, the period, the costume of the characters.

Only their heart is dealt with; always sentiment, as if there was nothing else in the world!"[62] Bouvard, whose admiration for Balzac is tellingly immense, claims that literature is to become a means of recording observation not unlike the measuring and recording instruments used in the sciences. To this, Pécuchet objects that literature might then become mere "statistics" if infinite amounts of "drivel" were included in novels.[63] Bouvard responds that, even if this were so, novels would still "have curiosity value as documents."

There is, then, no position from which the data collected by the two characters could be referred to that is not that of the archive. Whenever such a position—a position outside of their endeavor, outside of the collection they have established—comes within reach, they quickly discover that it is itself part of yet another archive, another discipline or field of knowledge that has to be studied, inventoried, and mastered. The maddening conundrum faced by Bouvard and Pécuchet is that everything that can be known is already archival.[64] As a storehouse of knowledge, the modern archive refers us to a place outside of itself, the very place Bouvard and Pécuchet are seeking. But this beyond-the-archive is not a transcendent outside or an empty space waiting to be filled; it is in fact another archive.

1
2
3
4
5
6
7
8
9
10
11
12
13

they mark the point where

3

19
20
21
22
23
24
25
26
27
28
29
30
31
32
33
34
35
36

# FREUD'S FILES

L

Sigmund Freud

The preservation of files corresponds to a need
that is innate in humanity, a need that ignorance
can perhaps trample on but can never repress.
Eugenio Casanova, *Archivistica*

AS A THEORY AND PRACTICE ENGAGED IN THINKING THROUGH THE RELATIONSHIP BETWEEN
RECALL AND REPRESSION, PSYCHOANALYSIS REPRESENTS ONE OF THE KEY RESPONSES TO
THE MODERN STORAGE CRISIS. Modern archive architecture, with its three intercon-
nected stages devoted to the production and storage of files (office, registry,
archive), represents a prototype for the model of the psyche constructed by
Sigmund Freud at the very time when the principle of provenance was being
introduced at the Privy State Archive in Berlin-Dahlem. In the same year 1881,
Freud graduated as a doctor of medicine from the Medical School at the University
of Vienna. Jacques Derrida has argued that Freudian psychoanalysis is archival
in at least two related ways.[1] First, as the archive of Freud's legacy, psychoanalysis
represents the entirety of his published writings, private papers, case histories,
clinical files, transcripts, etc. This archive, its reach, its interpretation, and its
authority were challenged again and again even during Freud's lifetime, and it
became a point of contention after his death when various factions of Freud's

colleagues began to vie for legitimacy. Second, there may be an archive implicit in Freud's theory of the unconscious and the way it stores traces of the past.[2] While it would be fruitless to simply declare that what Freud referred to as the psychical apparatus is an archive, it shares a sufficient number of traits with actual archives to make such a link productive, even compelling. We can add a third aspect: given Freud's (unacknowledged) reliance on the written notes he took after the analytic sessions during which his patients relayed their thoughts to him, psychoanalysis is as much a science of writing and of the archive as it is a talking cure.

In Freud's topographical view of the psyche, the unconscious occupies the position of a "different psychic territory."[3] It is by making parts of this territory available to his patients that Freud hoped to cure them of their neurotic symptoms. During treatment, Freud strove to relate his patients' conscious thoughts and associations to sets of repressed thoughts and desires to which the patient had no conscious access, but which nevertheless exerted their force on their words. Freud's efforts to connect sets of visible, conscious facts with their repressed, unconscious counterparts form part of an epistemological shift with profound implications. Instead of focusing on explanations of observable facts, Freud establishes relationships between such facts and their latent, unobserved or unobservable counterparts, hoping to account for psychical forces, such as repression, that can be observed only in their impact on the psychical material in the present, but never as such. As an archive, the psychical apparatus is not a monolithic, unified site for storage but the interface between two distinct sets of data, one manifest and subject to observation, the other latent and visible only to the extent that it is imperceptibly woven into the first. This model recalls the relationship, in nineteenth-century archival architecture, between the archive proper and the registry, and the assertion by nineteenth-century historians that to study archival records is to observe, in the present, the fragmented remnants of a past that can never become subject to observation as such. Even more striking, however, are the similarities between Freud's scheme and other sciences that attempt to account for unobservable forces. For instance, when the physicist Heinrich Hertz questioned Newton's basic laws of physics, he gave the example that some of the types of motion with which modern physics is concerned—such as the forces that move the stars in the sky—cannot be observed in nature. However, according to Hertz, even though these forces

have never been subject to direct observation, there can be no doubt that they do exist:

> But it is otherwise when we turn to the motions of the stars. Here the forces have never been the objects of direct perception; all our previous experiences relate only to the apparent position of the stars. Nor do we expect in the future to perceive the forces. The future experiences which we anticipate again relate only to the position of these luminous points in the heavens. It is only in the deduction of future experiences from the past that the forces of gravitation enter as transitory aids in the calculation, and then disappear from consideration.[4]

The forces that account for anticipated changes in the positions of the stars cannot be seen; they can only be deduced by studying the stars' positions at different times *in the present*.[5] What seemingly accidental slips of the tongue and other lapses were to Freud, the seemingly random shifting positions of the stars in the sky are to Hertz. Again we are dealing not with an archive of static facts but with the dynamic relationship between two sets of facts—one observed and the other anticipated and/or invisible—with the difference between them hinting at the hidden forces behind their transformations.

As is the case with Hertz's revision of the basic laws of mechanics in the electrical age, visibility or invisibility—the fact that an object can or cannot be seen in its place—is not the criterion on which an analysis of a psychical object has to rely. Even if something is not visible (that is, cannot be retrieved or remembered) in the psyche, this does not mean it is not present. Importantly, such "invisible presence" must not be confused with a metaphysical origin that would exceed the confines of exact science. As with the archive, the functioning of the psyche shifts the parameters of what constitutes presence; in the Freudian psyche, as in the archive, an object is shaped by forces that, while they may be unremembered or invisible, are nevertheless palpably present in the object itself.

Already in *On Dreams* (1901) Freud had challenged the more traditional approach to dream analysis, casting aside what he calls the "mythological hypothesis," that is, the assumption that dreams are unified allegorical transcripts

of a hidden meaning. Instead Freud views dreams as composites of discrete elements, each of them connecting with a latent set of other elements—the dream thoughts—that come to light at that point during analysis when the patient is asked to reproduce the thoughts or impressions he or she connects with different elements in the dream: "In order to contrast the dream as it is retained in my memory with the relevant material discovered by analyzing it, I shall speak of the former as the '*manifest* content of the dream' and the latter ... as the '*latent* content of the dream.'"[6] The significance of the dream will become apparent only at that point where further analysis has revealed the specific transformations that have converted the latent dream thoughts into the manifest dream: "I am now faced by two new problems which have not hitherto been formulated. (1) What is the psychical process which has transformed the latent content of the dream into the manifest one which is known to me from my memory? (2) What are the motive or motives which have necessitated this transformation?"[7]

In spite of the apparent symmetry between the manifest dream and the latent dream, the dream thoughts are nothing less than simple translations of the thoughts from which they derive. Not unlike Hertz in his revision of Newton, Freud proposes that the relationship between these two sets of facts is one of dynamic interaction whereby one set (the latent dream thoughts) is transformed into the other (the manifest dream) in a process whose reconstruction is the analyst's most formidable task. He points out that one element in the manifest dream may be linked to one or several latent dream thoughts, and that one dream thought may in its turn correspond with one or several elements in the manifest dream. While it is clear, then, that every single component in a dream must be understood as deriving from one or several elements forming part of another, latent archive, this latent archive is far from constituting the hermeneutic horizon that would ground and direct the interpretation of the dream at hand. The significance of a dream must instead be gleaned from the complex set of transformations—Freud names dramatization, condensation, displacement, and care for representability (*Rücksicht auf Darstellbarkeit*)—that turn the latent dream thoughts into the manifest dream. The broader significance of this process of transformation in the context of Freudian psychoanalysis is the fact that it represents the first instance where unconscious material can be observed to be an effect of emotive reformatting: "The transformation of the latent dream-thoughts into the manifest dream-content deserves all our attention, since it is the first instance known to us of psychical material being changed over from

one mode of expression to another."[8] The psyche thus reveals the operations of a force that prevents its holdings from ever being selfsame; in the way in which it reflects an invisible force outside of itself—be it the past, the unconscious, or life itself—the psyche, like the nineteenth-century archive more generally, is always the "other" place.

While Freud used the term "archive" explicitly only once in his writing, he did on more than one occasion compare psychoanalysis to archaeology, which is both an etymologically related term and a metaphor for the archive.[9] In a paper titled "Constructions in Analysis" (1937), he wrote:

> His [the analyst's] work of construction, or, if it is preferred, of reconstruction, resembles to a great extent an archaeologist's excavation of some dwelling-place that has been destroyed and buried or of some ancient edifice. The two processes are in fact identical, except that the analyst works under better conditions and has more material at his command to assist him, since what he is dealing with is not something destroyed but something that is still alive—and perhaps for another reason as well. But just as the archaeologist builds up the walls of the building from the foundations that have remained standing, determines the number and position of the columns from depressions in the floor and reconstructs the mural decorations and paintings from the remains found in the débris, so does the analyst proceed when he draws his inferences from the fragments of memories, from the associations and from the behaviour of the subject of the analysis.[10]

Here Freud endorses the analogy between the archaeologist and the psychoanalyst, even though he admits that the overlap between the two may not be complete ("and perhaps for another reason as well"). Freud again portrays himself as an excavating archaeologist who has to content himself with whatever he manages to bring to the surface: "I had no choice but to follow the example of those discoverers whose good fortune it is to bring to the light of day after their long burial the priceless though mutilated relics of antiquity."[11] Given Freud's own repeated use of the archaeological metaphor, it has often been accepted as a foregone conclusion that psychoanalysis represents a kind of "archaeology of the psyche."

As Kenneth Reinhard has pointed out, the antiquities in Freud's own possession have, as a result, often been understood as a kind of objective correlative of this metaphor:

> Freud's famous "archaeological metaphor" has frequently been invoked as an adequate and compelling figure for the logic and practice of psychoanalysis— a metaphor which, seemingly with Freud's authorization, has taken on the stature of a self-evident credo rather than a crucial yet ambiguous trope. Such appropriations of the metaphor figuratively stratify the psyche by portraying psychoanalysis as a process of plumbing the subject's unconscious "depths" and bringing repressed material to the conscious "surface."[12]

However, there are, as Reinhard further argues, a number of problems with the pair psychoanalysis/archaeology, not the least of which is that psychoanalysis focuses on writing as its principal medium and that it deals with psychical rather than material objects. Another difference is that the archaeological metaphor, while it allows for thinking of psychic life in layers, eschews the dynamic relationship between these layers that is characteristic of the psychical apparatus. Further, and most importantly, where psychoanalysis insists that nothing can be fully expunged from the psyche, even if it is physically destroyed, this is not the case in archaeology, where the traces of past realities are either preserved or destroyed, but where there is no way of accounting for destroyed objects once they have disappeared. Freud makes precisely this point in a later passage of "Constructions in Analysis":

> The analyst, as we have said, works under more favourable conditions than the archaeologist since he has at his disposal material which can have no counterpart in excavations, such as the repetitions of reactions dating from infancy and all that is indicated by the transference in connection with these repetitions. But in addition to this it must be borne in mind that the excavator is dealing with destroyed objects of which large and important portions have quite certainly been lost, by mechanical violence,

by fire and by plundering. No amount of effort can result in their discovery and lead to their being united with the surviving remains.... But it is different with the psychical object whose early history the analyst is seeking to recover. Here we are regularly met by a situation which with the archaeological object occurs only in such rare circumstances as those of Pompei or of the tomb of Tut'ankhamun. All of the essentials are preserved; even things that seem completely forgotten are present somehow and somewhere, and have merely been buried and made inaccessible to the subject. Indeed, it may, as we know, be doubted whether any psychical structure can really be the victim of total destruction.[13]

Given the apparent disparity between Freud's model of the psyche and the archaeological site—with the latter incapable of dealing productively with what has been expunged—it might be more appropriate to think of the psychical apparatus as an archive. In an archive, as in the psyche, what has disappeared or become illegible is often still recorded in its finding tools or in other records, so that nothing can be fully expunged.[14] Freud presented a precise description of the psyche as a form of archive in his "Notiz über den Wunderblock" ("A Note upon the 'Mystic Writing-Pad,'" 1925). As a reaction to the modern storage crisis, Freud's "mystic" pad, and by extension the psychical apparatus which it is said to resemble, reconciles two seemingly incompatible demands: how to store records in perpetuity without running out of space for new accessions. Relying on the functional interaction of its different parts—an interaction that continuously disrupts the self-presence of the writing on the block—the "mystic" writing pad is a mechanical archive for storing written memoranda that combines into one the responsibilities of the office (record production/perception), the registry (storage of files still in circulation), and the archive (permanent storage of files no longer in circulation). The very term *Notiz* suggests a brief written note made in order to prevent something from being forgotten. In that sense, the "Notiz" functions like a memo both to Freud himself and to his followers, an archive of the psyche as archive.[15]

Freud's pad consists of three parts: a slab of resin or wax at the bottom, and a thin transparent sheet that covers the slab and that is itself split into a top part and a lower part.[16] At the top end, this transparent sheet is fixed to the slab,

while its bottom end "rests on it without being fixed to it."[17] The transparent sheet itself, Freud explains, "consists of two layers, which can be detached from each other except at their two horizontal ends. The upper layer is a transparent piece of celluloid; the lower layer is made of thin, hence translucent waxed paper. When the apparatus is not in use, the lower surface of the waxed paper adheres lightly to the upper surface of the waxed slab."[18] The *Wunderblock* is no ordinary archive: in order to leave a mark, one does not need to permanently deposit anything on its surface, as would be the case with writing in ink on paper. Instead, the pad's surface is scratched with a stylus, in a movement that recalls ancient writing practices (Mesopotamian clay tablets, for instance) as much as the movement of a needle on a phonograph. The pressure brought to bear on the surface by the stylus is passed onto the waxen slab underneath: "At the points which the stilus touches, it presses the lower surface of the waxed paper on to the wax slab, and the grooves are visible as dark writing upon the otherwise smooth whitish-grey surface of the celluloid."[19] Here, another difference emerges between an ordinary writing block and the *Wunderblock*. In order to grasp this difference, one must bear in mind that the block's celluloid surface is not, like paper, capable of storing any marks on its surface. Like the registry to which it is the direct equivalent in Freud's administration of *psychische Akte/n*, the block's surface layer keeps files available only as long as they are needed for the dispatch of ongoing (read: conscious) business.

The permanent storage function in the *Wunderblock* is carried out not by the surface layer but by the waxen slab underneath. The crucial point here is that the creation of grooves on the waxen slab is a condition for the appearance of visible traces on the pad's surface. We see these traces not because they are stored on the registry-like celluloid surface layer (which is incapable of holding them) but because they have created a trace on the archive underneath. As is the case in the nineteenth-century archive, in Freud's model registration (conscious perception) and archivization occur in different locations. This spatial differentiation between the celluloid layer (the registry) and the waxen block (the archive) does not, however, imply a chronological one. It would be a mistake to assume that the archive (the grooves on the waxen slab) simply precede registration (conscious perception) since, in fact, both occur at the same time: no registration (conscious perception) without the archive, and vice versa. With every new grooving that imposes itself, the waxen block changes its surface structure as its patterns become more and more intricate. That the legibility

of these patterns decreases steadily in the process only goes to show that the modern archive does not count on meaning or intelligibility as a prerequisite for storage.

There are of course also differences between Freud's model of the psyche and the archive. For one thing, when an administrative archive receives a series of files from a filing office (a registry), these are arranged either chronologically or according to subject matter (or both); in the case of a private archive, papers and other documents may be stored in folders, envelopes, and other such storage devices. The archivist receives these materials, evaluates them, and then decides which files will be adopted into the archive and which will be destroyed. By contrast, in the Freudian archive, no positive decision is made to accept one psychical trace over another, and no file is destroyed because its value for posterity is in question; instead, everything is stored in the unconscious to the extent that it has managed to break the unconscious's considerable resistance to permanent storage. For the archive of the unconscious does not arise from a conscious will to store what may be useful in the future; it is, on the contrary, a result of force being applied to overcome the *resistance to archivization*. Further, while materials arrive in an administrative archive in series of chronological files that are more or less neatly separated, indexed, numbered, and registered, this is not the case with the Freudian unconscious. Here, mnemonic traces are stacked on top of each other without regard for clarity or readability, and crucially, without regard for time. For Freud, the unconscious was timeless; consequently, the chronological sequencing typical of a registry does not apply here.

What may distinguish Freud's psyche even more sharply from the archive elaborated by the likes of Ranke and Droysen is what Derrida has referred to as "archive fever"—his term for Freud's introduction into his psychical apparatus of a force that has no place there, threatening the archive and its well-greased economy of accession and repression at its very foundations: the "archive-destroying" death drive.[20] Derrida claims this drive has an "anarchivic" force because it does not leave traces of its own, escaping from the archive's most fundamental requirement that there be an archival outside, an external place of consignment.[21] Crucially, the death drive destroys not simply memory—archives are never simply institutions of memory—it destroys the exteriority of the archive to what it stores—the very exteriority on which both the *Wunderblock* and the historicist archive are founded: *"There is no archive without a place of consignment, without a technique of repetition, and without a certain exteriority.*

*No archive without outside.*"[22] As we saw, one of the most important elements of the nineteenth-century project was the fact that it tied hermeneutics to the archive's outside (the registry), a place or address to which its records allude and whose formal procedures it reflects—in short, a provenance. In an archive, everything has to come from somewhere, everything must act as evidence or clue, a hint at a place or site where it is not. The archive cannot function without such provenance. It is in bypassing the archive's heterotopy, its power as evidence and clue, that the death drive makes archivization impossible. That is incidentally also why trauma that leaves no traces—the Holocaust being the most glaring example—escapes objectivist historiography of the kind practiced by Ranke and Droysen.[23]

For all their differences, administrative and psychical registries do converge on at least two counts. For one thing, in both cases the materiality of the record is of the greatest importance for the storage of traces. Freud viewed memory as nothing beyond the forceful *Bahnung*, the "breaking of a pathway" that results in a trace in the unconscious; to an archivist too the materiality of the record, its presumed status as an indexical trace of the past rather than its mere representation, is a crucial part of its ability to testify to past events. The other important point of convergence between archives and the Freudian unconscious is Freud's insistence on the topological nature of the psychical apparatus, with its spatially and functionally concrete divisions. The space of the archive, its *arkheion*, plays a twofold role in psychoanalysis: first, as the material substratum that enables mnemonic traces to be inscribed in the unconscious; and second as the topography of the psychical apparatus itself, an apparatus where perception and consciousness are strictly separated from each other both spatially and functionally, and where the relations between different mnemonic traces are a function of their relationships in space.

Although the archive plays a powerful if unacknowledged role in Freud's elaboration of his metapsychology, in his clinical practice he was careful to downplay the importance of recording and archivization. As he moved away from the abreaction theory of his early days, references to the problem of transcription and recording during treatment began to appear in his writings with greater frequency. In the preface to the Dora case ("Fragment of an Analysis of a Case of Hysteria," 1905), for example, he writes: "I will now describe the way in which I have overcome the *technical* difficulties of drawing up the report of

this case history."[24] Freud is aware that the practice of psychoanalysis poses a recording problem, a problem of archivization: "I have not yet succeeded in solving the problem of how to record for publication the history of a treatment of long duration."[25] One of the crucial differences between Freud's earlier work and the Dora case is that he now considered *all* of the patient's memories to be valuable material for his analysis. Where before Freud and Breuer had dismissed the conscious (prehypnotic) reminiscences by the patient as so many signs of repression, now Freud's attitude toward these reminiscences changes dramatically. In an important, if cryptic, aside in the preface to the Dora case, he proclaims that since the publication of *Studies on Hysteria*,

> psycho-analytic technique has been completely revolutionized. At that time the work of analysis started out from the symptoms, and aimed at clearing them up one after the other. Since then I have abandoned that technique, because I found it totally inadequate for dealing with the finer structure of a neurosis. I now let the patient himself choose the subject of the day's work, and in that way I start out from whatever surface his unconscious happens to be presenting to his notice at the moment [*welche das Unbewußte in ihm seiner Aufmerksamkeit entgegenbringt*].[26]

The considerable administrative problem posed by considering everything the patient said admissible evidence was especially severe when Freud saw several patients in succession; it then became increasingly difficult to retain the specifics of each patient's memories without taking a written record of what he had heard.[27]

However, while he acknowledged the importance of writing for diagnostic purposes and for his scholarly publications, Freud also consistently minimized its practical impact. Instead of preoccupying himself with taking notes, Freud contends, the analyst ought to spend his time "interpreting what one has heard," a phrase that stresses the ear over the writing hand while also highlighting the curious contradiction in psychoanalysis between a model of the psyche to which a form of archival inscription is central, and a clinical practice where it is expected to play no vital role whatsoever.[28] It is of course interesting and perhaps symptomatic that, in the passage quoted above, the patient's unconscious reads

the surface offered to her by her consciousness as if it were a page coming off her typewriter's platen, with Freud perched over the machine ("I start out from whatever *surface* his unconscious happens to be presenting to his notice at the moment").[29] Regardless of the archival nature of this scene, which includes a material *arkheion*, Freud's model for the treatment situation is the telephone rather than the office:

> To put it in a formula: he must turn his own unconscious like a receptive organ towards the transmitting unconscious of the patient. He must adjust himself to the patient as a telephone receiver is adjusted to the transmitting microphone. Just as the receiver converts back into soundwaves the electric oscillations in the telephone line which were set up by sound waves, so the doctor's unconscious is able, from the derivatives of the unconscious which are communicated to him, to reconstruct that unconscious, which has determined the patient's free associations.[30]

The reason Freud does not regard writing—the classical archive medium—as useful for this process of transforming incoming signals (the patient's words) into the patient's unconscious is ostensibly that taking notes might tempt the analyst to censor what he hears: "A detrimental selection from the material will necessarily be made as one writes the notes or shorthand."[31] Linking note taking to a lapse from the presence of the analytic moment, Freud argues that what may be allowed in the subsequent scientific work may prove harmful during treatment: "It is not a good thing to work on a case scientifically while treatment is still proceeding—to piece together its structure, to try to foretell its further progress ... as scientific interest would demand. Cases which are devoted from the first to scientific purposes ... suffer in their outcome."[32] To Freud, who assumed that in psychoanalysis clinical practice and research coincided, note taking was tantamount to sidestepping the media network that tied his unconscious to his patient's—in short, it was a distraction from what with Droysen we might call the synchronicity of the "moment." Even his published scholarly work, Freud reasons, would not benefit from full recordings since those of his readers who trust the analyst blindly would believe him even if he were to introduce changes, while those who mistrust him would not be swayed in their

opinion even with the most complete recording.[33] Confident that taking no or only partial notes during treatment would suffice, Freud makes the case that a full recording or transcript of his sessions, even if it were available to the doctor, would not be in his patients' best interest: "The case history itself was only committed to writing from memory after the treatment was at an end, but while my recollection of the case was still fresh and was heightened by my interest in its publication. Thus the record is not absolutely—phonographically—exact, but it can claim to possess a high degree of trustworthiness."[34] Freud considered any gaps and inconsistencies in his published case histories nothing more than the inevitable side effects of the fact that they had their origins not in literary consciousness but in what he refers to above as "derivatives of the unconscious." In the Dora preface he notes: "If I were to begin by giving a full and consistent case history, it would place the reader in a very different situation from that of the medical observer."[35]

Remarks such as this one have sometimes been interpreted as suggesting that Freud's case histories ought to be treated as works of fiction in which the narrator's assertion that the story he tells is "nothing but the truth" often serves to underscore a text's fictional status. The argument that the case histories ought to be treated as (pseudo-) scientific correlatives of, say, Victorian novels was advanced by Michel de Certeau, among many others, and is based on the claim that, to quote de Certeau, "psychoanalytic conversion is a conversion to literature."[36] One of the passages quoted most frequently to support the "fictional hypothesis" is the following excerpt from *Studies on Hysteria:*

I have not always been a psychotherapist. Like other neuro-pathologists, I was trained to employ local diagnoses and electro-prognosis, and it still strikes me myself as strange that the case histories I write should read like short stories and that, as one might say, they lack the serious stamp of science. I must console myself with the reflection that the nature of the subject is evidently responsible for this, rather than any preference of my own. The fact is that local diagnosis and electrical reactions lead nowhere in the study of hysteria, whereas a detailed description of mental processes such as we are accustomed to find in the works of imaginative writers enables me ... to obtain at least some kind of insight into

the course of that affection. Case histories of this kind are intended to be judged like psychiatric ones; they have, however, one advantage over the latter, namely an intimate connection between the story of the patient's sufferings and the symptoms of his illness—a connection for which we still search in vain in the biographies of other psychoses.[37]

While to some critics Freud's assertion that "the case histories I write should read like short stories" is proof that he himself considered his writing a form of fiction, to others, it actually proves the opposite. As Dorrit Cohn has argued, "I understand [the quoted passage] as the germinating moment of Freud's enduring concern with the way analytic investigation of the human psyche differs from fictional creation, as well as of his continuing effort to distance his case histories from their spurious resemblance to short stories."[38] However, perhaps the problem with either claim—Freud as a writer of fiction, or not—is that it overlooks Freud's background in nineteenth-century scientific historicism and his involvement with the archive. For Freud doesn't pit fiction against nonfiction as much as he pits narrative—fictional or otherwise—against the classification of discrete symptoms that lack a provenance. He does not regard narrative as being *necessarily* fictional, in much the same way that Droysen, who based his innovative approach to historiography on a succession of recorded moments, did not think of the writings of historians as fictional, let alone literary. The question posed here is whether a narrative case history that is interpretive and descriptive rather than classificatory can pass for scientific. I agree with Cohn that Freud's admission that his case histories should read like short stories "can hardly be taken as a 'disarming admission' that he was in fact infringing on the fictional preserve, much less as a symptom of his 'conversion to literature,'" and that Freud is "asking his readers to convert to a different scientific code—a code in which texts that 'read like short stories' are not read *as* short stories."[39] My question, however, is where Freud receives the authority for this "different scientific code." To my mind, he derives it from nineteenth-century historicism and its belief in the synchronous presence of the moment. Although the case histories might be narratives, the fact that they have their basis in an archive of moments in the present whose provenance is "another territory" effectively shields them, in Freud's estimate, from being fiction.[40] This is also why Freud was surprised by the "smooth and exact" case histories of other doctors,

given that their patients would be "incapable of giving such reports about themselves."[41] To Freud there is no question that any remnant (or derivative) has a meaning; however, that meaning cannot be gleaned unless we carefully reconstruct the operations of the place or territory that produced it in the first place. Like the nineteenth-century archive which permits the historian to reconstruct not so much history but the anatomy of another place—the workings of the office or agency that produced its records—so psychoanalysis also aims not at the meaning of the patient's words but at the geography of the territory from which they stem.

an experience is missing from its proper place,

4

# 1913
# "DU HASARD EN CONSERVE":
# DUCHAMP'S ANEMIC ARCHIVES

Marcel Duchamp

MARCEL DUCHAMP'S READYMADES ARE OFTEN VIEWED AS SQUARELY NOMINALIST INQUIRIES INTO THE CONDITIONS UNDER WHICH ART CAN BE CONSIDERED AN EFFECT OF LINGUISTIC DETERMINATION. Yet they also function as critical interventions in the nineteenth-century archive and its ambition to reconcile the contingency of time with the continuity of symbolic representation. As a form of spacing, the readymades tamper both with the archival signifiers ($a$-$b$-$c$-$d$-$e$-$f$) and with the intervals that separate them. In their insistence upon intervals, the readymades approach time in relation to movement, a fact that positions them close to the medium of film. As a media technology whose goal is the archivization of time in flux, film produces a living present from a mechanically accelerated series of stills. Thought of as a series of discrete recorded moments that aim to register the contingent, film partakes of the Real;[1] as a continuous motion projected on a screen, however, it is part of the Imaginary, translating the discrete series of still images into a more or less

coherent visual flux. In his book on film and time, Gilles Deleuze distinguishes two aspects of time in relation to movement:

> Whenever time has been considered in relation to movement, whenever it has been defined as the measure of movement, two aspects of time have been discovered, which are chronosigns: on the one hand, time as whole, as a great circle or spiral, which draws together the set of movement in the universe; on the other, time as interval, which indicates the smallest unit of movement or action. Time as whole ... is the bird which hovers, continually increasing its circle. But the numerical unit of movement is the beating of a wing, the continually diminishing interval between two movements or two actions. Time as interval is the accelerated variable present, and time as whole is the spiral open at both ends, the immensity of past and future. Infinitely dilated, the present would become the whole itself; infinitely contracted, the whole would happen in the interval.[2]

As chronosigns, the readymades may be thought of as intervals in Deleuze's sense of that term; they are indicators of the "smallest unit or action," or the relationship between smaller and larger such units. They not only alert us to the fact that the value of each individual element in the series $a$-$b$-$c$-$d$-$e$-$f$ is determined by the gaps between the elements—by their context—rather than by the elements themselves, but they also hint that these gaps function as entryways for what the series was designed to shut out in the first place: chance and contingency—that other, unconscious time which in Wundt's model is surreptitiously turned into a regular rhythm by the time the *Zeitvorstellung* reaches consciousness. In a comment on Thierry de Duve's oedipal model for Duchamp's transition to constructing readymades, David Joselit has asserted that "the seemingly irreversible passage from the Real to the Symbolic by which de Duve explains Duchamp's transition from painting to the readymade masks the extent to which a fragmentary or acephalous carnality irrupts within the readymades themselves. Even when he seems at his most nominalist ..., Duchamp is never far from what de Duve classifies as the Real. In these works the nominalist schema is reversed—instead of the Symbolic irrupting within the Real, the Real irrupts in the Symbolic."[3]

Joselit is right to point out that the readymades cannot be firmly located in the symbolic order. What Lacan calls the Real—that which resists symbolic encoding, suggesting a fissure or tear on the archive's surface—obscures and confuses the sublimatory path on which de Duve sets the readymades, implying a return to trauma rather than its successful deferral. Expanding on Joselit's analysis, I want to stress the element of temporality that accompanies this irruption of carnality, an irruption that often occurs in the form of chance and contingency. Crucial "stoppages" in Duchamp's fight against retinal art, the readymades are not symptoms of a sublimatory turn to the symbolic order; instead, they demonstrate the surging of contingent time at its very center. In a note from the *Green Box*,[4] Duchamp explicitly linked the readymades to a (missed) encounter with time, here understood as a single point ("a minute") whose material signifier, its archive, is the readymade:

> by planning for a moment to come (on such a day, such a date such a minute), "to *inscribe* a readymade"—The readymade can later be looked for.— (with all kinds of delays)
> The *important thing then is just* this matter of timing, this snapshot effect, like a speech delivered on no matter what occasion but *at such and such an hour.* It is a kind of rendezvous.

—Naturally inscribe that date, hour, minute, on the readymade as *information.*[5]

As "planned snapshots," the readymades pose the question of whether there can be such a thing as an encounter with time, or an archive of such an encounter. Such an encounter would have to be a point or moment that—unlike the Wundtian *Zeitvorstellung* with its assumption of a stable, immutable center—is always anticipated, always in suspense and always in the future ("planning for a moment to come")—an encounter always already missed. How can the readymades be conceived as archives (or inscriptions) of a missed encounter that is always—always—in the future? Can there be an archive of future traces, an inscription devoted to future events in the past?[6] Jean Clair has called the time marked by the readymades the "immediate future" (*l'avenir immédiat*): "The immediate future escapes very precisely from my tastes and distastes, it is the only place to which

I am really indifferent because it is the only place that is still unknown to me."[7] The "immediate future" is an interval that eludes all our *Zeitvorstellungen*, a point of indifference that we cannot inhabit or know. As inscribed and inscribing archives of such points, the readymades inform us that there is nothing to know.

Duchamp, whose attitude to his own work was archival in any number of ways,[8] was most explicit about the relationship between the readymades and the archivization of chance with regard to his *3 Standard Stoppages* (1913), when he famously referred to three pieces of tailor's thread dropped from a height of one meter onto a strip of painted canvas as "du hasard en conserve" ("[a bit of] chance in a can"). As a (failing) encounter with time, *3 Standard Stoppages* (and the readymade more generally) registers time not as continuity but in the form of accidental fissures or scars on an otherwise well-regulated surface. The phrase "du hasard en conserve" can be understood in a number of ways. First, in a heroic register, it can refer to the final victory of the archive (here figured as a tin can) over chance, a victory that is often associated with the media technology of film (the can). Conversely, and uncinematically, the phrase "du hasard en conserve" can be understood, much less heroically—and more plausibly—as a reference to chance having invaded the archive, where it now wreaks havoc with the archive's ambition to produce an ordered record of time. Duchamp's phrase purposefully avoids the direct article "le": "du hasard en conserve" implies a part of a larger whole, suggesting that while contingency may to some extent be amenable to mensuration and archivization, some chance will always remain outside, resisting all efforts to be symbolized.

Besides reminding us that chance (*Zu-fall*) is related to things falling, Duchamp also links the idea of fabrication to an archive of contingent moments:

### The Idea of Fabrication

—If a thread one meter long falls from a height of one meter straight on to a horizontal plane twisting *as it pleases* and creates a new image of the unit of length.—[9]

The French term *fil* (thread) is related to the English term "file," which in some Romance languages (such as Spanish and Portuguese) is translated as *archivo*. Its threads thus link *3 Standard Stoppages* to the archive in a very concrete way. Whereas in the registry threads were used to stitch files together, in the archive

4.1

Marcel Duchamp, *3 Standard Stoppages* (1913–1914). Wood box 11⅛ x 50⅞ x 9 in., with three threads 39⅜ in., glued to three painted canvas strips 5¼ x 47¼ in., each mounted on a glass panel 7¼ x 49⅜ x ¼ in., three wood slats 2½ x 43 x ⅛ in., shaped along one edge to match the curves of the threads. © The Museum of Modern Art / Licensed by SCALA / Art Resource, NY. Courtesy The Museum of Modern Art, N.Y., USA. © 2007 Artists Rights Society (ARS), New York / ADAGP, Paris / Succession Marcel Duchamp.

proper, special "archive knots" that only archivists knew how to tie properly kept file folders closed. As I mentioned above, the earliest known archives contained objects neatly strung up on suspended threads, "one thing after another." These archive strings functioned as navigational tools—a kind of cybernetic feedback— that allowed their users to keep their bearings in time and space, much like the thread that once helped Theseus navigate his way through Daedalus's labyrinth. And, as a way of submitting chance to successful symbolization, Ariadne's thread has often been viewed as a metaphor for the production of art. For example, Walter Benjamin observed:

> To begin to solve the riddle of the ecstasy of trance, one ought to medi-
> tate on Ariadne's thread. What joy in the mere act of unrolling a ball of
> thread! And this joy is very deeply related to the joy of intoxication, just
> as it is to the joy of creation. We go forward; but in so doing, we not only
> discover the twists and turns of the cave, but also enjoy this pleasure of
> discovery against the background of the other, rhythmic bliss of unwinding
> the thread. The certainty of unrolling an artfully wound skein—isn't that
> the joy of all productivity, at least in prose?[10]

If on the one hand the artist submits willingly to chance, on the other hand, she or he relies on the feedback provided by the thread to mitigate its effects, using it to suture a gap or hole at the very center of the symbolic. Fingering the thread, stitching it into a text, the artist in Benjamin's account occupies a place simultaneously inside and outside of contingency, finding a rhythm in or through the waywardness of chance.[11]

Unlike Theseus, who eagerly lets Ariadne's thread slip through his fingers, Duchamp lets his threads fall to the ground, signaling in this way that (unlike Benjamin) he is not interested in art as a way of suturing the symbolic. (In fact, in Duchamp's last painting, *Tu m'* [1918], a painted scar on the surface of the canvas seems to be held together by simple safety pins.) According to Lewis Kachur, Ariadne's thread loses its navigating powers in Duchamp's work: "Duchamp's [thread] ... does not lead anywhere or locate direction, [but] rather confuses direction."[12]

In Duchamp's readymades, strings or threads—taut or curled; wound up or unwound; suspended or glued down with varnish—are a constant presence, ranging from the "five meters of string weighing ten grams" that Duchamp added to his 1918 *Recette* (a handwritten "recipe" on a fragment of a 1914 photograph of a gauze held before an open window) to the strings in *Sculpture for Traveling* (1918) that were used to attach strips cut from rubber bathing caps to the corners of Duchamp's New York studio.[13] In some cases, strings are used to document a change in the aggregate state of an object through the impact of chance. In 1919, Duchamp created *Unhappy Readymade* by attaching strings to a geometry text-book and hanging it from the balcony of his apartment.[14] The idea was that, by exposing the book to the weather, the wind would go through it, "choose its own problems, turn and tear out the pages."[15] Here the strings both represent materi-alized versions of the drawn line in the textbook of Euclidean geometry and help bring about a change in the object's aggregate state, switching it from a "happy" to an "unhappy" mode: "I knew that the rain would fall and the wind would blow and the book would be unhappy for being in the open air like that."[16] As the book is exposed to the elements, it diminishes further as more and more of its pages are torn out or damaged. Allowing the weather to interfere in the book's integrity is to allow contingency to intervene in geometry's regulated symbolic universe. Here as elsewhere, the "missed encounter" marked by the readymades is the trace—the inscription—of a force that runs counter to orderly symbolization, leaving nothing in its wake. With Duchamp, threads (*fils*) do not seal an object for preservation, they expose it to the savagery of contingent time.

4.2
Marcel Duchamp, *Recette* (1918).
Ink on plastic, 5¼ x 5⅜ in.
© Philadelphia Museum of Art:
The Louise and Walter Arensberg
Collection, 1950. © 2007 Artists
Rights Society (ARS), New York /
ADAGP, Paris / Succession
Marcel Duchamp.

4.3
Marcel Duchamp, *Sculpture for Traveling* (1918). © Philadelphia Museum of Art: Duchamp Archive. © 2007 Artists Rights Society (ARS), New York/ADAGP, Paris/ Succession Marcel Duchamp.

4.4
Marcel Duchamp, *Unhappy Readymade* (c. 1919–1920). Gelatin silver print. © Philadelphia Museum of Art: The Louise and Walter Arensberg Collection, 1950. © 2007 Artists Rights Society (ARS), New York/ADAGP, Paris/ Succession Marcel Duchamp.

In *3 Standard Stoppages*, the changes in the aggregate state of the threads introduce contingency into the rigidity of the decimal system, a system whose hegemony was traditionally vested in the archive. After the introduction of the metrical system by the French National Convention in 1795, the so-called *mètre des archives* was deposited in the form of a platinum-iridium bar in the French State Archives (Pavillon de Breteuil, Sèvres). In its authority as the meter a priori, a measurement that legislates over all deviations and differences, the *mètre des archives* functioned not only as the master meter but also as a symbol of male hegemony (*maître*), a standardized emblem of masculinity at (or as) the center of the archive.[17] By challenging the *mètre/maître* and its elision of gender differences, *3 Standard Stoppages* stages a drama of affil(l)iation and metamorphosis as Duchamp's threads, in falling to the ground, change from symbols of heroically taut masculinity into more curved feminine forms.[18] It is as if in falling to the ground the male strings (*fils*)—symbols of the universal masculinity of the archive in general (*mètre/maître*)— switched to a more particular feminine mode (*fils > filles*). For Duchamp, the figuration of contingency, its archivization, is closely linked to this gender switch.

In another readymade, *With Hidden Noise* (1916), a string that does not unwind, remaining firmly attached to its skein, represents the counterpart to the falling threads in *3 Standard Stoppages*. *With Hidden Noise* consists of a tightly wound skein of twine between two brass plates joined by four long bolts. Prevented from unraveling by the metal plaques, Duchamp's neatly wound string cannot fulfill the measuring, sublimatory, symbolizing functions associated with lines of thread that unwind in an orderly and regulated fashion, like Ariadne's thread or Wundt's series of inscribed moments of time. The skein that cannot unwind amplifies the trauma of demasculinization, understood as the loss of one's ability to symbolize successfully, that was already hinted at in *3 Standard Stoppages*. At the hollow center of the skein, unseen and unknown, lies a secret object placed there by Duchamp's friend Walter Arensberg; Duchamp himself did not know whether this object was "a diamond or a coin." The two brass plaques that seal the hole at the center of the wound skein bear written inscriptions in white paint. The top of the upper plaque reads:

P.G. .ECIDES DÉBARRASSE.

LE. D.SERT.F.URNIS ENT

AS HOW.V.R COR.ESPONDS

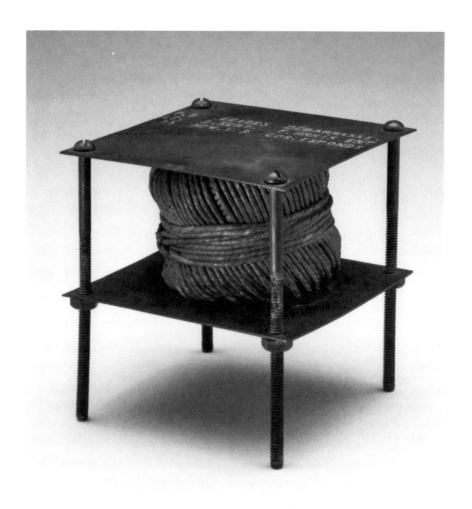

4.5
Marcel Duchamp, *With Hidden Noise* (1916). Assisted readymade: ball of twine between two brass plates, joined by four long bolts, containing a small unknown object added by Walter Arensberg, 5 x 5 x 5⅛ in. © Philadelphia Museum of Art: The Louise and Walter Arensberg Collection, 1950. © 2007 Artists Rights Society (ARS), New York / ADAGP, Paris / Succession Marcel Duchamp.

The bottom of the lower plaque reads:

.IR. CAR.É LONGSEA→

F.NE, .HEA., .O.SQUE→

TE.U S.ARP BAR.AIN→

Unlike Wundt's orderly series of letters, Duchamp's series is inconsistent and unreadable, containing numerous gaps where letters are either missing from their place or temporarily invisible, "like in a neon sign when one letter is not lit and makes the world unintelligible."[19] Duchamp asks us to replace these letters (whose absence is represented by the periods) in each line with others taken from the same vertical column as the period. However, even once the missing letters have been substituted (creating new gaps), no meaningful text emerges. This suggests that instead of representing a curable lapse, the workings of chance (of contingent time) in, or on, the symbolic order are intrinsic to its operation, a fact that no archive project can afford to ignore.

Instead of reading the lines on each plaque one by one, Duchamp insisted that the lines should be read across both plaques, so that after finishing the first line on the upper plaque we continue with the first line on the lower plaque, then move on to the second line on the upper plaque, and so forth: "The three arrows indicate the continuity of the line from the lower plate to the other [upper] still without meaning."[20] In this way, we turn the skein around every time we finish reading a line. However, the string wound around the skein does not unwind, despite such twisting and turning; instead of successful symbolic organization, the operation yields nothing but a meaningless motion over time and an indistinct sound emanating from the center of the object.

Duchamp's skein—and the readymades more generally—mark a traumatic incursion into the order of symbolic representation. A similar operation occurs with a spool in Walter Benjamin's "Berlin Childhood around 1900." Benjamin describes his mother's sewing box (*Nähkasten*), whose upper part is filled with neatly organized threads of silk, needles, and scissors. The lower part of the box offers a striking contrast to the well-ordered series of implements housed in its upper region. Here, "there was the dark underground, the chaos, in which the loosened ball of thread reigned supreme, and in which pieces of elastic bands, hooks, eyes, and scraps of silk were jumbled together."[21] The little boy nurtures

doubts as to whether the utensils in his mother's box are really meant for mending garments. Readers may wonder whether these doubts embody anxiety about a repressed desire, and in fact Benjamin confirms this suspicion: "That the spools of thread and yarn within it tormented me by their shady allure only strengthened my doubt. What attracted me about those spools was their hollow core; originally, this was intended for an axle which, on being rotated, would wind up the thread on the spool. Now, however, this cavity was covered on both sides by a black label [*die Oblate*] which bore, embossed in gold, the name and number of the firm."[22] The spools described in this passage—their cavities covered on either end by letters—recall Duchamp's tightly sealed skein hemmed in between the two metal plates with their meaningless inscriptions. In Benjamin's account, the hollow core on which the axle used to rotate becomes the focal point of the boy's fantasy of penetrating the spool with his finger, perforating the label with its written inscription as if it were a hymen: "Too great was the temptation to press my fingertips against the center of the tag; too intimate, the satisfaction when it tore and I dipped into the hole beneath."[23] As is the case with Duchamp, this incursion into the symbolic order—the destruction of the written labels whose German name, *Oblaten* (the body of Christ), marks them as sacrificial objects—proceeds under the persistent threat of demasculinization (the mother's *Nähkasten* as castration kit). In his essay on Franz Kafka, Benjamin associated the bizarre, anthropomorphous spool named Odradek from Kafka's short story "The Care of the Family Man" (1919) with "the form which things assume in oblivion" and with instances of distortion (*Entstellung*).[24] We may be tempted to apply the term *Entstellung* to Duchamp's readymades, too. The noise at the center of *With Hidden Noise*, a kind of unorganized *tukhē*, or chance, erupts in the very place where we expect time's successful ordering—the efficient covering of the hole or fissure at the center of the skein by means of an archive of readable, meaningful symbols. The readymades return to us what we know already—mass-produced, industrial objects—yet in a form suggestive of an *Entstellung*, a de-formation that precludes easy recognition. Like Kafka's world in Benjamin's interpretation, the readymades function as an index of contingent time; forgotten to the present and lost to the order of symbols, they carry with them the mark of what returns to us without ever becoming recognizable as such; they are like the nuclei of the past enclosed within the texture of the present. As instances of archivization, the readymades allow us to consider the present itself an archive; not as a monolithic

container of past events but as a convolute of textured threads that revolve around a hollow shaft whose open end points are covered with symbols.

In their relationship with time, the readymades recall—yet also crucially differ from—the nineteenth century's most elaborate effort to create an archive of contingency, the mechanically produced graphs or curves designed to trace the movements of bodies (*la méthode graphique*). One of the key proponents of the graphic method was the physiologist, engineer, and *bricoleur* Etienne-Jules Marey (1830–1904), whose work Duchamp knew through his brother, Raymond Duchamp-Villon, and "had read," according to Françoise Dragonet.[25] Discussions of Marey's relevance for Duchamp are canonical in studies of the artist, but they rarely go beyond Marey's experiments with chronophotography, which are thought to have influenced the painting *Nude Descending a Staircase No. 2* (1912). However, before it occurred to him, after his meeting with Eadweard Muybridge, to use photography for the registration of movement, Marey spent much of his time constructing and lecturing about writing machines designed to translate the forces of nature into graphic curves.[26] These registration machines, which Marey referred to as *appareils inscripteurs*, registered anything from the living pulse to a horse trotting or galloping to the flight of an insect. The phenomenon under observation emerged, ghostlike, as a graphic curve on a piece of paper.[27] In constructing his writing machines, Marey was acutely aware of the limitations of writing, and of language more generally: "Science has two obstacles that block its advance … first the defective capacity of our senses for discovering truths, and then the insufficiency of language for expressing and transmitting those we have acquired. The aim of scientific methods is to remove these obstacles."[28] According to Marey, the function of writing in science should be restricted to the naming and classification of static facts; he even advised biologists to abandon any descriptive account of their experiments and use curves instead. Only if

4.6
"Tracés recueillis avec le sphy[g]mographe à transmission," in H. A. Snellen, *E. J. Marey and Cardiology: Physiologist and Pioneer of Technology, 1830–1904* (Rotterdam: Kooyker Scientific Publications, 1980), 166.

4.7

Marcel Duchamp, *3 Standard Stoppages*
(1913–1914). Wood box $11\frac{1}{8}$ x $50\frac{7}{8}$ x 9
in., with three threads $39\frac{3}{8}$ in., glued
to three painted canvas strips $5\frac{1}{4}$ x
$47\frac{1}{4}$ in., each mounted on a glass panel
$7\frac{1}{4}$ x $49\frac{3}{8}$ x $\frac{1}{4}$ in., three wood slats
$2\frac{1}{2}$ x 43 x $\frac{1}{8}$ in., shaped along one
edge to match the curves of the threads.
© The Museum of Modern Art/Licensed
by SCALA/Art Resource, NY. Courtesy
the Museum of Modern Art, N.Y., USA.
© 2007 Artists Rights Society (ARS),
New York/ADAGP, Paris/Succession
Marcel Duchamp.

writing was abandoned in favor of more immediate types of graphic registration—the graphic method—could biology rid itself once and for all of what Marey called "the illusion of the observer" and "the slowness of the descriptions, the confusion of facts."[29]

With the construction of the sphygmograph (or pulse writer), Marey widened the scope of his mechanical measurements to include the motions of the human body. Consisting of a lever whose one end rested on the wrist's pulse point—applying slight pressure to the artery—while the other was connected to a stylus, the sphygmograph measured and recorded the pulse's throb in the form of a graphic line that moved in perfect sync with the phenomenon recorded, suggesting a graphic archive of contingency, time in high flux.[30] Marey's method assumed that the registration of time could proceed in a medium—graphic curves—that would itself be immune to the effects of contingency. Building blocks for what Marey referred to as the "language of the phenomena themselves," curves called to mind a language of pure information, fixed by perfectly transparent indexical graphs that effectively circumvented the problems inherent in ordinary forms of representation. These curves, it appeared, were not in need of interpretation; they meant nothing beyond the force of which they were the immediate imprint, commanding an evidentiary power that was, Marey claimed, so obvious and so immediate that no analysis was necessary either during their production or during their subsequent scientific use.[31]

4.8
J. E. Marey, *Sphygmographe à galet servant à l'enregistrement du pouls de l'homme* (c. 1858). Courtesy Musée Marey, Beaune, France.
© Musée Marey, Beaune.

The curves written by Marey's *appareils* exhibit the tension that characterizes the nineteenth-century archive in its approach to time, the tension between the discreteness of the code ($a$-$b$-$c$-$d$-$e$-$f$) and cinematic continuity—or, in Lacan's terms, between the Symbolic and the Imaginary. When viewed as the Imaginary, Marey's graphs are pure cinema, the equivalent of a perfectly coherent motion unfolding in real time. On the level of the Symbolic, however, these same images are only a series of discrete elements or signifiers. Crucially, Marey argued that his graphs, continuous though they might seem, were in fact made up of a multitude of individual points, each of them corresponding with a change in the aggregate state of the measured phenomenon itself. The more points or aggregate states a curve took on, the denser and the more distinct it would become, implying a thickening of time that corresponded directly with a thickening of the curved line: "The more successive observations we bring together, the more complete will be our idea of the phenomenon under scrutiny. In graphic representation we have to multiply as many successive notations as possible since each single one of them corresponds to the state which the phenomenon presents at a given moment of observation."[32]

The notion of the "point," which is equivalent to Droysen's "moment," was widely discussed in the nineteenth century.[33] For Henri Bergson there could not be such a thing as an archive of time based on discrete moments, as he believed there was no single point at which time could reliably be said to be "present." Whatever is present becomes the past the very instant we call it "present"; Bergson asks, "What is, for me, the present moment? The essence of time is that it goes by; time already gone by is the past, and we can call the present the instant in which it goes by. But there can be no question here of a mathematical instant."[34] Bergson argued that the contingent present cannot be archivized; first, because we cannot speak it without slippage and, second, because there is no point in time that could be said to be independent from what preceded it or from what follows it. Since there can be no question of a disembodied past (there is only "my past"), the present can be thought of only as a duration with a "foot" both in "my" past and in "my" future. What Bergson addresses here is the threat posed by blur, the possibility that the present, understood by Droysen and Wundt as a chronology of legible moments neatly separated from each other by regular intervals, may turn out to be less clearly structured and defined than we would like it to be.

In their insistence on interval and difference, the readymades disavow Bergson's assertion that differentiation is impossible. But this is not to say that

they simply endorse Marey's cinematic mensurations.[35] The reason is simple: the readability of Marey's graphs, and hence their operational efficacy in the scientific context for which they were designed, depended on the fiction of a transparent, interpretable body powering the curves that trace and measure it. The universality of this body was underwritten not, eighteenth-century-style, by the fact that it could be classified but rather by the fact that it could be *measured.* Now, although the undulated lines described by *3 Standard Stoppages* might recall Marey's curves, their differences can certainly not be reduced to the labor of a universal body. After all, in falling to the ground, Duchamp's curves register nothing but *their own* mass.[36] If in doing so they nevertheless allow gender differentiation to surge (*fils* [threads; son] > *fille*), this implies that the production of such difference occurs at a point far removed from the kind of universal body presupposed by Marey's curves.[37] Apart from the readymades, Duchamp deconstructed the mensurated universal body of the nineteenth century most effectively in his film *Anemic Cinema* (1926), which shows the pulsations of an anemic— bloodless—artery.[38] Here, the fiction of a physical force or body preceding its own measurement and archivization is given up as the artery's motions become a function of the film apparatus itself, on the one hand, and of the act of vision, on the other.

Readymades such as *3 Standard Stoppages* do not simply duplicate the nineteenth-century archivization of the contingent ("Life"); they demonstrate that contingency lies at the very center of such registration. As a form of spacing that tinkers with the order of the graphic archive, the readymades suggest that contingency may intervene in any effort to graph, measure, or symbolically encode time. In a note from the *Box of 1914*, Duchamp elaborates on a type of inscription (the Bride's) whose letters would move freely along existing trajectories. While this project could be seen as Duchamp's own version of an *appareil enregistreur*, there was one important difference: in Duchamp's machine, the position and value of the signifiers that encode a given series (*a-b-c-d-e-f*) are themselves subject to the effects of the forces it registers:

To make an *Inscription* of it
(title,).

Moving inscription. i.e. in which the group of alphabetic units. should no longer have a strict order from left to right.—each *alphabetic* unit will be

present only *once* in the group ABC. and will be displaced from A to C and back again.—Since, from A toward C, the inscription should, according to the need for equilibrium of the plate D, displace a [stabilizer] (a ball or anything). On this plate D. At A. there will be [a sort of *letter box*] (alphabet) which will go toward B and C.[39]

Not only is the inscription itself mobile, but its constituent parts, the discrete letters, are also continuously sliding along a fixed trajectory. These letters, far from being ethereal or transparent, have sufficient mass so that when they leave their position, another object, such as a ball, has to be moved in place to preserve the mechanism's equilibrium. Duchamp explicitly linked this switch to *3 Standard Stoppages*, considering the fallen threads as the basic elements of a new graphic language:

**Conditions of a language:**

The search for *"prime words"* ("divisible" only by themselves and by unity).

Take a Larousse dict. And copy all the so-called "abstract" words. i.e., those which have no concrete reference.

Compose a schematic sign designating each of these words. (this sign can be composed with the standard stops)

These signs must be thought of as the letters of the new alphabet.

A grouping of several signs will determine

(utilize colors—in order to differentiate what would correspond in this [literature] to the substantive, verb, adverb, declensions, conjugations etc.)[40]

To construct a language based on the chance-riddled code figured by *3 Standard Stoppages* is to hint at an archive not of accumulation (in the manner of Marey) but of diminution and thinning. Duchamp further elaborated such an archive in readymades like *Comb* (1916) and *Tzanck Check* (1919). In a note on *Comb*, a dog comb whose relationship with time and the archive begins with the inscription "FEB. 17 1916," Duchamp proposed to classify combs by the number of their teeth ("Classer les peignes par le nombre de leurs dents"). The regular succession of teeth turns the comb into a measuring instrument, a kind of ruler.

In an interview with Arturo Schwarz, Duchamp reinforced the importance of the comb's teeth for his project: "The teeth of a Comb are not really a very important element in life…. In other words, when you look at a Comb, you just look at your hair, you use it or you don't, but the number of teeth of the Comb is really unimportant…. I was struck by this unimportance and so I made it important to me."[41] The experience Duchamp relates here is closely linked to the turning of *Bicycle Wheel* (1913). Just as we do not see the wheel's spokes when we turn it fast enough, so the comb's teeth also go unnoticed when the comb is put to its regular use. To make the unimportance of the comb's teeth important is to slow down the combing motion so that its constituent parts can be inspected more closely.

4.9
Marcel Duchamp, *Comb* (1916).
Gray steel dog comb, 6½ x 1¾ x ⅛ in.
© Philadelphia Museum of Art:
The Louise and Walter Arensberg
Collection. © 2007 Artists Rights
Society (ARS), New York / ADAGP,
Paris / Succession Marcel Duchamp.

Like the readymades more generally, *Comb* critically intervenes in the nineteenth-century archive's ambition to register time past as "past present." Far from simply affirming this ambition, *Comb* implies that contingency and the possibility of accidents lie at the center of any effort to record and measure time, and that the incursion of chance affects the archive at every level. On one side of the comb Duchamp inscribed the phrase "TROIS OU QUATRE GOUTTES DE HAUTEUR N'ONT RIEN A VOIR AVEC LA SAUVAGERIE" (three or four drops of height have nothing to do with savagery).[42] By pairing a series of discrete letters that make little sense—not unlike Wundt's—with a series of equally discrete (and equally meaningless) teeth, Duchamp points out, first, that writing, the most classical of archive media, is made up of material signifiers just as a comb is made up of a series of teeth. In such a series, individual letters are defined not by what they mean but by the intervals that separate each one from the next. Second, as material

signifiers, letters, like teeth, are exposed to the vagaries of chance (teeth may fall out), introducing an element of time into what seems to be an immaterial and static sequence of signs. Duchamp was fascinated by the idea that some of the comb's teeth might go missing, an accident—an incursion of chance—that would radically change the intervals that separate one tooth or letter from the next: "In many Combs there may also be a tooth that's broken and that makes the relationship of space between two teeth different."[43] Duchamp's archive is an archive of broken teeth in which the regularity and density of discrete points in space (Marey) can no longer be called upon to figure contingent time.

Still, Duchamp insisted that the comb's irregular intervals—similar to that of a broken ruler as well as to a kind of anti-cinema in which the continuity of time is severely disrupted—would not prevent the object from functioning as a tool for mensuration; on the contrary, "with a kind of Comb, by using the space between 2 teeth as a unit, determine the relations between the 2 ends of the Comb and some intermediary points (by the broken teeth)."[44] Here, it is the effect of chance itself—the irregular interval—that becomes the unit of measurement, marking a decisive difference between Duchamp and Marey. Where Marey assumed that the more points or aggregate states his curves took on, the denser and the more distinct they would become, Duchamp proposes, on the contrary, that measurement and archivization contend with a progressive thinning of their constituent elements (combs can lose their teeth). In Duchamp's version of the nineteenth century's graphic method, chance gradually strips the graph's body of life. Instead of a body represented by a universally readable graphic curve made up of a regulated series of points, we are left with nothing but missing teeth, a measuring motion with nothing to measure, an anemic archive.

A similar thinning out of the symbolic code (conceived as a series of intervals) occurs in *Tzanck Check*, a hand-drawn check, larger than life-size, that Duchamp designed to pay his dentist, the Parisian art collector Daniel Tzanck, for treatment he had received. As was the case with *Comb*, an inscribed date (December 3, 1919) relates *Tzanck Check* to a specific point in time. Once again, the effects of chance here become the improbable units of measurement. In its capacity as payment to a dentist for services rendered, *Tzanck Check* notarizes both the fact that teeth may go missing or be damaged and the possibility of their successful repair. However, since the funds Duchamp's check promises to pay the check's bearer are drawn from a "bank of teeth," one has to wonder how successful or durable the dental treatment could have been.[45] Given the dentist's name—

almost a hybrid construct of *Zahn* (tooth) and *Zange* (pliers)—one presumes that Dr. Tzanck's repair job consisted not in restoring teeth but in pulling them out so they could then be used for payment. In this tautological scheme, the flow of capital is directly linked to trauma and chance—to intervals—because mensuration can no longer rely on a stable series of coordinates.

4.10
Marcel Duchamp, replica of *Tzanck Check* (1919) from the *Boîte-en-valise*. Color lithograph, 8⅞ x 15⁹/₁₆ in. © Philadelphia Museum of Art: The Louise and Walter Arensberg Collection. © 1997 Artists Rights Society (ARS), New York / ADAGP, Paris / Succession Marcel Duchamp.

With their reference to (missing) teeth, *Comb* and *Tzanck Check*—much like *3 Standard Stoppages*—hint at the surge of chance at the center of archivization. If this suggests a "body in the archive," that body could not be further from the ones studied in the late nineteenth century by the likes of Alphonse Bertillon from the police headquarters in Paris, or by Albert Londe, Charcot's chief imaging officer at the Salpêtrière. Photo databases helped Londe track, or even create, the symptoms of a disease called hysteria, and they helped Bertillon put together the physiognomic profiles of thousands of criminals. In Bertillon's and

Londe's archives—to which the readymades *are* linked by their ambition to be snapshots and by their insistence on mensuration and morphology—the body (as the object of photographic reproduction) refracts into an ever-expanding database of physical clues identified with increasing precision by their gridlike coordinates. Allan Sekula interprets the appearance of photo archives such as Bertillon's as a moment of crisis in optical empiricism, contending that they cannot produce their own truth without a bureaucratic supplement. In Sekula's reading, modernism, especially where it lays claim to absolute knowledge and unfettered immediacy that eschews administrative support, is steeped in the spirit of the bureaucracy, its archives and its filing techniques: "In short, we need to describe the emergence of a truth-apparatus that cannot be adequately reduced to the optical model provided by the camera. The camera is integrated into a larger ensemble: a bureaucratic-clerical-statistical system of 'intelligence.' This system can be described as a sophisticated form of the archive. The central artifact of this system is not the camera but the filing cabinet."[46] Whereas in Sekula's reading the written archive functions as a supplementary apparatus whose principal function is to notarize (photographic) truth by allowing for secure identification, in Duchamp's pieces letters are as exposed to the incursions of chance as the facts they are called upon to notarize. In fact the readymades notarize nothing if not a fundamental lack at the archive's very center. Here, clues are not accumulated, and not notarized, but progressively vanish (teeth may go missing, intervals may be changed), implying the archive's utter openness to chance.[47]

In two other readymades, *The* (1915) and *Rendez-vous of Sunday, February 6, 1916* (1916), Duchamp generated texts whose readability was similarly undermined by missing elements and irregular intervals. Written letters and words in these works function in much the same way as the *Comb's* teeth, as material elements in a series defined by the increasingly irregular intervals between them. *The*, a pseudo-telegraphic text with drawings that Duchamp produced when he had not yet fully mastered English, works by elimination, blocking out certain elements in order to prevent the text from making sense. With *Comb* in mind, we might think of the missing letters as "teeth" and of *The* as an instrument for the measurement of chance, much as *Comb* is. In *The*, Duchamp replaced the word "the"—perhaps the most frequently used word in the English language—each time it appeared with an asterisk, a substitution equivalent to the use of the shortest channel symbol (the dot) for the letter *E* in telegraphy:

**The**

If you come into * linen, your time is thirsty because * ink saw some wood intelligent enough to get giddiness from a sister. However, even it should be smilable to shut * hair whose * water writes always in * plural, they have avoided * frequency, meaning mother in law; * powder will take a chance; and * road could try. But after somebody brought any multiplication as soon as * stamp was out, a great many cords refused to go through. Around * wire's people, who will be able to sweeten * rug, that is to say, why must every patents look for a wife? Pushing four dangers near * listening-place, * vacation had not dug absolutely nor this likeness has eaten.[48]

Duchamp's avoidance of direct articles in front of nouns suggests his opposition to the normative, legislating quality inherent in all acts of naming. Crucially, the sequence of phrases that compose *The*, although more or less grammatically correct ("as soon as stamp was out") and marked by drawn "stoppages" (*), cannot be read aloud, unless we either omit the asterisks or replace them with another sound to indicate their presence in the text. Again, it is as if a hidden noise erupted at the very center of the symbolic order, disrupting all efforts to produce a coherent reading. By producing a text structured by unreadable omissions marked by graphic symbols acting as stops, Duchamp stubbornly leads us back to the material signifier, the archival mark itself.[49] More importantly, this iterative motion is compounded by Duchamp's adding a sentence to the very end of the text, instructing the reader to "replace every * with the word: the."[50] Inviting us to replace all the asterisks with the direct article "the," Duchamp, in a second iterative motion, challenges us to reread all the sentences of which *The* is composed. When this operation quickly reveals that the text remains as nonsensical as it was the first time around, we are made aware that the readymade's relation to time lies not so much in embodiment (the archive as its own truth, the "thickened" code) as in iteration itself, the repetitive motion of rereading devoid of any semantic (or scientific) gain that is *The*'s only signified.

*The* manipulates (hand-) written symbols under conditions that recall those of the Morse code and the mechanical typewriter. Both technologies introduced intervals as major organizing elements into the production and transmission of messages. The typewriter replaces the flux and continuity of the

The

If you come into ✳ linen, your time is thirsty because ✳ ink saw some wood intelligent enough to get giddiness from a sister. However, even it should be smilable to shut ✳ hair ✳ which ✳ water writes always plural; they have avoided ✳ frequency, mother in law; ✳ powder will take a chance; and ✳ road could try. But after somebody brought ✳ any multiplication as soon as ✳ stamp was out, a great many cords refused to go through. Around ✳ wire's people, who will be able to sweeten ✳ rug, that is to say why must every patents look for a wife? Pushing four dangers near ✳ listening-place, ✳ vacation had not dug absolutely nor this likeness has eaten.

remplacer chaque ✳ par le mot: the

writing hand with an archive of standardized letter types separated by regular intervals, adding to this an element of mechanically administered shock that returns every time the typist strikes a key.[51] With *The*, it appears, Duchamp sought to create a handwritten text *as if* it were typed by introducing stops and intervals and by wresting his text away from the living voice of the writing subject.[52]

In *Rendezvous of Sunday, February 6, 1916*—a readymade for which the typewriter is even more obviously relevant—Duchamp expanded on this procedure. He began by pasting together four postcards with typed text on them, forming a grid. Addressing the cards to Mr. and Mrs. Arensberg, Duchamp again produced a text that made no sense. As he explained:

> There would be a verb, a subject, a complement, adverbs, and everything perfectly correct, as such, as words, but meaning in these sentences was a thing I had to avoid ... the verb was meant to be an abstract word acting on a subject that is a material object, in this way the verb would make the sentence look abstract. The construction was very painful in a way, because the minute I did think of a verb to add to the subject, I would very often see a meaning and immediately [if] I saw a meaning I would cross out the verb and change

4.12

Marcel Duchamp, *Rendezvous of Sunday, February 6, 1916 (Rendez-vous du dimanche 6 février 1916)*. Typewritten text with black ink corrections on four postcards taped together. © Philadelphia Museum of Art: The Louise and Walter Arensberg Collection, 1950. © 2007 Artists Rights Society (ARS), New York / ADAGP, Paris / Succession Marcel Duchamp.

THE SECRET OF TYPEWRITING SPEED

| | | | |
|---|---|---|---|
| building | national | died | even |
| direct | near | fair | evening |
| does | nearly | get | fire |
| fact | nothing | injunction | interest |
| late | number | less | least |
| officers | o'clock | statement | letter |
| own | others | within | once |
| question | received | broken | officer |
| story | senate | cars | opinion |
| away | though | children | placed |
| best | asked | course | result |
| called | come | effect | see |
| girls | done | form | streets |
| know | election | give | want |
| large | go | himself | according |
| name | government | known | anything |
| off | high | making | automobile |
| open | hours | me | believed |
| press | lost | mother | candidate |
| soon | matter | pay | cause |
| women | political | sent | company |
| yet | primary | too | cost |
| almost | show | weeks | family |
| feet | side | whole | father |
| few | water | world | ground |
| however | celebration | amendment | half |
| injured | complete | board | hour |
| law | conference | boys | husband |

96

4.13
List of "friendly words," in
Margaret B. Owen, *The Secret of
Typewriting Speed* (1917).

qpwoeirutyrueiwoqpwoeirutyrueiwoqp

a;sldkfjghfjdksla;sldkfjghfjdksla;

z.x,cmvnbnvncmx,z.x,cmvnbnvncmx,z.x,

4.14
Typing exercise, in Margaret B. Owen,
*The Secret of Typewriting Speed* (1917).

it, until, working for quite a number of hours, the text finally read without any echo of the physical world.... That was the main point of it.[53]

*Rendezvous* highlights the tension between geometry (the regular grid formed by the postcards) and writing (the typewritten words). While the grid—described by the horizontal and vertical edges of the postcards and by the neat horizontal parallels formed by the lines of typed letters—visually integrates all four postcards, the text written on their surface is not semantically continuous, creating the impression that some cards might still be in the mail. Duchamp's insistence on intervals and omissions—on the gap—as an empty placeholder for the workings of chance links *Rendezvous* to *3 Standard Stoppages*, *Comb*, and *The*, while its emphasis on the absence of meaning ties it to popular typewriting manuals of the time that focused on speed and mechanics in the process of writing, in an effort to make the typewriter as fast as a machine gun.[54] A routine ingredient in such typing manuals were "practical lists" of those "friendly" words that were arguably in most common use. In one manual, Margaret B. Owen's *The Secret of Typewriting Speed* (1917), its author—who declares typewriting a form of art and links its exercise to unconscious reflex[55]—includes the list shown in figure 4.13. These "friendly words" consist of terms whose inclusion in the list is based not on syntactical coherence but on statistics alone; typing mastery over the listed words was gained in a daily process of repetition. Owen advises, "in order to get the most benefit from the practice of these words I would suggest that you combine a number of words in sentences instead of writing each word over and over again."[56] In creating *Rendezvous*, Duchamp—who according to Amelia Jones learned to type and acquired his first typewriter in 1915[57]—appears to follow this advice rather literally—combining words by choosing them from a list of "friendly words" without any regard for the meaning of the ensuing syntactical unit. The speed that the lists of such words helped typists attain was, after all, built on the rhythm of the fingers hitting the keys rather than on meaning; and, in fact, the sample sequences of letters recommended for daily practice often resembled Dadaist poems. In Owen's case, the sequence shown in figure 4.14—recalling sound poems by Raoul Hausmann or Kurt Schwitters—is recommended for daily practice. It would be pointless to qualify such sequences—or indeed Dadaist poems—as simply meaningless. After all, they were never created to make sense in the first place. Their sole purpose was to improve the typist's reaction time and motor skills.

Manuals such as Owen's view the speed and efficiency with which it computes symbols as the typewriter's greatest asset. Speed and efficiency also made the typewriter attractive to futurists such as Anton Giulio and Arturo Bragaglia, whose goal was to make the sensory essence of speed visually accessible. Rejecting the analysis of temporal progression that relies on an archive of discrete points separated from each other by intervals—the model put forward by Wundt and his colleagues—futurist photodynamism is strictly anti-archival. Instead of creating archives organized by intervals and discrete points, it produces images whose main characteristic is the blur resulting from overlapping motions that was thought to be the visual correlative of speed itself.[58] Even where they introduce irregularity and contingency into Wundt's orderly series of moments, Duchamp's readymades are much closer to his analytical model than to the Bergson-inspired experiments of the Italian futurists. In *Rendezvous* Duchamp's "puncturing" of time is precisely that, a "pricking" of a series of points or marks.[59] Nowhere is this more obvious than in the way in which Duchamp hyphenates words. While generally a typist will hyphenate a word according to semantic criteria before moving on to the next line, Duchamp places hyphens—which can also be read as minus signs—wherever the machine reached the end of a line, regardless of a word's meaning. In this way, the word "plissent" is hyphenated "p-lissent," and "moins" becomes "moin-s." The gaps that are the result of this operation function as equivalents to the asterisks in *The*, creating a text (dis-) organized by omissions. Duchamp's technique—progressively stripping words of sense—again suggests not an archive built on embodied code, on accumulation and expansion (as was the case with those of Marey, Bertillon, Londe), but an anemic archive predicated on interval, subtraction, and lack ("−").

4.15
Anton Giulio and Arturo Bragaglia, *Typist* (1911). © 2007 Artists Rights Society (ARS), New York.

4.16
Marcel Duchamp, *Fountain*
(1917; replica 1964). Porcelain,
36 x 48 x 61 cm. Courtesy Tate,
London/Art Resource, NY.
© 2007 Artists Rights Society
(ARS), New York ADAGP, Paris/
Succession Marcel Duchamp.

In the typewriter, the absence of code—the regular intervals separating one symbol from the next—is the necessary condition under which its symbols can become significant. The same is true for the Morse code, which was relevant to Duchamp not merely because of his attempt to produce a text devoid of sense (*The*). In order to decipher a word, the telegraph operator, like a typist operating a writing machine, does not search for the meaning of written symbols, but listens to the pattern inherent in a series of meaningless signals structured by gaps. Perhaps the most striking reference to telegraphy in Duchamp is the signature on the famous *Fountain* (1917), where a gap marked by a period (.) in the signature "R. Mutt" allows for the articulation of gender difference through a process of elimination. Its two parts read backward in German, the signature yields the word "Mutt.R," or *Mutter* (mother), with the dot replacing the letter "E" in Morse code.[60] Once again, the switch from an arguably male "R. Mutt" to a female "Mutter" is not the result of an amplification (an added element or quality) or of the code's "thickening" (Marey); it is, on the contrary, the consequence of the code's diminishing (the missing letter). In Duchamp's archive, the gap (the missing letter or tooth) must always be allowed to function.

In his effort to reduce the tendency of his readymades to signify through spacing—that is, by introducing irregular gaps into a regulated series of points or moments—Duchamp benefited not only from typewriters, Morse code, and

film—a series of shots separated by regular gaps—but also from nineteenth-century scientists who, like the psychologist Hermann Ebbinghaus, used discrete code in a way that deliberately excluded meaning. In the mid 1880s, Ebbinghaus had already used clusters of discrete letters to quantify the human capacity for remembering. These sequences consisted of one vowel surrounded by two consonants, resulting in 2,300 syllables that were randomly chosen and assembled to form sequences of differing length. The reason Ebbinghaus preferred chance-generated sequences of discrete letters to more traditional material, most notably poems, is plain and simple: they did not mean anything, and were therefore not likely to interfere with his desire to create standardized trial conditions.[61] Much like Duchamp's readymades, Ebbinghaus's experiments could not have been conceived without the existence of the mechanical archive of the typewriter, with its ability to treat discrete letters as material units whose functioning does not depend on meaning.

The most famous readymade to (not) involve a typewriter, *Traveler's Folding Item* (*Pliant… devoyage*; 1916), is a plastic-coated typewriter case on a wooden stand with the trademark "Underwood" printed on its surface. It seems to hide the machine underneath. The brand name "Underwood" is richly ambiguous when combined with the title *Traveler's Folding Item*. When Duchamp produced his readymade, the Underwood company did not yet produce portable travel typewriters. At the same time, given its bulky size, the regular Underwood #5 would hardly fit the description of a "traveler's item."[62] Is the typewriter that we suspect is hidden under the case actually of the same brand that is announced by the letters on its surface? Or, if we assume that another typewriter is hidden under the cover, are these letters blind to what the case conceals? Or, yet another possibility, does the title *Traveler's Folding Item* refer simply to the foldable, portable case itself?[63] If a typewriter *were* hidden under Duchamp's case, it would likely not be an Underwood but the famous Standard Folding Typewriter (1907; later called Corona), the world's first truly lightweight, portable typewriter and ideal for traveling. Made of aluminum, the Standard Folding Typewriter's carriage was "folded" over the keyboard for storage in the case, greatly reducing the case in size.

However, if the machine presumably stored under Duchamp's case were a Standard Folding Typewriter—which could explain why Duchamp called his readymade *Traveler's* _Folding_ *Item* (emphasis mine)—what are we to make of the name "Underwood" on its surface? In posing this question, I am less concerned with the case's referent—Underwood or not—than with the undeniable fact that

Duchamp is reckoning with our desire to know.[64] In Duchamp criticism, the viewer's desire to know what is concealed under the teasing, fetishistic cover is habitually associated with issues of gender and sexuality. In this line of argument, the typewriter case functions as a female (under-) skirt—Underwood/*Unterrock*—that the observer is eager to penetrate visually.[65] If the Underwood cover is viewed as a female (under-) skirt and if this reading switches the machine's gender from male to female—in line with the demographics at the office, where the production of typed paperwork had largely become a woman's job[66]—this switch also has a media dimension whose focus is the intersection of desire and (mechanical) writing. In looking at *Traveler's Folding Item,* one would find it difficult not to be reminded of the most important historical innovation with which the Underwood is usually credited, the fact that it literally lifted the veil (or skirt) off the mechanical production of text by allowing the typist to see (onanistically), for the first time in the history of typing, the progression of the line before her.[67] Until the arrival of the famous Underwood #1 in 1897, typewriters such as the Oliver and the Remington[68] had rendered their operators blind, in that they were not able to see what they were typing on the keyboard. By shielding the typewriter from view and by leaving us in the dark about what its case conceals, *Traveler's Folding Item* evokes the Underwood's history as the first machine of its kind to make peeking—the voyeuristic desire to see what was formerly hidden from view—an intrinsic part of the mechanical production of symbols. That association gives the typewriter a stake in the unconscious—the desire to watch the machine write in order to know how signification works—and the Surrealists would be the first to take Duchamp's hint by using the typewriter for the transcription and archivization of the unconscious.

· · ·

4.17
Marcel Duchamp, *Traveler's Folding Item* (replica, 1964/1965). Plastic-coated cloth and metal, 23 x 50 x 30 cm. Courtesy Réunion des Musées Nationaux/Art Resource, NY. Photo: Christian Bahier/Philippe Migeat. © 2007 Artists Rights Society (ARS), New York/ADAGP, Paris/Succession Marcel Duchamp.

4.18
Underwood Standard Model 5
Mechanical Typewriter (circa 1916).
Courtesy Sally Smith.

4.19
Underwood Standard Model 5
Mechanical Typewriter (circa 1916).
Courtesy Sally Smith.

4.20
The Standard Folding Typewriter
(c. 1909). Courtesy The Robert
Collection.

A discussion of Duchamp's archive might reasonably have been expected to focus on the way in which the readymades challenge either art as an institution or art institutions such as the museum. Or it could have taken on works such as *The Box of 1914*, with its photographic reproductions of sixteen manuscript notes (plus one drawing) stored in a commercial box made of cardboard and labeled with the trademarks and logos of companies that specialize in photographic processing. If such a reading of Duchamp's archive would legitimately revolve around issues of representation, embodiment, and reproduction—in short, around amplification and expansion, the "thickening" of the code—it would also miss the crucial element of time and contingency that affects Duchamp's attitude toward language and objects at all levels. In the context of the readymades, the archive does not function primarily as an endorsement of the nineteenth-century effort to produce flawlessly transparent code for the archivization of time—signs with bodies that accept as a given the legislative power of life over signs—but as a reminder of what is (or might become) amiss in these operations. Rather than simply duplicating the ambition of the nineteenth-century archive to store contingent time—time past as time present—Duchamp's readymades dramatize the incursion of chance at the very center of this endeavor. Where the nineteenth-century archive is cumulative—based on the idea that new files can always be added to it, increasing the archive's evidentiary power—the readymades represent steadily diminishing archives, archives whose power to act as evidence or to control and measure time is tied up in a continuous process of diminution whose material traces are pervasive gaps and omissions. As chance eliminates more and more of the archive's files (or teeth), what comes to the fore is not the truth but a series of more or less irregular intervals. What we find in Duchamp is not the overabundant archive of clues assembled by Morelli and Marey but rather the suspicion that such an archive might be subject to the very contingency over which it seeks to rule.

5

and what is returned to us in an archive

# 1924
# THE BUREAUCRACY OF THE
# UNCONSCIOUS (EARLY SURREALISM)

└

André Breton
Max Ernst
Le Corbusier

IN 1921 THE GERMAN UNIVERSITY PROFESSOR FRIEDRICH KUNTZE PUBLISHED A BOOKLET THAT SOUNDED THE DEATH KNELL FOR THE PRINCIPLE OF PROVENANCE (PP) AND ITS EMPHASIS ON ARCHIVAL STORAGE BASED ON PROVENANCE AND THE FIGURATION OF CONTINGENCY. Entitled *The Technique of Intellectual Labor*, Kuntze's treatise was a plea for the mechanization of scholarly writing with the help of card indexes and mathematical computation. The modern scholar, Kuntze argued, could not hope to master the ever-increasing amounts of information stored in books, journals, and archives without organizing the fruits of his or her labor systematically.[1] To manage this overload, Kuntze proposed the creation of what he called a "geistige Maschine" (a spiritual/intellectual machine) in the shape of a standardized card index, containing systematically numbered cards with excerpts, commentaries, and notes taken from books and articles by other scholars.[2] All notes and excerpts would be filed in a decimal tabulator (*Dezimaltabulator*), a box of medium size that fits "every desk" and that orders all excerpts by their respective numbers.[3] Accord-

ing to Kuntze, the advantage of this system was that "once I start copying marked passages [from books] … the single excerpts should immediately and automatically find their place, and that place should be chosen in such a way that those excerpts that are conceptually related to the most recent one come to be deposited in their immediate vicinity."[4] By using a mathematical model to interface the cards filed in the *Dezimaltabulator*, the process of academic writing would, Kuntze believed, be mechanized to a point where the writer's own creative input was reduced to the barest minimum. Writing would be converted into a form of mechanical computation rather than composition.

5.1
Victor Vogt, *Die Kartei: Ihre Anlage und Führung* (Berlin: Organisation Verlagsanstalt, 1922). Courtesy Markus Krajewski.

5.2
Victor Vogt, *Die Kartei: Ihre Anlage und Führung* (Berlin: Organisation Verlagsanstalt, 1922). Courtesy Markus Krajewski.

Card indexes like the one Kuntze proposed as a replacement for ordinary scholarly writing are the natural enemy of the PP-based archive, in which a record's position is tied to its origin, giving it a stable and inalterable address. Card indexes allow their users to regroup their elements freely and repeatedly, an operation that equals the complete overhaul of the system as a whole. The proponents of the PP were predictably hostile to their introduction: "If you want to work conscientiously, you cannot aimlessly reach into a numbered card index [*Zettelkasten*] and pull out whatever it is that you may need. If you do this, you will soon notice that what you have in front of you is hack work [*Pfuscharbeit*]."[5]

When he visited an industrial fair devoted to office technology, Kuntze was most fascinated by the filing methods based on the decimal system. An ideal system would be one where "numbers directly signify concepts ... and organically model a system of concepts."[6] Kuntze found this condition fulfilled only by the Dewey model, in which the decimal number assigned to each card identified its position in the system without fail, suggesting that system's "unlimited ability" to "mold itself" according to concepts.[7] Kuntze believed that the decimal system would make his *Dezimaltabulator* even more useful, as every sentence or statement in a given volume could instantly be copied to a card and assigned a number that corresponded directly with its subject matter.

As early as 1914 Duchamp had introduced as art a card index whose sole purpose was the disruption of such well-ordered discursive correspondences. He suggested the creation of a dictionary whose various entries would be stored on discrete pieces of paper organized by visual tabs:

### Dictionary

—of a language in which each word would be translated into French (or other) by several words, when necessary by a whole sentence.

—of a language which one could translate in its elements into known languages but which would not reciprocally express the translation of French words (or other), or of French or other sentences.

—Make this dictionary by means of cards.[8]

Duchamp goes on to wonder how such a dictionary index ought to be classified ("find out how to classify these cards") and concludes that, rather than arranging the cards by the traditional alphabet, one should group them according to "a few [chance-generated] elementary signs [*signes élémentaires*], like a dot, a line, a circle etc. (to be seen) which will vary according to the position etc."[9] By questioning the translational economy that governs the dictionary, Duchamp also questions the discursive foundations of card indexes such as Kuntze's with its assumption that the identification of similar characteristics in a variety of objects (*Merkmale*, in Kant's terminology) can be used to organize and unify knowledge. Traditional dictionaries assume that words in different languages can be translated to the extent that they correspond to hidden universals of which they are but different incarnations. In this understanding, the French word "table" corresponds to the same

universal idea of a table as, say, its German or Spanish counterparts. By contrast, in Duchamp's dictionary-index, words cannot be directly translated into French; they can only be circumscribed by several other words, creating the need for new entries and classifications. Duchamp's experiment represents an expansion of Mallarmé's secret card index, which Walter Benjamin—himself an avid user of indexes for computing his texts—described as a "poetic working instrument."[10] Under the veneer of the rationalizing card index based on the similarity of shared characteristics, Duchamp creates an ever-expanding web of differences classified by arbitrary symbols (dots, circles, etc.) that disrupts mechanical models for the computation of written symbols such as Kuntze's. It is not surprising that Duchamp admits that his language has no sound: "—Sound of this language, is it speakable? No. Relation to shorthand."[11] Consisting of nothing but differential relationships between signs, the language proposed by Duchamp's dictionary cannot be spoken because it cannot be systematically represented.

· · ·

Early Surrealism's infatuation with card indexes and other office technology—typewriters, office pencils, carbon paper, stenography—can, I would argue, be connected to its ambition to assemble an archive of unconscious facts, an ambition that disavows, in the spirit of Duchamp, both the rationalizing impulses apparent in Kuntze's *geistige Maschine* and the PP-based archive with its appeal to origins and the archivization of contingent time. Founded by civil servants, pharmacists, doctors, and lawyers, Surrealism appeared to be interested exclusively in extreme phenomena that defy the archive and the ambition to record. However, the painstaking, ordered registration and archivization of shock, ecstasy, and delirium were at least as important to the Surrealists as these states themselves. For that reason Theodor W. Adorno held that the Surrealists saved Paris during World War II by raising what he called the city's *Angstbereitschaft* (its "preparedness for fear"). While it is not completely clear what Adorno meant by this statement, one possible interpretation is that, by recording moments of shock and delirium and by creating an archive devoted to such instances, the Surrealists ensured that these states of shock could not overwhelm the individual because they had become predictable, at least to an extent.[12]

The Surrealists' interest in order, whether subliminal or rationally contrived, is well documented, yet it is rarely linked to specific media practices. In fact, the Surrealists were interested in order less as a universal value than in the

specificity of bureaucratic order, and it is here, in the office, that they sought to distill and archivize that order's traumatic core. In pronouncements by members of the group, references to the office and its media occur with great regularity. Not coincidentally, Surrealism abounds in all manner of lists, protocols, memoranda, circular letters, and memos, many of them closely resembling the organizational tools used in offices.[13]

Walter Benjamin defined the *flâneur* as someone to whom dead facts may become lived experience: "That anamnestic intoxication in which the flâneur goes about the city not only feeds on the sensory data taking shape before his eyes but often possesses itself of abstract knowledge—indeed, of dead facts—as something experienced and lived through."[14] The Surrealists act as reverse *flâneurs* through the unconscious; to them, lived experience was like a long-forgotten archival file. When Man Ray created his collage of the movement's members, published in the first number of *La Révolution Surréaliste* (1924), he arranged them in alphabetical order around a photograph of the famous assassin Germaine Berton—her name an anagram of "Breton"—hinting at the traumatic core at the center of archival information.

Nowhere was early Surrealism as close to the office as in the practice of automatic writing (*l'écriture automatique*). The practice, which Breton and Soupault developed in 1919, is linked not only to nineteenth-century spiritualist techniques but also to that most clichéd of all office situations whereby the boss dictates a letter to the secretary, who types away as fast as she can with her thoughts elsewhere, oblivious to the meaning of the words.[15] *L'écriture automatique* places such absentmindedness at the very center of the writing process; what is being recorded or registered is not meaning, not sense, but the unconscious as a series of intervals that separate one letter from the next. Surrealist automatic writing establishes the office as the site for the revelatory production of data that by definition elude conscious apperception and intentional meaning. Not coincidentally, the Surrealists regularly practiced automatic writing on a typewriter, huddled around a typist.[16] The function of the typewriter in automatic writing was not unlike that of the camera in films by avant-garde directors such as Eisenstein or Vertov; like the camera in constructivist cinema, it was less an instrument for the depiction of reality than a means to reveal the subliminal principles of its temporal and spatial organization. To the Surrealists, the typewriter was much more than a machine that mechanized the production and archivization of symbols; its accelerated beat embodied the shocklike rhythm of life itself, a pulse well below

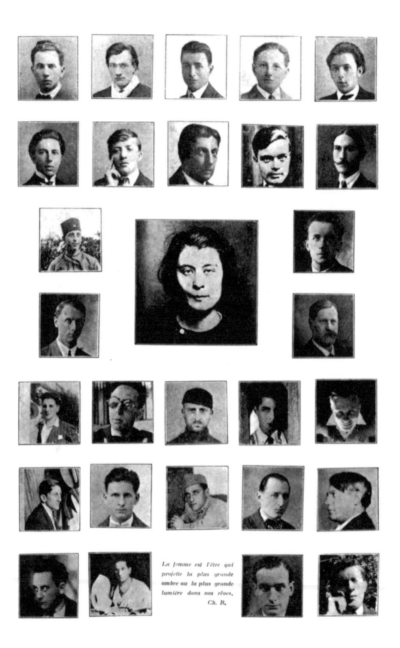

5.3
Man Ray, *Members of the Surrealist
Movement,* in *La Révolution
Surréaliste* 1 (1924), 17. © 2007
Artists Rights Society (ARS), New York.

the threshold of consciousness. As Rubén Gallo has argued, typewriters are machines less for description than for transcription, and the marks they produce function as a "trace left by a mechanical event—the random pressing of the typewriter's keys."[17] A mechanized series of standardized letters used to compute variable texts, typewriters do not have a memory function; every new mark they inscribe on a page is utterly distinct from the one that preceded it. As recording devices, they exist in a temporal mode that would best be described as the discrete present; every time we hit a key, we mark a moment in time that exists only in the present moment, with no discernible relations to the events that preceded it or those that follow it. While they were capable of computing pieces of text mechanically, typewriters therefore cannot write, if by "writing" we mean a process of intentional composition that involves some form of mnemonic feedback. (As we saw, even Freud's case histories were "writing," whether or not they were fiction, in this sense of the word).[18] To the Surrealists, the fact that the typewriter does not retain what it writes was of central importance. In mechanized *écriture automatique*, the typewriter is not simply a substitute for handwriting, a type of composition that links the past to the present and the subject to what it writes. Its use suggests, on the contrary, that handwriting could fulfill its mission to produce transcripts of the unconscious only to the extent that it operated like a typewriter.[19]

5.4
Taking automatic dictation from Desnos at the Bureau de Recherches Surréalistes (1924). Courtesy S. Sator Archives, Paris.

Jacques Lacan, an expert in the administration of letters, once described the unconscious as an archive of documents with an unknown provenance: "The unconscious is that part of the concrete discourse ... that is not at the disposal of the subject in re-establishing the continuity of his conscious discourse.... The unconscious is that chapter of my history that is marked by a blank or occupied by a falsehood: it is the censored chapter. But the truth can be rediscovered; usually it has already been written down elsewhere. Namely: ... in archival documents: these are my childhood memories, just as impenetrable as are such documents when I do not know their provenance."[20] Early Surrealist practice took very seriously the idea of the unconscious as an archive of files without an address, as demonstrated by the numerous calls made by the Surrealist leadership to collect, record, and classify the data of the unconscious. Even novels such as Breton's *Nadja* (1928) are structurally homologous with administrative files. As Denis Hollier has noted, in Breton's novels we never really know how, or even if, they might end: "The specific feature of Surrealist writing, whether it be autobiographical or automatic, is, in fact, less the lack of knowledge of its final destination as such than the identical position into which this lack places both the reader and the author in the face of a text whose unfolding neither the one nor the other controls, and about which both of them know neither the future nor the ending."[21]

In Breton's novels, writing is used not to sum up a phenomenon or event (as in ordinary fiction) but to register it. As files of ongoing (unconscious) events, these novels aspire to be transcripts of a process that they themselves helped create, registries or registrations of a hidden order that is also their own. From the point of view of the early Surrealists, there cannot be any action without *Akte/n*, without transcript and registration (*faire acte*).[22] In Breton's and Soupault's play *If You Please*, the typist aptly comments that "chance dictates the colors that we like. It does not depend on us to stake our happiness on the green."[23]

What better way to discuss early Surrealism's involvement with the archive than to point out that its *arkhē*, its commencement and inception, was nothing short of an *arkheion*, a house or domicile that served as archive, the Bureau de Recherches Surréalistes (Office of Surrealist Research), located in an apartment that Pierre Naville's father rented in 1924 on the first floor of a villa in rue Grenelle and that also served as the editorial office for the journal *La Révolution Surréaliste*.[24] The Surrealists met on a regular basis in the Bureau, and it was here, at least in theory, that they filed away their notes and manuscripts, kept track of outgoing and incoming mail, and took written note of everyone who visited the office. The

Office of Surrealist Research was open every day except Sundays from 4:30 to 6:30 p.m. According to a plan set up by Breton, who served as Surrealism's office chief and chief archivist all in one, every day two Surrealists were assigned to be on duty at the Bureau (Monday: Breton, Aragon; Wednesday, Saturday: Simone and Jacques-André Boiffard). Breton watched punctiliously, and with growing frustration, over the (lack of) conscientiousness of his associates, who were ironically called *permanents*.[25] It soon became evident that those Surrealists who were present in the central office were usually precisely those who were not on duty, while the *permanents* of the day were absent.[26] Breton notes in an acerbic tone: "The central office's activity leaves something to be desired, and this has something to do with the daily presence of seven or eight of us who should not come there. It is of great importance that the two Surrealists in charge should be able to work in peace. The others should limit themselves to the second floor."[27] The *Cahier de la Permanence*, a large register book that was updated more or less regularly between October 11, 1924, and April 20, 1925, not only provides eloquent testimony to the Bureau's failures and shortcomings; it also demonstrates vividly that Surrealism took its paperwork seriously from the very beginning.[28] In the *Cahier*, the *permanents* on duty were supposed to enter, on a daily basis, any current business; incoming and outgoing correspondence; the names of visitors, and the times when these arrived or left the office. This they did, often with a zeal that rivaled that of any office worker. Faithfully the Surrealists list and briefly describe phone calls ("An individual … called for information about Surrealism"),[29] incoming mail ("Received for the second number [of *La Révolution Surréaliste*] a negative sent by Max Ernst"; "Received two letters from strangers: to be answered"),[30] and visitors ("Visit by Mme Terpsé. She asks that we keep her informed").[31] Like all register books, the *Cahier* was designed to keep time, and to ensure that the information circulating in the office remained under control. Still, the accounting practices of the Surrealists were far from perfect. An entry of January 5 notes: "The receipts book still cannot be found."[32] Artaud was especially critical of his fellow Surrealists: "From today the *Cahier de la Permanence* is once again kept strictly up to date…. The shift will become an effective work shift."[33] Even though in its early phase the Bureau opened its doors regularly between 4:30 and 6:30 p.m., very few members of the public, most of them friends of the Surrealists, responded to the invitation to deposit their dreams in the archive, and any revolutionary action that was hoped to spring from this activity remained in short supply. As Breton notes: "#1. The cahier. Too much useless spirit…. Aragon and

Vitrac are right, the meaning of Surrealist activity still has to be defined. No plan for serious action has been suggested."[34]

Despite these failings, the Bureau was of crucial importance for the establishment of Surrealism as an archive of the unconscious. According to Artaud, who presided over the Bureau from January 26, its task was not only to store manuscripts and notes by members of the movement—to serve as Surrealism's registry—but also to collect data that would help elucidate the workings of the unconscious by collecting written transcripts of unconscious dreams and other material: "The Office of Surrealist Research occupies itself with the collection … of news items that comprise the different forms adopted by the unconscious activity of the mind.… Everyone who is willing in one way or another to contribute to

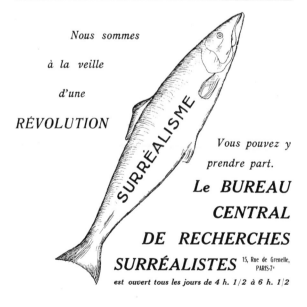

# LA RÉVOLUTION SURRÉALISTE

Directeurs :
Pierre NAVILLE et Benjamin PÉRET
15, Rue de Grenelle
PARIS (7ᵉ)

*Le surréalisme ne se présente pas comme l'exposition d'une doctrine. Certaines idées qui lui servent actuellement de point d'appui ne permettent en rien de préjuger de son développement ultérieur. Ce premier numéro de la Révolution Surréaliste n'offre donc aucune révélation définitive. Les résultats obtenus par l'écriture automatique, le récit de rêve, par exemple, y sont représentés, mais aucun résultat d'enquêtes, d'expériences ou de travaux n'y est encore consigné : il faut tout attendre de l'avenir.*

*Nous sommes*

*à la veille*

*d'une*

**RÉVOLUTION**

*SURRÉALISME*

*Vous pouvez y*

*prendre part.*

**Le BUREAU**

**CENTRAL**

**DE RECHERCHES**

**SURRÉALISTES** 15, Rue de Grenelle, PARIS-7ᵉ

*est ouvert tous les jours de 4 h. 1/2 à 6 h. 1/2*

5.5
Page from *La Révolution Surréaliste* 1 (1924).

the establishment of a real Surrealist archive is called upon to come forward."[35] With its two floors—one devoted to the archive of dreams, the other designed to hold manuscripts and serve social life—the architecture of the Bureau de Recherches mirrored the divisions of Freud's psychical apparatus into two major parts, the system perception-consciousness (represented by the second floor of the archive of Surrealism) and the unconscious (the first floor).[36] Meanwhile, the medium used to organize the data of the unconscious was the card index; as Artaud wrote in a circular letter in 1925 that bears the stamp of the Bureau: "My goal is to build a real archive [constituer de véritables archives] of all possible Surrealist ideas that one could search with a view to future issues of the Revue, or to whichever other written or performed form of expression we will deem useful. I therefore ask each one of us to fill an index card [une fiche] with the ideas that occurred to us concerning every question which will be raised by our entire group or which is being debated in the Revue. Michel Leiris has taken responsibility for receiving and filing all the index cards."[37] In their use of an index with movable, standardized cards filled, among other things, with the facts of the unconscious, the Surrealists, for the first time in history and in a curious departure from Freud, constructed an archive of the unconscious based less on hermeneutics and interpretation than on the possibility of mechanical computation.

In the "Manifesto of Surrealism," Breton wrote of the Surrealists' ambition to become "simple receptacles of so many echoes, modest recording instruments who are not mesmerized by the drawings we are making."[38] If from this perspective early Surrealism is an archival enterprise in much the same way as Marey's graphic method, from another perspective it differs dramatically from Marey's ambition to transcribe life itself. Nietzsche wrote of the Greek spirit that it was capable of defending itself against onslaught from everything that was foreign and past by developing an ability to forget.[39] The same might be said for the (early) Surrealists, who set themselves the goal of not perishing under the weight of the past. However, unlike the Greeks, who simply strove to expunge history, the Surrealists tried to preserve it in its very state of being forgotten. The archive of Surrealism as embodied by the Bureau de Recherches represents the paradox of an archive that serves not memory but something we might call the recall of forgetfulness: not the history of great men and great deeds of which Nietzsche was so critical, then, but the return of what has been forgotten as the forgotten, a return that Freud was to call the uncanny.

Where traditional archives safeguard the preservation of historical facts, the archive of Surrealism collects events that, to the extent that they are unconscious, function as interruptions of historical process. The Surrealists wanted to establish an archive not of history but of its rupture, not of narrative but of its other. Not surprisingly, they were systematically opposed to the idea of abolishing the unknown by making it known. Filing, in the context of the Bureau, does not create a pedagogical space for the preservation of knowledge; it aims to create an archive of what is not known. In his discussion of the realist novel in the "Manifesto of Surrealism," Breton writes: "Our brains are dulled by the incurable mania that consists in reducing the unknown to what is known, to what can be filed."[40] When compared with the novelists' obsession to reduce the unknown to the known—what can be filed—Surrealism goes the opposite way, reducing what is known to what is unknown (*ramener le connu au inconnu*): "All I have to do is relate on the margins of the narrative that I will undertake only the most remarkable episodes of my life the way I can conceive it outside of its organic plan, be it to the extent that it is exposed to chance events, whether they are the smallest or the greatest.... It is a matter of real facts [*faits de valeur intrinsèque*], which are undoubtedly hard to control."[41] In this passage from the beginning of *Nadja*, Breton casts himself as an office supervisor who annotates the margins of his own text, noting that his novels record life not as historical process but as a series of instances or facts that unexpectedly interrupt that process, just as the interplay of writing and photography disrupts his novels' narrative cohesion. In a similar vein, Aragon charged that the Bureau was devoted to unclassifiable ideas: "At 15, rue Grenelle we have opened a Roman lodging house for unclassifiable ideas and planned revolts."[42]

Automatic writing, too, was essentially designed to register forgetfulness. As Breton advised, "Write quickly, without any preconceived subject, fast enough so that you will not remember what you're writing and be tempted to reread what you have written."[43] Once again, and in direct contradiction of the Platonic tradition that assigns to writing a largely commemorative function, the Surrealist archive is not at the service of memory. What registers during the act of automatic writing is a series of events of whose existence the writing subject never knew but that nevertheless have been filed away in the archive of the unconscious. Much as Lacan did, the Surrealists held that the facts of the unconscious existed as organized archive matter already at the time when they were found and collected. For that reason, as Artaud points out in his note on the activities of the Bureau, it

was never a matter of simply filing unconscious facts but rather of *refiling* them: "This revolution ... aims at the rupture and the disqualification of logic.... It aims at the spontaneous refiling of things [*reclassement spontané des choses*] on the basis of a deeper and finer order, an order that cannot be explained by ordinary reason but that is an order nevertheless, an order that can be perceived by a sense of which one does not quite know which one ... but an order that is nevertheless perceivable, an order that does not really belong to death.... The central office of Surrealist research dedicates itself with all its power to this refiling of life."[44] The refiling of life that occurred at the Bureau was a revolution in the precise sense of that term; the Surrealist revolution functions as a return (revolution < *revolvere* = to roll back) that allows for the reclassification of those unconscious files whose provenance has been lost.[45] Whereas Marey wanted to create "a language of the phenomena themselves," the Surrealists discovered the (bureaucratic) order underlying such phenomena.[46] The Surrealist revolution was not simply a break or rupture in the absolute sense of that term. Surrealism critically revised the revolutionary traditions of the nineteenth century with their assumption that a revolutionary's primary task was the wholesale destruction of the archives held by those in power so that the new, revolutionary order could establish itself.[47]

Based on organization and the possibility of computation, the Surrealist archive of unclassifiable facts—a filing room for what is beyond filing—reflects the high degree of structure in unconscious objects such as dreams: "Within the boundaries where it occurs ... the dream seems to be continuous and to carry traces of being organized. Only memory takes the right to carve segments out, to disregard the transitions and to give us a series of dreams rather than the dream."[48] The Surrealist revolution was unthinkable without order and organization: "The idea of a Surrealist revolution aims at the profound substance and at the order of thought."[49] However, such order must not be confused with the mechanization of thinking advocated by Kuntze. To the Surrealists it was not a matter of imposing order on what is contingent but of finding traces of organization in contingency itself.

The order inherent in contingency and chance was of importance already to the Dadaists, whose overt devotion to chaos and disorder masked a profound concern with order, the order inherent in chaos itself. Nowhere is this more apparent than in Tristan Tzara's famous directive regarding the chance production of poems:

**How to Make a Dadaist Poem:**

Take a newspaper.

Take a pair of scissors.

Choose in that newspaper an article that has the length you want to give to

      your poem.

Cut out the article.

Then cut up ... all the words of which the article is composed

And place them in a sack.

Shake lightly.

Then take out one cut-out after the other.

Copy conscientiously

in the order in which they have exited from the sack

The poem will resemble you.

. . .[50]

The result of this procedure was not simply a poem based on random stochastic events or the decomposition of an existing text, important though both of these effects may be. What emerges from the archive of the sack filled with printed words, rather, is the order of disorder, an order that only the chance event (the drawing of the words) makes visible through a process of reproduction. This order—an order that produces itself at the same time and on the same level as the chance drawing itself—also serves to describe the Surrealist archive of "unclassifiable yet refiled" unconscious facts.

Walter Benjamin insisted that we can understand the Surrealist endeavor only if we do not confuse the Surrealists' interest in ecstasy and delirium with the cognition (*Erkenntnis*) of these phenomena: "The most passionate investigation of the hashish trance will not teach us half as much about thinking (which is eminently narcotic) as the profane illumination of thinking will teach us about the hashish trance."[51] The administrative zeal of the Surrealists, even where it is applied with a certain self-irony, may be viewed as an instance of profane illumination in its own right. As Breton writes: "Surrealism has always suggested they [the unexpected facts of life] be written like a medical report, with no incident omitted, no name altered, lest the arbitrary make its appearance. The revelation of the immediate, bewildering irrationality of certain events

requires the most severe authentication of the human document conveying them."[52] Instances of such "severe authentication" abound in Surrealism. One of them—an authentication of contingency itself—was the technique of *frottage* (rubbing) that Max Ernst developed, according to his own testimony, when he was staring at a wood floor in a hotel on the French Atlantic coast in 1925, not long after the publication of the "Manifesto of Surrealism." Rubbing with a charcoal crayon across a piece of paper lying flat on the floor until the floor's structure became visible, Ernst created objects whose form and structure owed little to the consciously drawn line and almost everything to the "tracing" of which Breton speaks in his manifesto. Reducing the impact of the drawing hand to repeated gestures of mechanical rubbing, *frottage* was—at least in Ernst's own view—a partially, if not fully, automatic technique that replaced the agency of the artist with a structuring process for which the artist acted as archivist. *Frottage* questions the relationship between ground and figure on several levels; the ground is the surface of the piece of paper, yet it is also the floor; and as for the figure, there is the image crafted by the author, yet its spatial structure is a function of the two grounds (the paper and the floor) whose structure the mechanical rubbing reveals. This spiraling motion—the hand being guided by something that precedes it; the ground being given depth by something that comes before it—is predicated, crucially, on the artist's blindness, which is in its turn a function of the machine-like nature of the technique. The white sheet of paper above which Ernst is perched (in a characteristic inversion of Alberti's window) acts as a screen that shields him from the ground (the floor) whose structure will come to organize the image. Which is to say no less than that the creative act is, in this instance at least, a deliberately blind act, a kind of rhythmical groping that copies a structure to which only the completed work can give it access.[53]

In the context of the office and its media, *frottage* functions as an inversion of a reproduction technology that had become indispensable to the modern office, carbon paper.[54] Carbon paper presumes the virginity of the sheet of paper underneath; by contrast, *frottage* reveals the illusory nature of such emptiness.[55] Where carbon paper transmits an impression or imprint from the top sheet to the paper underneath, *frottage*—which communicates the floor's structure to the paper's surface—works the other way around. The question as to who or what plays the role of the carbon sheet in Ernst's scheme is not difficult to answer: it is the artist himself whose psychical apparatus functions, as carbon paper does,

as a receptive surface for progressive layers of incoming traces and whose creative act is fashioning a visible object from the archive of these traces.

Ernst unequivocally tied *frottage* to the realm of desire and sexuality. His blind rubbing results in an orgasmic production of symbols that explodes the office's rational facade, a fact that also links the technique to Duchamp's bride from the *Large Glass,* whose expansion results famously in the production of "alphabetic units."[56] *Frottage* belongs to the same category of libidinal writing as these units. As such, it is also a telling instance of the way in which the Surrealists conceived of order. Order, to them, is not an all-encompassing system that confronts the world from outside; rather, it is what organizes our activity from behind or beyond, including even those points or moments, such as ecstasy or delirium, that seem furthest removed from it. The example of *frottage* shown here

(*Les moeurs des feuilles,* as reproduced in *Histoire naturelle*) further displays the paradoxical temporality implicit in this idea. For the picture seems to show the trees from which the floor that structures the image was made; in other words, in a curious extension of the principle of provenance, the subliminal structure behind the image (the structured/structuring wooden floor) produces or reproduces its own point of origin.

The office-driven archive of unconscious facts set up by the Surrealists competed with a more heroic rival scheme for the "refiling" of life in which the card index also played a central role—Le Corbusier's efforts to usher in a neo-Cartesian era based on numbers and correct filing.[57] The filing cabinet and the card index play key roles in Le Corbusier's book *The Decorative Art of Today.* Written in 1925 and based on essays written, for the most part, during the previous year—the same year that the Surrealists opened their Bureau—it views the twentieth century as an age of documentation and the human being as a kind of prosthetic god who interacts with the world around him through mechanical implements that function as extensions of his body (furniture, filing cabinets, the telephone, etc.).[58]

Whereas the officials at the Prussian Privy State Archive looked upon a convolute of records as a living body, taking an approach not unlike that of a surgeon to a patient on whom he is about to operate, Le Corbusier is more concerned with the possibility of the archive's mechanization. In an age when carbon paper and the typewriter combined to mechanically produce standard-sized copies of every conceivable document, the provenance of all this office paperwork was, for Le Corbusier, increasingly reduced to the technical specifications of the machines that produced it.

Placing a Ronéo filing cabinet at its center, Le Corbusier proposes the establishment of a museum whose task would be the exhibition of objects that are particularly fit to serve the new era: "Let us put together a museum of our own day with objects of our own day.... We will install in the museum a bathroom with its enameled bath, its china bidet, its washbasin, and its glittering taps of copper or nickel. We will put in an Innovation suitcase and a *Ronéo* filing cabinet with its printed index cards, tabulated, numbered, perforated, and indented, which will show that in the twentieth century we have learnt how to classify."[59] A poetics of filing that aims to subject literally everything—from objects to social classes and the arts—to rigorous classification, *The Decorative Art of Today* locates the museum in a posthistorical age in which time and, with it, conflict and struggle have lost

their meaning because everyone either already participates or is striving to participate in a culture of well-designed consumer objects whose primary characteristic is that they are eternally new and ideally timeless. As such, objects lose their ability to testify to the passage of historical time or to act as clues, in the nineteenth-century sense of that term. The museum and the archive, consequently, do not account for historical time; they account for the irrelevance of the past itself. If this fact distances Le Corbusier's museum from the PP-based archive and the traditional (history) museum alike, it also marks his museum's difference from the Surrealist archive of unconscious facts and its ambition to file what is not known. Rather than being concerned with what is forgotten or outmoded, Le Corbusier focuses only on what is known: "The fabulous development of the book, of print, and the classification of the whole of the most recent archaeological era, have flooded our minds and overwhelmed us. We are in an entirely new situation: *Everything is known to us....* Ours is certainly an era of documentation."[60] Where Duchamp "diminishes" the meter and mensuration based on standardized measures, Le Corbusier celebrates both: "The poet ... makes himself more useful as a cutter in a tailor's shop, with a man standing in front of him and he, metre in hand, taking measurements. Here we are back on terra firma. The uplifting calm of certainty!"[61] Modernity, in Le Corbusier's reading, approaches the problem of knowledge not as a problem of provenance but primarily as a problem of address. Information, Le Corbusier argues, is not there to be uncovered step by step in a process that resembles an archaeological excavation; it is there to be *accessed* through a secondary system of coordinates that gives everything its unmistakable address. As is the case with Kuntze's *geistige Maschine*, this address corresponds to standardized types of needs instead of to an origin in time and place. Gradually, life itself becomes a function of the need to file systematically: "We have learnt that in the context of the rigorous order demanded by business, *it is necessary to have a file on the filing system itself....* So now we have the invaluable arrays of precisely detailed filing cabinets. This new system of filing which clarifies our needs, has an effect on the lay-out of rooms, and of buildings. We have only to introduce this method into our apartments and decorative art will meet its destiny: type-furniture and architecture."[62]

In the age of documentation that replaces the age of the archive, Le Corbusier claims that the card index, carbon paper, and the filing cabinet—all of which the Surrealists reserved for the classification of the forgotten and the outmoded—fill in the blanks where we struggle to remember: "Filing cabinets and copy-letters

make good the inadequacies of our memory."[63] By saving us time, the card index and the filing cabinet allow us to focus on desires from which they aim to liberate us at the same time: "To free our attention for a few moments from bondage to its habitual tasks and to think about *the why*, reflect, weigh up, decide....This is as much as to say, to set aside our acquired preconceptions, to deposit our fund of memories in the safe of our bank in the third basement, behind a steel door, and leaving alongside it the whole poetic of the past, to formulate our most fundamental desires."[64] Organization and consumption—the consumption of organization—releases Le Corbusier's (well-heeled) subject from all daily chores, freeing up time and energy for the pursuit of the beautiful. In Le Corbusier's (and Kuntze's) version of heroic, hypermale, hyperrational modernism, the card index plays a role roughly equivalent to a compression program in a modern computer. As the continuous accumulation of knowledge began to be seen not as a tool for enlightenment but as enlightenment's most formidable foe, secondary indexing provided a way to be intellectually and artistically potent even though one could no longer hope to master the archive.

These strategies of compression and rationalization seem designed to distance Le Corbusier from the early Surrealist effort to create an archive of unconscious facts that refuses to be at the service of desublimation by reducing the unknown to what is known. As we saw, the Surrealist archive did not seek to introduce order (*l'ordre*) into what is conscious and known, but to detect organization in what is unknown. To the Surrealists there could be no question of desire (and art, to the extent that it is based on desire) being "freed" through the use of office tools. Rather, their archive reconstructed the organization of desire itself. An even more important difference between Le Corbusier and the Surrealists, however, is Le Corbusier's insistence on objectification as a prerequisite for control and organization. Only by rigorously objectifying desire could Le Corbusier hope to save himself from the uncanny archive of the repressed and unknown to which the Surrealists devoted themselves. To the Surrealists, gadgets such as Kuntze's *geistige Maschine* and filing cabinets that function as prosthetic extensions of memory (Le Corbusier) represented haunting specters rather than models for the reasonable organization of life.[65]

may well be something

6

# AROUND 1925
# THE BODY IN THE MUSEUM

$\llcorner$

El Lissitzky
Sergei Eisenstein

IN THE EARLY 1920S, SEVERAL SOVIET FUTURISTS—WHOSE ACTIVE CAMPAIGN TO DESTROY THE BOURGEOIS ART MUSEUM AND REPLACE IT WITH A "NEW MUSEUM" IS BY NOW WELL-DOCUMENTED[1]—DISCUSSED THE RELATIONSHIP BETWEEN ARCHIVES AND MUSEUMS, USING THE TERM "ARCHIVE" AS DEROGATORY SHORTHAND FOR A REVISIONIST ATTITUDE TOWARD THE PAST. In 1921, El Lissitzky polemically intertwined the "backward-looking" architectural projects of his day with the archive:

> They are planning a 'City' for Moscow …, corresponding to London's belly of world capitalism. In the suburbs they are building 'pleasant estates' and suchlike for the workers.
>
> Where are such paltry Utopias born?
>
> In the archives!

When they came to design a new Kamenny Bridge over the Moskva River for their projected Utopia ..., they dispatched a gravedigger to 'carry out a thorough excavation in the archives, to unearth a historical reference to the Kamenny bridge.' ...

Now we have had the opportunity of becoming acquainted with the forms resulting from this search in the archives.... With a miscarriage it is not necessary to pay for a midwife; similarly, to pay for reports which have not the slightest connection with the present face of the city is a frivolous waste of public funds.[2]

In the same year, Lissitzky's rival, Aleksandr Rodchenko—at the time head of the Soviet Museum Bureau and charged with the administration of the country's artistic heritage—extended the use of term "archive" to include the then-defunct traditional art museum: "In those museums that are most faithful to the historical method, the hanging of the pictures ... underlines its most characteristic feature: ARCHIVE."[3] According to Rodchenko, the archive was devoted to the merely static preservation of art, serving "ethnographers, specialists, and amateurs."[4]

If these pronouncements associate archives squarely with the storage of dead, irrelevant objects—and as synonyms for the traditional art museum—a statement by Varvara Stepanova from the machine-typed catalogue accompanying the "5 x 5 = 25" exhibition in Moscow (1921) suggests that the boundary separating the archive from Rodchenko's new museum of "living things" may have been more porous than it might seem at first glance. Stepanova wrote that "the 'sacred' value of the work of art as the only type of uniqueness has vanished. The Museum as a repository of this uniqueness is being turned into an archive."[5] Cited in Camilla Gray's influential *The Russian Experiment in Art, 1863–1922*, this passage has been interpreted either as the art museum's final consignation "to the archives" or, on the contrary, as an endorsement of its transformation *into an archive*—the archive as the "new museum."[6] Given that Stepanova advocates here not the museum's elimination but merely a change in the way it functions (no longer as a repository of uniqueness but instead as an archive), the second reading seems to be more plausible. However, a third variant is also possible, in which it would not be a matter of the old museum being dissolved in the archive, nor indeed of its simple disappearance, but of the archive's *incorporation into*

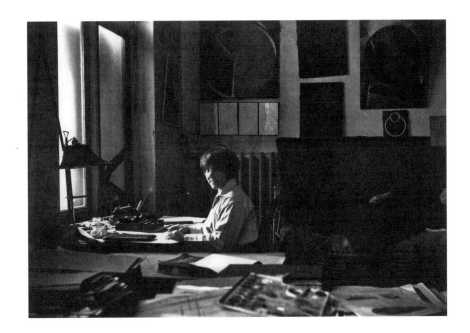

6.1
Aleksandr Rodchenko, *Stepanova in the Workshop* (1924). Negative 13 x 18 cm, glass. Photograph courtesy of Rodchenko-Stepanova Archive, Moscow.

the museum, setting off a dynamic interplay between representation and contingent time, between the static display that characterizes the traditional art museum and a more active form of reception. I would argue that such an archive-museum comes close to what Rodchenko defined as the new museum of "living things"—a museum devoted to "the dynamic origin that drives art forward"[7]—and that related ideas also inspired the innovative gallery designs (*Demonstrationsräume*)[8] that Lissitzky constructed in the mid 1920s: the Room for Constructivist Art (*Raum für konstruktive Kunst*, 1926) in Dresden, which exhibited works by Mondrian, Léger, Picabia, Moholy-Nagy, Naum Gabo, and Lissitzky himself, and the Cabinet of the Abstracts (*Kabinett der Abstrakten*, 1927–1928) at the Hannover Provinzialmuseum.[9]

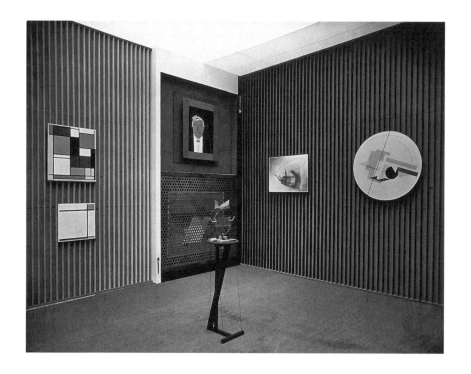

6.2
El Lissitzky, Room for Constructivist
Art, Dresden (1926). Courtesy Getty
Research Institute, Los Angeles.
Photo: Alexander Paul Walther.
© 2007 Artists Rights Society (ARS),
New York.

In pragmatic terms, Lissitzky's ambition in designing both galleries was the presentation of contemporary art in a setting that would be free of clutter and crowding.[10] However, the economic mission of the Demonstration Rooms is closely linked to a shift in the archival parameters of seeing, and to the restructuring of the museum advocated by Stepanova. Subjecting the museum—traditionally grounded in a Newtonian understanding of space as a homogenous container for objects—to a process of continuous differentiation, the Demonstration Rooms focus not so much on the autonomy of the architectural space as on its human observer. By turning the visitor into the dynamic agent of a continuously

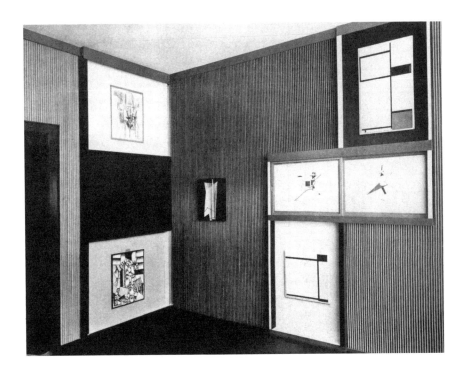

6.3
El Lissitzky, Cabinet of the Abstracts,
Provinzialmuseum Hannover (1928).
Courtesy Getty Research Institute,
Los Angeles. Photo: Redemann.
© 2007 Artists Rights Society (ARS),
New York.

shifting viewpoint whose movements create the space in which they unfold, Lissitzky's designs recalibrate what it means to see in a gallery setting. No longer based on the autonomy of the stationary "correct standpoint" (Ranke) that characterized the nineteenth-century archive and the museum alike, the perception of art in Lissitzky's rooms becomes similar in function to film, and more specifically montage. Just as montage subjects traditional representation to time and movement, so the Demonstration Rooms also suggest that time is the museum's most essential element.

In both the Dresden and the Hannover galleries, Lissitzky paid special attention to the surfaces of the interior walls. Already in a text from 1923 he had declared the recalibration of the museum walls one of his central goals: "We are destroying the wall as a holding bay for … images."[11] By the term "holding bay for images," Lissitzky meant the wall's function as a base that enables the perception of the art object as autonomous, freed both from the constraints of its architectural setting and from the process of its perception. In an effort to change this regime, Lissitzky mounted the gallery walls of the Dresden room—conceived for the Internationale Kunstausstellung of 1926—with seven-centimeter-wide wooden laths, set seven centimeters apart from each other.[12] Then he painted these laths white on their left side and black on the right, while the wall itself was painted gray.[13] Similarly, in the Hannover Provinzialmuseum where the room he was given measured only 23.41 square meters, he fitted the gallery walls with wall-sized frames of steel bands set at much smaller intervals than in Dresden.[14] One side of the bands was painted (enameled) black, the other white.[15] What might seem like a set of largely decorative measures was, in fact, aimed at turning the wall from a static optical support into an active part of the optical environment: "In the room I was given I did not view the four walls as supporting or protective screens but rather as the optical background for the painting."[16] While the term "optical background" suggests the activation of the wall, its transformation from a static support into an active part of art's perception, there is a second activation at stake, one involving the observer him- or herself. The goal was that every time the gallery visitor changed position inside the gallery space, the appearance of the walls changed according to which side of the painted laths or bands he or she confronted, and with it the background of the images displayed on their surface: "With every movement of the spectator in the room the impression of the walls changes … thus an optical dynamic is generated as a consequence of the human stride."[17] The creation of an "optical dynamic" was central to Lissitzky's designs. What he means by this term is not an independent vision that would ideally be free from subjects or objects but rather an individualized, embodied—if continuously shifting—eye whose motions ("a consequence of the human stride") are in sync with the emergence of the space around it. With the activation of the visitor from an immobile observer to an active agent of this "optical dynamic," the images that correspond with his or her shifting positions are subject to continuous change: "The images appear on a white, black, or gray background depending on the observer's standpoint, they assume a triple life."[18] If we take the term "triple

life" in this statement seriously, we have to conclude that under the sway of the "optical dynamic" neither the walls nor the images are ever selfsame. There is no (one) "wall" and no (one) "image"; there is only an archive of its perceptions from a variety of specific, embodied points of view. Instead of an eye that apprehends the space around it in one sweeping gaze and from a position that is as fixed as it is supraindividual and transsubjective, we are confronted with a series of differences to which the body is central—"triple lives."[19]

In his lecture about the activities of the museum office, Rodchenko had argued that it was the museum walls in particular that helped turn the traditional art museum into what he referred to, pejoratively, as an archive: "Strictly speaking, in the historical museum the character of an ARCHIVE is created by the habit of carpeting the walls from top to bottom. Even the physiological impossibility of seeing the art work was not taken into account."[20] In the Demonstration Rooms, what Rodchenko calls the purely economic approach taken by the historical art museum—"the economy of the place was given absolute priority"—meets with a shrewd response: on the one hand, Lissitzky greatly diminishes the number of artworks exhibited in the galleries, alleviating the effect of crowding lamented by Rodchenko; but on the other hand, he suggests that there is in fact no single art object but only the "triple life" it receives from its perception over time and before three differentiating backgrounds. What the Demonstration Rooms demonstrate, then, is not the endless accumulation of art objects that is a characteristic of the traditional art museum, but the cumulative effect of perceptions that refuse to add up to the abstraction of an object before experience, an (an-) aesthetic Thing in Itself.

Lissitzky conceived the Dresden Room for Constructivist Art as a standard-setting environment for the exhibition of the new abstract art. As Maria Gough has noted, Lissitzky developed this room at a time when standardization was one of his most crucial concerns,[21] and it aligned the artist with the more general efforts at standardization—in the office and elsewhere—that were afoot in Germany in the mid 1920s. During the very year when the Dresden gallery room was designed, the Commission on Industry Standards of German Industry (Normenausschuß der deutschen Industrie, founded in 1917) renamed itself Deutscher Normenausschuß (German Commission on Industry Standards). The commission's goal was to supervise standardization and rationalization of all aspects of commerce, industry, and administration. The assumption was that with the standardization of all hardware the hitherto unregulated human use of

materials would become equally standardized and that the standardization of one product would spawn an entire industry of related products. In his book on the 1925 Exposition Internationale des Arts Décoratifs et Industriels Modernes in Paris, Le Corbusier gives a good example of the effects of industry standardization in the area of office technology: "When the typewriter came into use, letter paper was standardised; this standardisation had considerable repercussions upon furniture.... Typewriters, file-copies, filing trays, files, filing drawers, filing cabinets, in a word the whole furnishing industry, was affected by the establishment of this standard; and even the most intransigent individualists were not able to resist it."[22] Lissitzky's alignment of the museum with places such as the modern, increasingly standardized office—designed not merely to store equipment but to produce symbols according to industry standards—shows once again the extent to which the Demonstration Rooms move away from the archive as an immobile repository of things.

An important element of the "optical dynamic" that Lissitzky sought to unleash with his gallery designs is the interplay—rather than the static layering—of the armatures, the system of laths or bands on the walls, with the images on their surface.[23] As the structured walls—images in their own right—interact with the images hung on them, and as one moves about in the room, it becomes difficult to decide what is figure and what is ground, what is the archive's base and what is contained by it. If in one sense the laths and steel bands contrast with the artworks on their surface, they also give the impression of extending into them. In the Dresden room, the vertical lines described by the system of laths continue the vertical lines in the paintings by Mondrian. Meanwhile, the paintings' horizontal lines cross the laths' vertical lines as well as their own to form a grid that appears to oscillate between the picture plane and its architectural support. Another example of such oscillation is the presentation of an enlarged fragment of Lissitzky's self-portrait (often titled *The Constructor*, 1924) in the Dresden room. Not only does the multilayered self-portrait—put together from six different exposures—include a system of broadly drawn intersecting vertical and horizontal lines, but these lines appear before (and behind) a background of graph paper, forming a grid, that seems itself projected on a background formed by broad vertical lines. The self-portrait confronts us with a dizzying array of grids composed by various layers both on and off the picture plane (the system of laths on the walls and the broad lines in the image; the checked paper and the broad lines in

6.4
El Lissitzky, *The Constructor,
Self-Portrait* (1924). Gelatin silver
print, 10.7 x 11.8 cm. Courtesy
Victoria & Albert Museum, London/
Art Resource, NY. © 2007 Artists
Rights Society (ARS), New York.

the background, etc.) that both accentuates and sublates the difference between the paintings and the wall, between the archival base and its signs.

Confronting the visitor with two independent yet related (or relatable) surfaces—the armature on the walls and the images hung on it—the Demonstration Rooms assimilate the principal lesson taught by nineteenth-century optical physiology, the notion that vision is not instantaneous but a construct informed by difference and interval. In the way they make the activation of the gallery visitor dependent on the interplay of two surfaces that can both be either figure or ground, the Demonstration Rooms allude to optical devices, such as the phenakistoscope, that furnished nineteenth-century scientists with proof that seeing, rather than taking in its object in a single, undifferentiated sweep, involved a series of individual shots whose successful superimposition or assimilation resulted in what passes for normal vision.[24] Jonathan Crary has argued that, in such instruments, "physical proximity brings binocular vision into play as an operation of reconciling disparity, of making two distinct views appear as one."[25] Of course, as the Demonstration Rooms show, such reconciliation does not preclude the possibility of focusing on difference—on the apparatus or the armature—over the illusion of motion it creates. (It is no coincidence that Helmholtz used a related instrument, the stereoscope, for proof of his thesis that "seeing with two eyes, and the difference of the pictures presented by each, constitute the most important cause of our perception of a third dimension in the field of vision.")[26]

Implicit in Lissitzky's reference to nineteenth-century binocular optics is his dismantling of the opposition between the archive and the gaze, an opposition that is often viewed as emblematic of modernism in general. Foucault gives an eloquent description of this antinomy in *The Birth of the Clinic* when he opposes the freedom of the (medical) gaze and the archive of written knowledge, suggesting that the decline of ancient medicine with its immediate relationship between doctor and patient began when writing intervened to concentrate knowledge in the hands of a privileged few: "Before it became a corpus of knowledge [*un savoir*], medicine was a universal relationship of mankind with itself…. And the decline began when writing and secrecy were introduced …, and the dissociation of the immediate relationship, which had neither obstacles nor limits between Gaze and Speech [*parole*]."[27] With the introduction of writing, so the argument goes, vision became a function of the archive, and as a result, the immediacy of the unfettered gaze was obstructed. Applying this line of reasoning to the Demonstration

Rooms, we may be tempted to assume that Lissitzky's objective in structuring the walls of his galleries was to reverse the effect Foucault describes by making the archive (that is, its walls) itself the content of his message, roughly in the spirit of Marshall McLuhan's thesis, developed on the example of cubism, of "the medium as message." However, as we saw, Lissitzky's strategy does not aim at switching from the archival surface to its depth, from stored content to its material substratum, so that this substratum or medium—the wall—may be lifted from obscurity into visibility. Rather than isolating the archive from what it stores, the Demonstration Rooms hint that one cannot easily be distinguished from the other and that both can be either figure or ground. The model of vision implicit in this switch implies the persistent oscillation between the archival background and its surface, an oscillation that precludes a reliable distinction between the two and that is, as such, the prerequisite for the integration of time and space in the Demonstration Rooms.

The oscillation between the images in the foreground and the gridlike background (the system of laths or bands) is prefigured in the collages and overpaintings with which Max Ernst impressed the Surrealists upon his arrival in Paris and with which Lissitzky was likely familiar. *La chute d'un ange* (1922) includes a painted screen made up of a field of regular vertical lines in front of a skylike scene of which we see only a small strip at the upper edge and a circular opening below. It is not easy to position the vertical lines that form the screen with any degree of certainty vis-à-vis the painted scene behind it or the figures and shapes projected on its surface. Does the screen suggest an element within which the painted/cut-out figures move as if in water or air? Or do its vertical lines on the contrary represent a structuring system that is external to the represented scene like a second canvas? At a minimum, *La chute d'un ange* invites us to question how many surfaces we are dealing with as we try to imagine whether the naked blue torso we see plunging headlong through the semicircular opening on the right finds itself in the same space as the disappearing figure at the upper edge of the screen. By forcing us to reconcile (at least) two images, Ernst's collage, like the Demonstration Rooms, refers us to an archival model of vision for which seeing is a gradual process of assimilation and differentiation that constitutes its object in a series of discrete shots rather than in one single sweep.

Ernst's collage reminds us of the play of difference—between foreground and background, between a system of regular intervals and a moving image—as the prerequisite for the perception of motion. Lissitzky referred this experiment

6.5
Max Ernst, *La chute d'un ange*
(1922). Collage and oil on paper.
Private collection. © 2007 Artists
Rights Society (ARS), New York.

**THE BIG ARCHIVE**

more explicitly to the perception of motion over time in a series of photo collages depicting sports events from the same year as the Dresden room (1926). *Runner in the City* shows runners in full motion before a nighttime cityscape. On the picture plane, Lissitzky superimposed a series of vertical bands—refracting the image into a series of thin slivers that leave short intervals between each consecutive moment—that can be linked to the phenakistoscope and to the system of laths installed in the Dresden room that same year. These bands intersect with the lines in the image (the runner's arms, the street curb, the elongated neon signs), often making it difficult to decide what is foreground and what is background. Does the grid formed by the intersecting bands and lines, in and outside of the depicted scene, precede that scene, or is it on the contrary the scene's effect? Is the grid the archive, or is it produced by it? Lissitzky does not allow us to decide these questions with any degree of certainty, just as film does not as a rule allow us to distinguish between the moving screen and the archive of stills in which it originates. Neither fully foreground nor background, neither archive nor fully what it contains, the grid formed by the intersecting lines differs dramatically from the one that provided a neutral background to nineteenth-century efforts to produce archives of motion, such as Muybridge's *Animal Locomotion* (1887) or Ottomar Anschütz's experiments with chronophotography.[28] In Muybridge's work, the grids before which his characters perform their motions remain squarely confined to the background, lending realism and narrative plasticity to the depicted scenes. By contrast, what is on display in the ambiguous grids that organize Lissitzky's *Runner in the City* and the Demonstration Rooms is not a narrative of motion but the archive of discrete, differential moments that enables its perception.

The oscillation between the armature of the walls (the system of bands and laths) and the artworks on their surface also marks the cinematic dimension of the Demonstration Rooms, moving them close to avant-garde montage. Montage in film is often correctly described as an emphasis on the mechanical apparatus, on interval and differentiation, over the reconciliation of difference that characterizes devices such as the phenakistoscope. However, to Sergei Eisenstein, one of montage's most prolific theoreticians and practitioners, montage is an effect not only of separation and division—one shot after another—but also of the *superimposition* of contiguous shots in a single frame as a result of the observer's subjection to movement. As superimposition, montage represents the counterpoint to the nineteenth-century archive and its autonomous recording of movement from

6.6
El Lissitzky, *Runner in the City*
(c. 1926). Gelatin silver print,
13.1 x 12.8 cm. © The Metropolitan
Museum of Art / Art Resource, NY.
© 2007 Artists Rights Society
(ARS), New York.

6.7
El Lissitzky, *Soccer Players* (1926).
Gelatin silver print. Courtesy Getty
Research Institute, Los Angeles.
© 2007 Artists Rights Society
(ARS), New York.

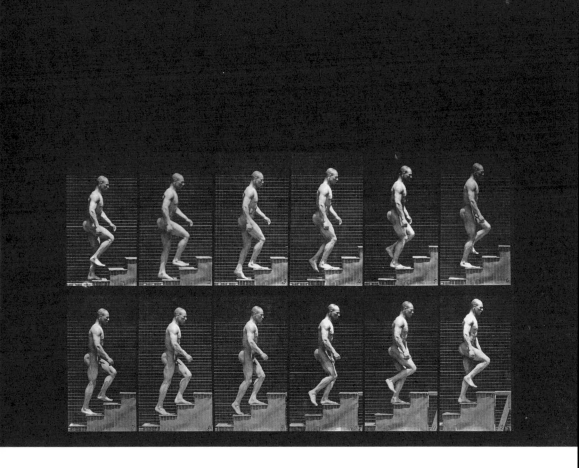

6.8
Eadweard Muybridge, *Motion Study
Photograph: Movements, Male,
Ascending Stairs*, in *Animal
Locomotion* (1887), plate 91.
Courtesy Collections of the University
of Pennsylvania Archives.

a stationary position (Ranke's "richtiger Standpunkt"). In avant-garde montage, the observer's position is itself subject to temporality, so that there is no single correct viewpoint on reality, only a dynamic sequence of moving shots from a series of standpoints and their merging through the body of the observer. Eisenstein gives an example of such embodied montage in his essay on Valentin Serov's 1905 portrait of the actress Maria N. Yermolova. Serov's painting, Eisenstein contends, is the product not of a single exposure but of the superimposition of several perspectives that view the actress from different angles. Crucially, these perspectives—combining points of view that are fundamentally incompatible with each other—mark different moments in time. Identifying them one by one, Eisenstein suggests that Yermolova's improbable depiction and pose reflect not a stationary observer—the standard procedure in portraiture—but an observer who travels, unseen, along a trajectory that leads from an elevated perspective to an admiring position literally at the actress's feet: "What has here been fixed on canvas is not a series of four successive positions of an object but four successive positions of the eye of the observer. Therefore these four points are not a function of the behavior of the object ... but are a characteristic of the behavior of the spectator."[29] Functioning much as a camera does in film, the moving spectator—or perhaps four separate spectators—replaces the stationary painter and ensures that the depicted subject (Yermolova) cannot be said to preexist its own archivization.

6.9
Valentin Serov, *Portrait of M. N.
Yermolova* (1905). Individual shots
from Sergei Eisenstein's essay
"Yermolova." In S. M. Eisenstein,
*Selected Works,* vol. 2, *Towards
a Theory of Montage* (London:
BFI Publishing, 1991), 84, 85.

By setting the recording agent in motion, Eisenstein replaces the nineteenth-century archive with an archive based on embodiment and montage. Lissitzky's "activation" of the observer in the Demonstration Rooms subscribes to the same logic. By turning the museum visitor into an active agent, Lissitzky refracts the space of the museum into an archive of dynamic viewpoints that eschew the unity of Newtonian space. Just as Yermolova's portrait is composed of individual shots that reflect the observer's motions, so Lissitzky too sets up an optical regime characterized by change and motion. An important part in this scheme was played by the system of open frames that he installed in the corners of the Dresden and Hannover rooms. These frames—small archives in their own right—contained images that were partially obscured by vertically movable, perforated—or, as in the Hannover room, solid[30]—metal plates that could be moved by the visitors with a small wooden handle.[31] In the case of the Dresden room, this resulted in an obfuscation that left parts of the obscured image visible: "I have interrupted the evolving lath-system by placing frames in the corners of the room (five in all, of widths from 1.10m. to 1.90m.). Each is half-covered by a sliding area (of stamped sheet iron). At the top and the bottom of each is a place for a picture. When one is visible the other shimmers through the lattice."[32] Intertwining the revelation of one image with the (partial) repression of another and inviting the visitor to interact physically with the gallery architecture, the movable screens archivized a trace of the visitor's presence in the gallery by remaining in the position in which they were left; however, as soon as the next user moved the screen, the (impermanent) trace was erased again.

If the frames' emphasis on repression—every time a visitor reveals one image by moving the screen up or down, she obscures another—links them to Freud's "mystic" writing pad, so does the fact that like Freud's pad they fulfill an economic function, by increasing the number of works that can be stored on, or in, the gallery wall without creating a crowded effect. For Freud, the attraction of the "mystic" pad was its combination of an unlimited storage capacity with an equally unlimited ability to store new traces. Similarly, for Lissitzky, the cassettes helped maximize the museum's storage capacity: "In this way I have found space in the room for one-and-a-half times as many works as in other rooms, but only half the number are visible at any one time."[33] In their economic function, the vertically movable plates that partially obscure the painting behind them furthermore recall the office technology of vertical filing, which Prussian and American office reformers were struggling to introduce at the very time that Lissitzky

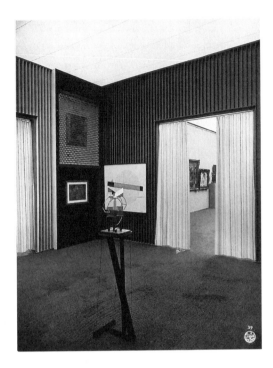

6.10
El Lissitzky, Room for Constructivist
Art, Dresden (1926). Courtesy Getty
Research Institute, Los Angeles.
Photo: Alexander Paul Walther.
© 2007 Artists Rights Society (ARS),
New York.

was building his Demonstration Rooms. As his work on advertisements for the German office supply company Pelikan from around the same time (probably on the recommendation of Kurt Schwitters) demonstrates, Lissitzky was intimately familiar with advanced office technologies. (See figure 6.13.) Unlike older filing systems in which documents were folded twice before being deposited in narrow drawers or pigeonholes, vertical files—which evolved from the vertical card indexes used by librarians—stored documents on edge, with their contents immediately visible to the user.[34] The retrieval of information in a vertical filing cabinet, organized with the help of movable indexes that straddled the files, was an effect of spacing. As the fingers of both hands identified the place where a desired document is located, they separated the desired file or document from other files or documents by opening a space between them.[35] Lissitzky's cassettes also adopt such spacing by having the visitor use his or her fingers to move the screens separating the images. Beyond this, the cassettes in the corners of the Demonstration Rooms are an instance of what Benjamin, referring to montage, called *Zerstreuung*, a term he associated not with entertainment but with a tactile

quality based on "successive changes of scene and focus which have a percussive effect on the spectator."[36] The experience the Demonstration Rooms made available to their visitors is analogous to the one Benjamin claimed for film; instead of an illusion of continuity and flux, they permit a glimpse at the archive of differential moments—their oscillation and differentiation—that represent that illusion's phenomenological horizon.

6.11
Library Bureau system of vertical filing with interchangeable unit cabinets (Library Bureau, Boston, 1903). Courtesy Markus Krajewski.

Given the importance of montage for the architecture of the Demonstration Rooms, it will not come as a surprise that Lissitzky's friend and colleague Dziga Vertov was one of their early admirers. After his visit to the Hannover room in the summer of 1929, Vertov wrote in a letter: "I saw your room in the Hannover museum. I sat there for a long time, looked around, groped [*Dolgo tam sidel, osmatrival i oschschupyval*]."[37] In her essay on the Demonstration Rooms, Maria Gough interprets the verb *oschschupyvat'* (groping) in Vertov's cryptic remark as an intransitive gesture without reference to an object: "In groping about as if in the dark or deprived of sight, one's body becomes implicated ... in the performance of that action in a way that is not the case when one is merely examining something."[38] In the following discussion, I want to expand on Gough's crucial identification of instances of blindness as central elements in Lissitzky's museum designs. If "groping about" is indeed the most appropriate way to describe the visitor's interaction with the Demonstration Rooms, the reason is that only through groping can the rooms be understood as archives, as being grounded in time as well as in space. Just as Yermolova's position in space is a

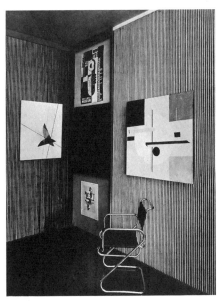

6.12
El Lissitzky, Cabinet of the Abstracts,
Hannover (1928). Courtesy Getty
Research Institute, Los Angeles.
© 2007 Artists Rights Society (ARS),
New York.

6.13
El Lissitzky, advertisement for carbon
paper produced by the Pelikan
Company. Courtesy Getty Research
Institute, Los Angeles. © 2007 Artists
Rights Society (ARS), New York /
VG Bild-Kunst, Bonn.

function of a succession of different views over time, so the perception of art in the Demonstration Rooms proceeds as a sequence of local perspectives in an environment that is itself a function of time.

6.14
Still from *The Man with the Movie Camera*, dir. Dziga Vertov (1929). Courtesy Kino/Photofest.

Beyond that, "groping about"—an activity not ordinarily associated with the appreciation of art in a museum setting—may be read, transitively, as a reference to experimental science, a sphere to which the Demonstration Rooms are related in more ways than one.[39] For one thing, the German term *Demonstration*, a near-synonym of the English word "experiment," is commonly used in experimental science to connote the visual display of an experiment by a scientist. The term "groping," a tactile fingering that replaces reasoning with sensing, has a

long pedigree in the history of modern science. It plays a role already in Bacon's *New Organon*:

> There remains mere experience: which is chance, if it comes by itself; experiment, if sought. This kind of experience is like a brush without a head (as they say), mere groping, such as men use in the dark, trying everything in case they may be lucky enough to stumble into the right path. It would be much better and more sensible to wait for day or light a lamp, and then to start the journey. The true order of experience, on the other hand, first lights the lamp, then shows the way by its light, beginning with experience digested and ordered, not backwards or random, and from that it infers axioms.[40]

For Bacon, groping has purely negative connotations because it signifies a blind, unorganized way of proceeding that lacks any system. In post-Baconian accounts of experimental science, the status of groping changes considerably. Rather than connoting messiness and a lack of foresight in conducting an experiment, as it does for Bacon, groping began to be deployed as a key term in the modern effort to distinguish experimental from merely observing science. In Claude Bernard's *Introduction to the Study of Experimental Medicine* (1865), which laid the systematic groundwork for experimental science in the modern age, an experiment is characterized, first, by (natural or induced) disturbances and, second, by the experimenting scientists' ability to "touch the body on which they wish to act, whether by destroying it or by altering it."[41] The tactile contact the experimenter maintains with his object of inquiry is what for Bernard distinguishes an experiment from mere observation.[42] This contact includes groping as one of its key gestures: "Observers, then, must be photographers of phenomena; their observations must accurately represent nature.... But when a fact is once noted and a phenomenon well observed, reasoning intervenes, and the experimenter steps forward to interpret the phenomenon.... To do this, an experimenter reflects, tries out, gropes, compares, contrives ...".[43] Bernard views groping as an innovative way of thinking, a tactile thinking with one's hands that replaces thought as a purely cognitive activity relying on reason alone. In this scheme, it is not a matter of first "lighting a lamp" in order to preview in its light the future experiment.

On the contrary, the point is to view such anticipating foresight as a distortion that can have a negative impact on the experiment at hand.

At this point, groping—"touching the body with one's hands"—becomes groping for difference. Hans Jörg Rheinberger has noted that "the coherence of an experiment system is based on recurrence and repetition, not on anticipation and foresight."[44] Here is Rheinberger's description of what he calls an *Experimental-system* (experiment system): "Experimental systems are inherently open structures. An experimental setup can be compared to a labyrinth under construction whose already existing walls both adjust and limit the disposition of the new walls and which by that token both guide the experimenter and bar his vision. A labyrinth that deserves its name forces us to ... grope [*tappen*]."[45] According to Rheinberger, experimental systems are the result of the "feeling and groping for differences." While groping can be (and sometimes is) associated with the mind, its primary organs are the hands. Rheinberger argues that in modern experimental science, "being experienced" (*Erfahrenheit*) does not mean having foreknowledge, the ability to predict the outcome of an experiment, but thinking with one's hands, "penser avec ses mains."[46] In a labyrinth, where eyesight is blocked from taking control, the scientist only has his or her hands to find the way. Rheinberger's argument is a variation on Helmholtz's assertion that "the meaning we assign to our sensations depends upon experiment, and not upon mere observation of what takes places around us."[47] More specifically, however, Rheinberger defines the modalities of such experimentation as being temporally in sync with what it explores. The labyrinth he uses as an analogy for the modern experiment does not exist already, it is "in construction," just as the movements of the experimenter in an experimental setup are never coordinated in advance; the experiment evolves in sync with its observer.

In Rheinberger's terms, groping means not allowing what we know or have learned to interfere with our perception of the new; it means to be present in it. To be present in the new is to find that the old epistemological model, based on archives of knowledge that transcend experience and bodily presence, has become obsolete. In this sense, Lissitzky's archival Demonstration Rooms, where the visitor's partial blindness is a functional element in the phenomenological construction of art and where art is activated in line with the observer's movements around the room, may be understood as experimental systems in Rheinberger's terms. Rheinberger's description of the experimental setup as a "labyrinth under construction," in which walls both guide and blind the scientist, further

echoes the disposition of the "doubled" walls in the Demonstration Rooms. In Lissitzky's galleries, too, the spectator moves around as if in a labyrinth-archive whose parameters shift all the while, a space where groping and feeling (*oschschupyvat'*) are literally the only means for orientation.

"Thinking with one's hands" and "being present to the new" may have been precisely what Lissitzky had in mind when he constructed his archives for art. That he should have relied on montage as his principal technique for constructing such an archive is hardly surprising. Eisenstein, for one, attempted throughout his career to put montage at the service of an innovative tactile experimental science in the spirit of Bernard. In 1929 the director wrote: "It [art] must restore to science its sensuality. To the intellectual process its fire and passion. It must plunge the abstract process of thought into the cauldron of practical activity.... A cinema of extreme cognition and extreme sensuality that has mastered the entire arsenal of affective optical, acoustical and biomechanical stimulants."[48] In the Demonstration Rooms, the perception of the art object sets off a play of differences involving the structured walls, the observer's position, the light coming through the windows, and the movable screens from which nothing is exempt, least of all the gallery visitor. As a result, the act of visual perception has a tactile dimension in much the same way that the mind has a tactile dimension in Rheinberger's labyrinth ("penser avec ses mains"). "Groping," here, is the only way of seeing. It is crucial to understand, then, that if Lissitzky brings back into art the hand that Arp, Tzara, and Schwitters had sought to remove from it about ten years earlier, he does so under conditions that prevent it from being what it always was in art: the handmaiden of an eye whose element is the autonomous, all-seeing subject in full control of its optical field. In the Demonstration Rooms, the hand does not follow the eye; it replaces it: seeing as groping.

we never possessed

# 1970–2000
# ARCHIVE, DATABASE, PHOTOGRAPHY

└

Hans-Peter Feldmann
Susan Hiller
Gerhard Richter
Walid Raad
Boris Mikhailov

ACCORDING TO BENJAMIN H. D. BUCHLOH, THE INTEREST SHOWN BY LATE-TWENTIETH-CENTURY ARTISTS IN THE (PHOTO) ARCHIVE WAS LINKED TO THE WANING OF THE AESTHETIC OF SHOCK (PHOTOMONTAGE) DURING THE 1920S. At the dawn of the era of the Leica camera and mass amateur photography, Buchloh argues, the aesthetic of photomontage showed distinct signs of exhaustion. At that time, an internal rift within the Dadaist movement resulted in the suspicion that the critical potential of photomontage—founded as it was on rupture, discontinuity, and perceptional shock—might turn from being a weapon of resistance into an affirmative aesthetic without political effect. As a result of this self-questioning, a new aesthetic of photomontage developed which "not only defines the function of the photographic image in a fundamentally different way, but springs from the almost didactic emphasis of a new historical precursor.... Thus, as early as 1925, we were able to observe an initially hesitant, then more radical, change in the aesthetics of photomontage in which the epistemology of the shock effect was replaced by

the epistemology of archival order."[1] However, perhaps the difference between photomontage and the newly affirmative archive of the 1920s lies not so much in the replacement of photomontage with the archive—for, in any number of ways, photomontages function as (anti-) archives, too—but in the way both react to the nineteenth-century archive of provenance, with its emphasis on topological origin, readability, and the registration of contingent time as part of a "thickening of the code," in Marey's words. Whereas photomontage disavows this model, opposing it with an emphasis on shock, rupture, and a proliferation of archival bases (every picture can become the base for another layer of images), the archival movement of the late 1920s returns to it, celebrates it, and elevates it to the status of a monument.

One of the most eloquent testimonies to this development is Aleksandr Rodchenko's essay "Against the Synthetic Portrait, for the Snapshot" (1928). Written when the debate over photography in the Soviet Union was at its height, the essay speculates on the best medium for a monument to Lenin, who had then been dead for four years. Rodchenko proposes that the best format for preserving the memory of the founder of the Soviet Union would be a *papka*, an office file, filled with photographic snapshots and other bureaucratic records from Lenin's life:

> Today people do not live by the encyclopedia but by the newspaper, the catalogue of articles, brochures, and directories.... That is Lenin.... And show me where and when it could be said of an artistic synthetic work: this is the real V. I. Lenin. There is none. And there will not be any ..., because there is a file [*papka*] with photographs, and this file with photographs does not allow anyone to idealize or manipulate Lenin.... Tell me frankly, what should remain of Lenin: a bronze sculpture, paintings in oil, engravings, water colors ..., or files with photographs that show him at work and in his free time, archives of his books, notebooks, stenographic reports, films, phonographic notes?[2]

The Lenin file Rodchenko proposes in his essay is not composed like a painting but is constructed of discrete sets of data. However, while it is structurally open—with the possibility that new images can be added to it at any time—its surface

has nothing in common with photomontage. Where photomontage questions all models of (official) commemorative culture by relying on temporal and formal discontinuity and rupture, the Lenin file ultimately affirms such continuity. Rodchenko's monumentalization of the bureaucracy—which in turn implies the bureaucratization of photography—and the rhetorical pathos used to celebrate it go hand in hand with a renewed trust in photography's truthfulness and immunity from ideological (and technical) manipulation. This is again a decisive step away from the earlier aesthetic of photomontage, in which such manipulation was treated as the sine qua non of technical reproduction, and where photographs of monuments—or parts thereof—were routinely used to demonstrate the ruptures and fissures in official commemorative culture.

7.1
Aleksandr Rodchenko, *Down with Bureaucratism (*1928). Gelatin silver print. Photograph courtesy of Rodchenko-Stepanova Archive, Moscow.

Rodchenko's monumental file may be compared to nineteenth-century efforts to create photography-based archives of monuments that would act as blueprints for re-creation in case the originals were lost. Albrecht Meydenbauer's *Archive of Historical Monuments* (*Denkmälerarchiv;* 1881), which comprised 10,310 plates of 837 buildings in 185 different locations, is a case in point. Meydenbauer's idea—in itself monumental and reminiscent of Napoleon's plan to create a world archive—was to create an archive of photographs of all the historical buildings in the world.[3] Meydenbauer believed that architecture—and, by implication, the photographs of architectural monuments of which his archive consisted—was superior to the traditional archive medium of writing: "Throughout history architectural monuments have spoken an authentic and comprehensible language; when compared to written messages which only the strictest interpretation can struggle to purge of exaggeration, alteration, and misunderstandings, they always speak the truth…. When both contradict each other, it is always the building that will have the upper hand and that will, at a minimum, expose the imperfection of the written message."[4] Rodchenko shares this belief in the superiority of the photograph for the purposes of commemoration. Like Meydenbauer's archive of monuments, his *papka* functions as a surface with a maximum number of indexical traces. However, whereas Meydenbauer deploys the photo archive as a defense mechanism against the anticipated loss of monuments, Rodchenko deploys his as a means to construct a monument—to Lenin—after his demise. And whereas photomontage disavows a single provenance and questions chronological sequencing, Rodchenko's monumental archive, no matter how heterogeneous the images it contains, affirms both. Rodchenko's monument is ultimately a chrono-file in which photographs are deposited according to the position they occupied in their subject's life. In this file, the archive's traumatic core—Lenin's irretrievable loss—is at least partially recuperated in a practice that galvanizes a social body through the construction of a monumental archive based on progressive accumulation.[5] Crucially, such practice assumed, in a sense, that Lenin was never quite as present as in death and in his subsequent resurrection through an archive of photographs without noise or redundancy. Here, every detail, to the extent that it has entered the archive, has the power to testify to Lenin's powerful presence, a presence made all the more compelling by the fact that its alleged bearer, the historical Lenin, had been dead for several years.

It was Ernst Mach (1838–1916), the physicist, philosopher, and theorist of the analysis of sensations, who unwittingly provided the blueprint for Rodchenko's

monument: "To present the images of a human being from the cradle onward in its ascending development and then in its decay down to old age ... should be ethically and aesthetically magnificent."[6] The monumental pathos of Mach's proposition, a pathos derived from the idea that with the help of photography an archive might be constructed from which nothing—literally nothing—is missing, seems to have found its fulfillment in Rodchenko's file. However, there is also an important difference between them. While Mach's documentation of a human life from the cradle to the grave presupposes continuous surveillance and documentation, Rodchenko's Lenin file retrospectively collects images already in circulation (in the press, for example) and thus not produced explicitly for the purpose of documenting Lenin's life; furthermore, the images derive their presumed reliability and veracity from precisely this fact.

This also distinguishes Rodchenko's project from August Sander's monumental archive *People of the 20th Century*, which the photographer first sketched out between 1925 and 1927. Compared with Rodchenko's ambition to establish an archive of snapshots as an alternative to painting, Sander establishes a series of typologies whose continued allegiance to portrait painting is proportional to their disregard for historic specificity. Where Rodchenko proposes an archive in which no single image, no single moment, can be said to be the same as any other, to Sander portrait photography—not unlike portrait painting—resolves the tension between historical specificity and typological universality.

Though it is made up of discrete signs (images), Rodchenko suggests that the receptive mode that corresponds most closely to his file eventually elides the differences between the individual images in order to settle for its monumental signified (Lenin). Roland Barthes might have called such a consumption of the archive as a universal signified at the expense of its individual signifiers "mythical." In Barthes's understanding, myth is a semiological system to the second degree that speaks about a preceding set of signs in terms that reduce them to a universal signified.[7] Understood as myth, all of the constituent images in Rodchenko's file add up to an authentic, unchallenged, and hence monumental representation of Lenin's life. In this consumption of the *papka* as myth, the central, if uncertain, assumption is that nothing in the photographs contained in the file is staged or manipulated in any way, as their individual signifiers have but one fully transparent signified, Lenin. The signifier "Lenin," in this reading, is not the final term of the linguistic system but, as Barthes would put it, "the first term of the mythical system."[8]

In the photo archives compiled by late-twentieth-century artists—from Susan Hiller and Hans-Peter Feldmann to Walid Raad, Gerhard Richter, and Boris Mikhailov—the mythical (in Barthes's sense), monumentalizing reading of the archive that characterizes the archival turn of the 1920s is undercut in an effort to bracket the archive's consumption as myth.[9] Arranged formally in repetitive, gridlike structures, in pairs, or in albums that resemble a private archive of snapshots, these photo archives do not subscribe to the formal model of temporal flux implicit in the nineteenth-century archive (one moment after another), yet they also avoid the Bergsonian emphasis on blur and unreadability. Frequently resembling databases more than archives based in the principle of provenance, these archives focus on the signifier over its mythical or monumental signified, and they suggest that the relationship between signifiers in an archive is not determined by chronology alone. The principal difference between databases and archives lies in the fact that databases are modular—all their elements can be regrouped in any way—whereas the PP-based archive promotes the idea of an original order that the archivist adopts and preserves. In late-twentieth-century photo archives, too, it is not the linear sequence of moments (Droysen) that takes center stage but the possibility of their combination and concatenation. In this way, late-twentieth-century art continues the assault on the PP-based archive that was begun by the historical avant-garde movements, especially by Surrealism and its experiments with the card index.

In his preface to *Porträt* (Portrait, 1994)—an album containing hundreds of snapshots, all allegedly of the same person—Hans-Peter Feldmann comments on this type of database:

> This book shows photographs on which ... always the same person is shown. In terms of its contents, this is a summarized "family album" of a woman.... The selection of the pictures was based on documentary, objective criteria. The sequence of the photographs was based on the time when they were taken. The number of the photographers who took these pictures is not known but is likely to be above 200.... Most of the images are shown without any alterations.... All the images in this book are shown in black and white. During the first two decades of the time period shown, the original photographs are exclusively in black and white, before the first color images

7.2
Hans-Peter Feldmann, *Porträt* (1994).
Courtesy Schirmer and Mosel
Publishers. © 2007 Artists Rights
Society (ARS), New York.

7.3
Hans-Peter Feldmann, *Porträt* (1994).
Courtesy Schirmer and Mosel
Publishers, Munich. © 2007 Artists
Rights Society (ARS), New York.

**THE BIG ARCHIVE**

appeared in the 1960s. During the last two decades shown, the original images are all in color.[10]

Feldmann's album ends with a five-page index that lists the number of the photograph, the year it was taken, and what it allegedly shows. Like Rodchenko's photo file, Feldmann's album includes a large number of anonymous, indexed snapshots that all supposedly show the same person, adding up to her "portrait." However, where Rodchenko's monument points to a transcendental male signifier (Lenin) as its ultimate signified, Feldmann's database dramatizes a crisis of archivization, as none of the claims Feldmann makes in his preface can be verified with any degree of precision.

As far as chronology goes, it is impossible to ascertain whether Feldmann's claim that "the sequence of the photographs was based on the time when they were taken" is justified or not. And while Feldmann admits to reproducing certain colored images in black and white, he does not specify which of the images he is talking about. *Porträt* thus questions the truth claims of the nineteenth-century archive and its faith in the referentiality and authenticity of photography both as a technology and as a social practice. This can also be seen in Feldmann's allegation that all the images show the same person. While certain images are linked through their reference to the same woman, this does not seem to be the case for all of the photographs. The crisis of the photo archive to which Feldmann points concerns more than anything the archive's claim that all of its data are linked internally. Such linkages, Feldmann seems to argue, are frequently the result of a cognitive operation, a process of projection rather than an objectifiable fact.

Feldmann's critique concerns not only the PP-based nineteenth-century archive; it also extends to the avant-gardist critique of that archive. In another album, *1941* (1994), he reproduces photographs that were published in various places between the 1930s and the early 1950s. In his preface, Feldmann points out that the links between individual images are more important to him than the archive's cumulative effect: "It seems as if between the single images on one page, a double page, or the entire volume there are direct connections. This, however, is not the case. The images are arranged according to the laws of chance. It is the brain that searches independently and without being summoned to do so for explanations, relationships and stories behind the compilations of images—and it finds them. It is a function that is permanently active."[11] Here, the archive

exists as a reflexive mental operation—obsessively searching for links and relationships—as much as it functions as a series of sets of data. Crucially, in *1941* as in *Porträt*, the medium of writing—whose presence in a photo archive was, according to Allan Sekula, a sign of a lack of trust in photography's mimetic powers[12]— cannot necessarily be trusted any more than the photographs themselves.

Feldmann's critique of the archive's claim to objectify knowledge as a network of sets of data with different provenances (and no individual author) can be read as a commentary on an optimistic (avant-gardist) view of the archive—here identified with the principle of montage—as an agency that eschews the subjectivity and interpretation of the traditional text, producing meaning solely through the juxtaposition of its individual elements. A classic example of such optimism is Adorno's description of Walter Benjamin's *Arcades Project:* "Benjamin's intention was to eliminate all overt commentary and to have the meanings emerge solely through a shocking montage of the material."[13] Feldmann rejects this idea that the meaning of what is stored in the archive emerges in a quasi-mechanical fashion, "solely through a shocking montage of the material." Distinguishing sharply between an archive and the mode of its reception, he asserts that in an archive the subjective desire to interpret, to establish meaning and relationships of cause and effect, cannot be stopped even where such links cannot be reliably verified.

Apart from questioning the archive as a set of objectifiable, mechanically established relationships between individual records, Feldmann's albums also dramatize a crisis of provenance. For example, the index at the end of *Porträt* gives each image an individual number, apparently to help us navigate the collection, and yet no such numbers appear by the images themselves, so that it is impossible to match the entries in the index with the photos reproduced in the album. In Feldmann's reading, the archive is paranoid; by undermining our faith in the rationality of its compilation and organization, the artist forces us to accept the fact that words and images are no match for each other, that the images do not show what the words promise, and vice versa.

Once we conclude that the criteria for archivization outlined by Feldmann in his preface are invalid, or at least questionable, the album's holdings—both the individual photographs and the collection as a whole—become little more than static noise. It is as if the archive—the various criteria and principles Feldmann so eloquently presents in the preface—exercises random cuts in the data provided by the images; and once these cuts can no longer be accepted as valid, entropic disorder takes over. Now what we confront is nothing but a collection of randomly

chosen images whose organization into an archive is the result of a reflex-like mental operation rather than being based on objective fact.

Long before Feldmann, Susan Hiller brought together over 300 numbered and indexed postcards showing more or less clichéd motifs from British seaside resorts, referring to her archive as a monument (*Dedicated to the Unknown Artists*, 1972–1976). Her pioneering project, like Feldmann's albums, could be viewed as a recontextualization of Rodchenko's *papka*. Besides declaring her collection of snapshots a "monument," Hiller also insisted on the anonymity of those hundreds of photographers who had taken snapshots of waves breaking on sandy shores. However, where in Rodchenko's project the chronology of Lenin's life provides structure for his archive of technically archivized moments, in Hiller's monument there is no such chronology. In fact, Hiller herself has commented that what her archive includes are moments missed, fleeting encounters with a movement that never registered in consciousness (and that is, as such, homologous with trauma): "We love these pictures because they freeze a movement which otherwise we never realize we see."[14] It is this element in Hiller's archive that interests me most, a moment of missing out that is akin to the anaesthetizing experience Kant linked to the sublime. As an instance of transcendent greatness to which nothing can adequately be compared, the sublime points (as Kant remarked) to a problem of (or in) judgment. If the majestic, crashing waves and the harsh rock faces on the postcards Hiller collected hint at the natural sublime, the utter banality and clichéd depiction of the postcards together with their obvious manipulation—a trauma of the medium itself that is reminiscent of Warhol—neutralize any such reference. Although the sheer size of the archive with its mass of collected images could produce a sublime effect, that effect is emphatically a result of technical reproduction and serial repetition, and as such is distinctly out of joint with the singularity of the eighteenth-century sublime.

Dedicated to photography as social practice in the age of mass tourism, Hiller's archive is not monumental but private, not universal but particular, not cumulative but random. She presents images that were formerly in circulation, postcards written and sent through the mail (some of them even bear stamps glued on the image). These cards often contain handwritten personal messages that the viewer intercepts but whose meaning remains largely obscure. If at first glance the presence of writing in Hiller's archive points to the "crisis of faith in optical empiricism" which Sekula analyzes,[15] writing, in this instance, decidedly does not serve the purposes of objectivization and authentification; instead, it

7.4
Susan Hiller, *Dedicated to the
Unknown Artists* (1972–1976).
Courtesy Timothy Taylor Gallery,
London.

**THE BIG ARCHIVE**

testifies to a private communicative practice far removed from the universalizing aspirations of nineteenth-century historicism. What the postcards show and what the written greetings and notes transcribe are less what the individuals who sent them actually saw than—as Hiller herself remarked—what they wanted to see. The moment captured by the postcards, for all its natural drama, is a moment missed. Hiller's archive is thus a storehouse not of objective facts but rather of desire deferred and reproduced.

It would be a mistake to assume that the archival turn of the 1920s was without its own internal fissures and contradictions, or that the late-twentieth-century photo archive's insistence on the archival signifiers (over myth) did not have its early advocates. Where Rodchenko argues for what I call the archive as myth, his contemporary Siegfried Kracauer demonstrated that the semiological misprision that enables that reading (a semiological system read as a mythical sign) is itself not exempt from temporality. In his famous essay on photography published in 1927, a year before Rodchenko's essay, Kracauer maintains that photographs make sense as long as there is still a living memory of what they show; once that memory fades, they reveal their true nature as archives of disconnected signifiers whose integration and assimilation, as myth or otherwise, become more and more difficult. Kracauer emphasizes the close connection between photography and nineteenth-century historicism: "Advocates of … historicist thinking believe they can explain any phenomenon purely in terms of its genesis. That is, they believe in any case that they can grasp historical reality by reconstructing the course of events in their temporal succession without any gaps. Photography presents a spatial continuum; historicism seeks to provide the temporal continuum…. Historicism is concerned with the photography of time."[16] If historicism is concerned with "the photography of time," then the PP-based archive with its formal, linear succession of moments is its natural institutional outlet, a spatiotemporal continuum that "simultaneously contains the meaning of all that occurred within that time."[17] As Kracauer and Roland Barthes after him made clear, photography does not show or represent the past or history; it merely marks indexically the moment of its own production. Kracauer remains skeptical of the nineteenth-century view that the archive's (photography's) rootedness in the present moment—or in a succession of such moments—justifies its claim to afford us a glimpse of the past purged of narrative and representation. While Rodchenko—at least in this respect a faithful disciple of the nineteenth-century archive—resurrects Lenin as his file's ultimate, if aloof, signified, Kracauer

believed that photography as an archive is organized—or disorganized—around a void that cannot be filled: "The photographic archive assembles in effigy the last elements of a nature alienated from meaning."[18] Where Rodchenko wants to compile an archive of photographs, Kracauer regards the photographic image itself as an archive composed of discrete signifiers. Photographs inventory reality by picking up literally everything before their mechanical eye; yet these attributes can be integrated—recognized as accessories to a nucleus or essence—only as long as the viewer's memory can still imbue them with truth: "If one can no longer encounter the grandmother in the photograph, the image taken from the family album necessarily disintegrates into its particulars."[19] Kracauer's ploy is to argue that the nineteenth-century archive of historicism is itself subject to temporality; once we no longer recognize its fragments as being the attributes of a nucleus or essence, the image refracts into a set of disconnected signifiers whose attachment to their erstwhile center weakens to the point of utter transparency. What becomes visible now is the image's missing center, the place where grandmother once was: "The photograph gathers fragments around a nothing."[20] Unlike Rodchenko, who erects his archival monument on memory's empty site, Kracauer mourns memory's irreversible abandonment. As memory and personal experience no longer assign fixed positions to the object's attributes, helping us locate its essential truth, we are left with fashion and the ever-changing fads of popular mass culture.

Kracauer assigns to the photograph a place that is structurally akin to the Freudian uncanny, a place both familiar and strangely aloof.[21] In a way that is reminiscent of Lacan's later musings on the nature of seeing, he describes photography as a type of visuality that sees in our place, from a place and vantage point where we are not. To look at a photographic picture is to recognize as familiar a world from which we are excluded by definition. We might call this exclusion the mark of photography's traumatic center—Kracauer's "punctum." Unlike the Barthian punctum, Kracauer's offers no orientation among photography's uncannily transparent signifiers, associating the photographic with an aerial view of a city or landscape that prevents us from coming up close: "All spatial configurations are incorporated into the central archive in unusual combinations which distance them from human proximity."[22] Where the Barthian punctum—close as it is to Kracauer's in every other respect[23]—requires or invites proximity (the punctum "pricks" us), Kracauer's distances us and in this way alerts us to the nature of the social and economic conditions under which we see. Where to Barthes the

punctum is private and offers affective orientation to an individual lost in a vast archive of signifiers whose coding eludes him or her, Kracauer figures the archive—or the necessary disintegration of photographs into archives once their mnemonic life has run its course—as a trope of productive disorientation. Separated from the truth content of the memory image, photographs reveal the provisional nature of the social and economic order of which they are the product: "The barren self-presentation of spatial and temporal elements belongs to a social order which regulates itself according to economic laws of nature."[24] In becoming archive—what Kracauer calls the "warehousing of nature"—the world in which we do not exist refracts into a succession of moments whose meaning is revealed to be arbitrary, up for grabs. Crucially, however, this revelation is also the prerequisite for the playful reassembly of the discrete elements of the photographic image into new, alternative configurations in montage.[25] Only where reality returns to us as an archive of more or less incoherent signifiers from which we are excluded by definition can we begin to evaluate, and creatively change, our situation.

The two kinds of punctum—one homey and private (Barthes), the other alienated, distant, and directed at the economic and social continuum (Kracauer)—embrace the two poles of the Freudian uncanny, its homey (*heimelig*) side and the frightening or secret side (*heimlich*) that is its bedfellow. In late-twentieth-century photo archives, the two types of punctum articulated by Kracauer and Barthes—one keeping us at a distance, the other beckoning us to come up close—can both be found. As examples, Warhol's *Disaster* series beckons us to come close to the image to inspect in detail the gruesome accidents it repeats with such relentless bluntness, capitalizing on our voracious appetite for death and catastrophe; whereas Gerhard Richter's *Atlas* (1964–1995)—consisting of thousands of photo reproductions and snapshots cropped and mounted on rectangular panels of archival cardboard—confronts the viewer with images whose banality and inconspicuousness (reproductions from West German popular magazines; the portraits of politicians active in the Federal Republic during the 1960s and 1970s; Nazi-era personal snapshots; nature scenes; still lifes; and historical footage from World War II) prompt us to step back to a point where the archive becomes more abstract, like a terrain viewed from above. Situated on the borderline between the private and the public sphere, Richter's *Atlas* oscillates between the private photo album's claims to truth, identity, inclusiveness, interiority, and authenticity and the ideological manipulations that have characterized the history of photography as a mass medium.

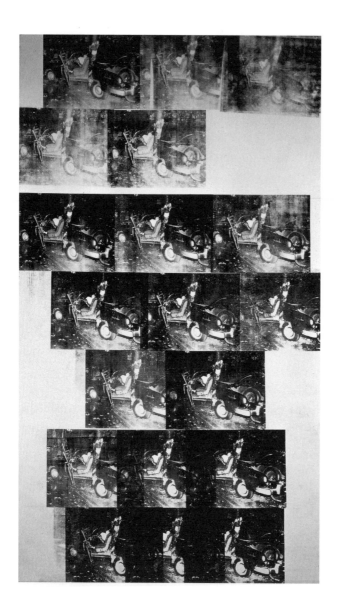

7.5
Andy Warhol, *White Car Crash 19
Times* (1963). Synthetic polymer paint
and silkscreen ink on canvas,
145 x 83¼ in. © The Andy Warhol
Foundation, Inc./Art Resource, NY.
© 2007 Artists Rights Society (ARS),
New York.

7.6
Gerhard Richter, *Atlas* (1962–), PL121.
Courtesy Städtische Galerie im
Lenbachhaus, Munich.

For Lacan, the traumatic real, which eludes all efforts at representation, is situated *behind* the image that screens it, perforating it as it were from behind, and resisting all attempts at reproduction.[26] In *Atlas,* that point is *above* the images, located at the very point where the images are transformed from being individual photographs of identifiable locations into abstract patterns without relief or profile, archives in Kracauer's understanding of the term.

The first aerial views of cities were created in the Renaissance, carried out by cartographers who defined themselves as "painters," reflecting the considerable tension between geometrical vision and religious symbolism that characterized cartography at the time. The formal arrangement of their painted maps—as in a seventeenth-century example showing Paris at the time of Henri IV—distinctly recalls that of the aerial city views in Richter's *Atlas.* However, it was the invention of aerial photography—which, unlike a conventional map, shows an actual portion of the earth's surface on a reduced scale—that finally turned coherent landscapes into archives of discrete signifiers.[27] Frequently recorded from great distances and presenting vertical views of the terrain below, aerial survey photographs replaced the deep horizon of a painting with the opaqueness of the earth's flat surface, abolishing the deep perspective of the conventional canvas together with the autonomous subject on which it is founded. From the vertical perspective of the camera mounted on a balloon or an airplane, the transcendent horizontal depth that has been the subject of painting ever since Leonardo da Vinci defined paintings as "parete di vetro" (window panes) no longer exists. To the aerial photographer, the limited field of the canvas becomes a vast expanse without definable contours, a field that cannot be controlled visually, only recorded.[28] Within this historical context, *Atlas* is archival not in the sense that it accumulates photographs (as in Rodchenko's work), but in the very same way that an aerial shot of a city or landscape is archival: excluding the linear perspective associated with a stable subject position, it refracts into a database of movable signifiers in much the same way as photographs refract into discrete signifiers in Kracauer's account. This is also why Richter's archive cannot, like Rodchenko's, be consumed as a cumulative, mythic monument.[29]

I want to examine the refraction of the archive into a database of movable signifiers in the work of two more late-twentieth-century artists who, each in his own way, work with or around the empty center that Kracauer considers photography's most prominent element. In both cases, such a void—understood as a space of (non-) figuration carved out by specific signifiers—relates to the

7.7
François Quesnel, *Carte ou
déscription nouvelle de la
ville cité université et
fauxbours de Paris* (1609).
Courtesy Bibliothèque
Nationale de France.

7.8
Gerhard Richter, *Atlas* (1962–), PL109.
Courtesy Städtische Galerie im
Lenbachhaus, Munich.

7.9
Gerhard Richter, *Atlas* (1962–), PL119.
Courtesy Städtische Galerie im
Lenbachhaus, Munich.

experience of traumatic history, as it does for Richter. Both Walid Raad and Boris Mikhailov connect photography with trauma; they assert that what we describe as traumatic is a constellation of signifiers that begins to haunt us at that point where we are no longer able to view the world around us as a coherent, integrated image—the point at which that image refracts into an archive of movable elements whose precise configuration eludes us.

Walid Raad's *Atlas Group Archive* (1989–2004) was designed to research and document the contemporary history of Lebanon, especially the wars of 1975 to 1990.[30] Each file in Raad's archive, containing found and produced audio, visual, and literary documents related to the civil wars, is accompanied by a summary that describes its content and history in narrative form. These descriptive summaries, creating contextual provenances for the records contained in the files, have often been praised for their poetic qualities. Yet they also reveal that Raad's archive is to be viewed less as a mythic appeal against the cruelty of war and human suffering than as testimony to what separates us from their experience. One of the narrative summaries, devoted to the file compiled by the fictional Dr. Fadl Fakhouri, reads

> It is a little known fact that the major historians of the Lebanese wars were avid gamblers. It is said that they met every Sunday at the race track—Marxists and Islamists bet on races one through seven; Maronite nationalists and socialists on races eight through fifteen.
>
> Race after race, the historians stood behind the track photographer, whose job was to image the winning horse as it crossed the finish line, to record the photo-finish. It is also said that they convinced (some say bribed) the photographer to snap only one picture as the winning horse arrived. Each historian wagered on precisely when—how many fractions of a second before or after the horse crossed the finish line—the photographer would expose his frame.[31]

Filled with photographic records of moments missed, the pages that make up this file—entitled *Notebook Volume 72: Missing Lebanese Wars*—take up Duchamp's critique of the archive of embodied moments that characterized the nineteenth century. Instead of mensuration—to which *Notebook Volume 72* refers ironically

He is not merely miserable. He is brilliant at it.
There seems no event, no matter how trivial that
does not arouse him to a frenzy of self-mortification

Historians' Initials and Bets:

1. KS   -717
2. MM  +830
3. FF   +729
4. PH   -222
5. HG  +311
6. RO  +001
7. AB   -921
8. SK   -112

Winning Historian / Time:

PH   - 222

Race Distance:
1000 m.

Winning Time:
1:10

Average Speed:
50.5 km/hr.

Distance Between Horse
and Finish Line:

- 18

7.10
Walid Raad, *Notebook Volume 72:
Missing Lebanese Wars,* PL 132.
Courtesy Sfeir-Semler Gallery and
Walid Raad.

7.11
Walid Raad, *No, Illness Is Neither
Here nor There* (1993).
Courtesy Sfeir-Semler Gallery
and Walid Raad.

7.12
Walid Raad, *Miraculous Beginnings*
(1993). Courtesy Sfeir-Semler Gallery
and Walid Raad.

**THE BIG ARCHIVE**

through the references on each page to the "distance between horse and finish line," the "race distance," the "winning time," the horses' "average speed," etc.—Raad's archive focuses on chance and contingency as crucial elements in any archival enterprise.

In their evocation of time past, Raad's poetic summaries clash with the repetitive seriality of the discrete records in the archival files themselves. This tension—between an archive authorized by narrative and the discrete, non-narrative typologies of which it is composed—structures the *Atlas Group Archive* throughout:

> Dr. Fakhouri carried with him wherever he went two Super 8mm film cameras. On one camera, he exposed a frame of film every time he thought the Lebanese wars ended. On the other, he exposed a frame of film every time he came across the sign for a doctor's or dentist's office. He titled the two films *Miraculous beginnings* and *No, illness is neither here nor there.*[32]

The file that corresponds with this description, again attributed to Dr. Fakhouri, lacks a coherent narrative, instead presenting us with two sets of records (taken by the two cameras) whose relationship remains elusive. We might read such a "binocular" view as referring us back to the nineteenth-century insistence that the superimposition of two images is a prerequisite for successful vision, yet Raad stresses not the reconciliation between two images but rather their irreconcilable difference. The first set of images ("Miraculous beginnings") contains discrete shots of signs announcing dentists' practices—a form of address—while the second ("No, illness is neither here nor there") contains images of yards, streets, and houses, "pricked" by punctum-like shots showing ruins, destroyed houses, and other traces of war. However, we are at a loss to match the addresses in the first set with the traces of traumatic history and destruction in the second. It is not even clear whether the images of war in the second set show places in Beirut.

In another file, entitled *Sweet Talk* (1992–2004), the Atlas Group "recruited dozens of men and women to photograph streets, storefronts, buildings and other spaces of cultural, political, and economic significance in Beirut."[33] One document in this file is referred to in the narrative summary as the "Hilwé commissions":

7.13
Walid Raad, *Sweet Talk:
The Hilwé Commissions*
(1992–2004), PL473.
Courtesy Sfeir-Semler
Gallery and Walid Raad.

7.14
Walid Raad, *Sweet Talk:
The Hilwé Commissions*
(1992–2004), PL503.
Courtesy Sfeir-Semler
Gallery and Walid Raad.

> The photographs ... are attributed to Lamia Hilwé, a dancer and pho-
> tographer recruited by The *Atlas* Group in 1990. Hilwé produced the small
> black and white photographs of buildings in 1992, but did not submit
> them to the archive then. Fourteen years later, she submitted over 900
> plates, each consisting of a black and white photograph of a building,
> along with an enlarged, cut out, distorted, and colorized photograph of
> the same building.[34]

If the Hilwé file as a whole legitimizes the authority of the fictional character that
is its archivist (Lamia Hilwé), its individual signifiers seem forever doomed to
miss their signified, the trauma of the civil wars in Lebanon. The photographers
sent out to take pictures of the buildings of Beirut, Hilwé among them, were
instructed to write down the time when an image was taken and to accompany
every photograph with three street addresses, only one of which corresponded
to the actual place where an image was produced. The correct street address was
not to be revealed even to the sponsoring group.[35] As a result, it became im-
possible to ascertain with any degree of certainty where the buildings captured
by the images were to be found, highlighting the loss of address that is trauma.
Under the traumatic conditions of the Lebanese civil war, a project so similar to
Meydenbauer's—with its limitless faith in photography as a means to register
and survey buildings and, through them, history itself—was bound to fail. *Sweet
Talk*, subtitled *A Photographic Monument of Beirut*, is dedicated not to the lasting
memory of the buildings it shows but rather to their future disappearance, a fu-
ture in the past ("it will have been") that is characteristic of trauma's temporality
more generally. In *Sweet Talk*, Raad's archive is less revelatory of its principal
historical referent, the Lebanese civil wars, than it is analytical of the elusive
relationships between its individual signifiers. The viewer's efforts to establish
relations between the original buildings and the enigmatic, fractal-shaped frag-
ments—paradoxically looming much larger than the originals from which they
allegedly derive—are not crowned with easy success. While in some of the Hilwé
document's panels the larger image's derivation from the smaller one is easily
established, in others, there seems to be no connection between the two pictures
whatsoever.

    When we read its poetic summaries, we may be tempted to consume Raad's
archive as myth in Barthes's understanding of that term, but on the level of the

records themselves, the artist stages a play of signifiers without a recognizable signified. Thus, the Hilwé document contains less traumatic history per se than the invisible transformations that have led from one photograph to its transformed, distorted, cropped, or colored counterpart, much as Freud was mainly interested in reconstructing the transformations that led from the latent dream thoughts to their condensed, sometimes distorted reappearance in the manifest dream. The *Atlas Group Archive* is poetic dream work in precisely this sense; its various parts and fragments—the rebus-like, turned-around, cut, and often unrecognizable counterparts of a dream (here, a nightmare) remembered—have their origin in related events and situations ("dream thoughts"), but the procedures that led to their figuration remain blatantly obscure.

*Notebook Volume 38*, also attributed to Dr. Fadl Fakhouri, contains 145 cut-out photographs of cars that are said to correspond to the models, makes, and colors of cars used in specific explosions in Beirut during the civil wars. Like the Hilwé document, this notebook raises the question of reference, this time between the banal cutouts of cars from which any trace of individuality has been purged—they merely represent a certain brand or model—and the specific handwritten information, on the same page, about car bomb attacks in Lebanon involving the same models. An unbridgeable gap or interval seems to separate the cutouts from the specific attacks with which they are associated. Once again this implies a clash between two different archival modes, one aimed at typological summary—a randomly chosen image of a car replacing a car of the same model destroyed in an attack—and the other aimed at the archivization of specific moments in time. Where the cars, or their cut-out reproductions, allude to repetition and seriality, the handwritten inscriptions—noting the make and model of the car, the time and place of the attack, the number of its victims, and the amount of explosives used—suggest an unrepeatable moment in time that is lost to consciousness. If this procedure recalls Duchamp's readymades—mass-produced, generic objects used as archival signs connoting specific points in time—the real scandal of Raad's document is the imprecision even of the verbal inscriptions themselves, their frequent indecision as to the color of the cars involved in the commemorated attacks, or even the precise name of the models ("Toyota or Subaru Celica or unknown"). Whenever the exact appearance of a car cannot be established, one instead of two cutouts appear on the page—often overlapping as if they were crashing into each other—implying that the car used in the attack may have looked either one way or the other, and that the handwritten

information applies either to one or the other of the two cars.[36] As these confusing repetitions take us further and further away from the uniqueness of the traumatic event, there is also a punctum in these images, a detail that figures trauma in a way that exceeds both the archive of types and the ambition to record moments in time, suggesting a form of orientation where reproduction and repetition lead us astray. The punctum, in this particular case, are the cut-out cars' often flat or strangely angular tires, an effect that makes them look immobile, as if they were awaiting the moment of their own destruction.

<div align="center">• • •</div>

The mythic, universal message we associate, reflex-like, with Raad's archive, specifically its commemoration of the Lebanese civil wars, can exercise its humanist appeal only if we blind ourselves to the effects of the archive's signifiers, effects that seem to thwart at every step its elevation to the status of a monument. In formerly Communist Eastern Europe, where (photo) archives frequently functioned as the clerical outlets of a near-ubiquitous apparatus of optical and acoustic surveillance and control, the (official) archive, similarly, was not at the service of memory. Rather it served as a tool for widespread repression and collective amnesia. Few artists from the former eastern bloc have analyzed the (photo) archive in this context as thoroughly as Ukrainian-born Boris Mikhailov. His work as a photographer is inflected, first, by the pervasive social and political repression in the former Soviet Union and, second, by the halting and ultimately unsuccessful attempts to rid the country of this legacy that characterized the mid 1980s. Mikhailov has commented:

> In the history of photography in our country we don't have photos of the famine in the Ukraine in the 1930s, when several million people died and corpses were lying around in the streets. We don't have photos of the war, because journalists were forbidden to take pictures of sorrow threatening the moral spirit of the Soviet people; we don't have non-"lacquered" pictures of enterprises, nor pictures of street events, except demonstrations. The entire photography history is "dusted." And we have the impression that each person with a camera is a "spy."[37]

7.15
Walid Raad, *Notebook Volume 38:
Already Been in a Lake of Fire*,
PL 57–58 (1991). Courtesy Sfeir-
Semler Gallery and Walid Raad.

*Unfinished Dissertation* (1984–1985)—an album of photographs that oscillates between the repressive amnesia of the public archive and the intense memory that characterizes the private (photo) collection—contains snapshots that Mikhailov began to take randomly in his native city of Kharkov in the mid 1980s and then arranged in pairs of two, gluing them on single leaves of coarse typing paper that are said to contain, on their reverse side, a (now invisible) anonymous dissertation. To these pages Mikhailov added handwritten notes that mix personal reflections with quotations from art, philosophy, literature, and science.

One of the more striking elements of Mikhailov's archive is its formal emphasis on repetition and differentiation, suggesting an approach to the archive that is structural rather than semantic. It is tempting to treat the paired photographs of the individual panels of *Unfinished Dissertation* as minimal pairs that function like the minimal distinctions in Roman Jakobson's elaboration of the structure of language. To Jakobson, English root words such as "bill" and "pull"—where the difference is to be found in the two words' initial sounds—can be broken down into distinctive fractions that can in their turn be broken down further: "Upon perceiving syllables such as bill and pull, the listener recognizes them as two different words distinguishable by their initial part /bi/ and /pu/ respectively."[38] Like Jakobson's minimal distinctions, the two photographs on the panels that make up *Unfinished Dissertation* seem to be binary, which is to say that what makes them a pair is the difference that separates them. However, the differences typical of Mikhailov's images do not show the same degree of symmetry as Jakobson's minimal pairs. In Jakobson's examples, both words have the same length and phonetic structure except for one single element. By contrast, in *Unfinished Dissertation* the multiple differences between the individual photographs are strictly asymmetrical. In the panel shown in figure 7.16, for example, the upper image has a vertical, meandering line, a detail that is missing from the lower image. In contrast to the historical view of photography as the most archival of media—photographs, it seems, collect "everything" before the camera's lens without discrimination—Mikhailov follows Duchamp in creating an archive of vanishing clues and disappearing evidence. In the context of the former Soviet Union, this semiological practice had particular relevance, hinting as it does at the longstanding practice of manipulating published photographs by eliminating people who had fallen from official grace.

In the arrangement of its constituent parts, *Unfinished Dissertation* evokes, among other things, the pairs of photographs that John Heartfield claimed had

7.16
Boris Mikhailov, *Unfinished
Dissertation* (1984/1998), detail.
Courtesy Boris Mikhailov.
© 2007 Artists Rights Society
(ARS), New York.

inspired his earliest photomontages. In one of his photographic juxtapositions for the magazine *Freie Welt* (*How a General Is Buried / How Those Slaughtered at the Front Are Dispatched in Mass Graves* [1920]), Heartfield placed a photograph showing the funeral of a general next to one of a mass grave into which the bodies of fallen common soldiers are thrown. Heartfield's idea was that the meaning of the second image could not fully be grasped without the first, so that both images, together with their captions, represent a minimal pair not unlike the ones employed by Mikhailov. In its reliance on two images rather than one, the "stereoscopic" vision implicit in Heartfield's technique demonstrates that what an image means is the result of dialectical juxtaposition, a form of negation that opens the possibility of a future synthesis. In his later work for the *Workers Illustrated Magazine* (*AIZ*), Heartfield used the same technique to expose the manipulation of existing archival photographs by the reactionary press, juxtaposing an original photograph with its altered version. Again the meaning of these pairs originates, properly speaking, in the gap that separates one image from the next, one panel from the other. I say it "originates" there, but it does not show itself in that space, for the space remains blank, undefined, and largely without elaboration.

Although *Unfinished Dissertation* preserves the serial principle implicit in Heartfield's montages, it abandons any claim to synthesis that this might be taken to imply. Whereas in Heartfield's work a successful reading of two contiguous images attempts to find a common denominator in the blank space between them (such as the correct conclusions regarding the bogus truth claims of press photography), in *Unfinished Dissertation* any such effort is doomed to failure from the start. The images differ in some ways, yet are also very similar to each other; their exact relationship or order cannot be established with any degree of reliability and cannot be reduced to the relationship of the two parts in a dialectic. Weary of dialectics, Mikhailov's archive makes it difficult to reduce the play of differences between its individual pairs, an operation of quintessential importance for the formulation of a judgment with more than local reach.

Mikhailov, who refers to his photographs as *kartochki* (index cards),[39] treated the images in his album technically in such a way that they appear old, an impression that is intensified by the yellow paper onto which they are glued. Commenting on this technique, he has proposed that photos should be made so that "just-born photography appears old, as if it had been met before."[40] The trope is a familiar one; like Duchamp's readymades, Mikhailov's snapshots aim

Wie ein in der Etappe gestorbener General begraben wurde —

7.17

John Heartfield, *How a General Is Buried,* in *Freie Welt* (1920). Courtesy Getty Research Institute, Los Angeles. © 2007 Artists Rights Society (ARS), New York / VG Bild-Kunst, Bonn.

7.18

John Heartfield, *How Those Slaughtered at the Front Are Dispatched in Mass Graves,* in *Freie Welt* (1920). Courtesy Getty Research Institute, Los Angeles © 2007 Artists Rights Society (ARS), New York / VG Bild-Kunst, Bonn.

— und wie die an der Front Geschlachteten ins Massengrab verladen wurden.

7.19
Boris Mikhailov, *Unfinished
Dissertation* (1984/1998), detail.
Courtesy Boris Mikhailov.
© 2007 Artists Rights Society (ARS),
New York.

to return to what is already familiar yet strangely distorted (*entstellt*). As instances of *Entstellung*, Mikhailov's archive spells out, in cryptic form, the traumatic repression that characterizes the history of photography in the artist's homeland. Its paired images function not unlike the syllables Freud refers to in his work on the etiology of hysteria. Freud found the establishment of the temporal contiguity of such syllables—his patients' ideas or associations—more important than their intuitive interpretation: "It is a rule of psycho-analytic technique that an internal connection which is still undisclosed will announce its presence by means of a contiguity—a temporal proximity—of associations; just as in writing, if 'a' and 'b' are put side by side, it means that the syllable 'ab' is to be formed out of them."[41] What such associations can tell the analyst about the patient's trauma depends fully on his ability to form "syllables" from these successive associations. Crucially, such contiguity is not synonymous with a semantic affinity between them, but refers only to their proximity in time.

To look at the pairs of photographs in Mikhailov's archive as syllables in Freud's sense is to explore the connection between the two images on a page in terms of their contiguity in space rather than to find a connection in their meaning. Taking this approach, we have to resist the temptation to link the two paired images as part of a linear narrative that explains the changes occurring from one image to the next in terms of cause and effect. Where a narrative would fill in any gaps that may exist between the different parts of a story, in a more structural approach like the one put forth by Freud such gaps or absences—such as the differences between one image and the next—are treated as functional elements in the analytical process.

Absence—the missing element I referred to above as a missing or vanishing clue—is one of the central motifs in *Unfinished Dissertation*, as in the pair in figure 7.20 where on the lower left of the upper image there is a bright, unidentified object that is missing from the lower image. Departing from the upper image, the observer's gaze moves to that point in the lower image where in the upper image the object is present. The main distinction between the images—the object missing in the second photograph that is present in the first—is supplemented by a host of other differences. While the scene and the person seem to be the same in both images, the movements executed by the woman's body are clearly not the same, a fact that might hint that we are dealing with two shots from a film sequence. However, like all other assumptions about the paired photographs in *Unfinished Dissertation*, this remains speculative. As inquiries into the evidentiary powers

7.20
Boris Mikhailov, *Unfinished Dissertation* (1984/1998), detail.
Courtesy Boris Mikhailov.
© 2007 Artists Rights Society (ARS),
New York.

7.21
Boris Mikhailov, *Unfinished
Dissertation* (1984/1998), detail.
Courtesy Boris Mikhailov.
© 2007 Artists Rights Society (ARS),
New York.

of photography, Mikhailov's images can be compared with John Hilliard's experiments with the cropping of images from the early 1970s (for example, *Cause of Death?*). Depending on what is taken away from an existing image, our understanding of the scene—and the narratives we construct to explain it—differ considerably.

One of the problems we face in figure 7.20 is the fact that we have no way of telling from the images themselves which photograph was the first in the sequence. Unlike the paired photographs published by the *AIZ* during the 1930s (Heartfield), in which an explanatory written commentary—mostly under the images, or to their side—established which photograph was the original and which the manipulated copy, in Mikhailov's album such a distinction remains elusive, as the handwritten notes surrounding the snapshots never comment on the images themselves. The difficulty we confront in *Unfinished Dissertation* is therefore the difficulty of turning these images into a story, an operation that would require us to establish a point of origin. What we are left with is disturbingly close to Feldmann's later archives: a random accumulation of images whose relations (similarities, differences) are rhizomatic, random, and chance-driven rather than vertical, organized, and predetermined. Not Jakobson's binary pairs, then, but Freud's syllables: nothing but discrete elements that are contiguous in space. Whatever relations exist between the images are a function no longer of the archive—the formal arrangement of the images in rows one over the other— but of our visual experience with the images themselves.

In the panel shown in figure 7.21, a fleeting glance might easily create the impression that the two pictures show the same scene at different times. Only on closer inspection do we become aware of the fact that we are dealing with two different scenes. The landscapes are complementary: what is land in one is water in the other, and vice versa. In terms of archive theory, the implication is simple enough: like Feldmann and Richter, Mikhailov disavows the view of the archive as an agency that predetermines the terms of our visual perception before it occurs, establishing a field of (empty) relations waiting to be filled. By systematically undermining our sense that the images collected in the album represent binary pairs—so many discrete elements in a coherent narrative—he opens up the possibility of an archive that constitutes itself only as part of the viewer's interaction with it. In other words, the archive as a set of relations, similarities, or differences between a set of images does not preexist our experience of the rhizome-like relations between them. In this respect, *Unfinished Dissertation*

differs dramatically from the nineteenth-century photo archive whose morphological approach assumed that perception needed to arm itself with the archive and a variety of bureaucratic supplements in order to control its objects effectively. In this spirit, nineteenth-century archives assumed that difference could be classified, and that archives preexisted the visual practice they were designed to administrate. In the late-twentieth-century archive, from Hiller and Richter to Raad and Mikhailov, the relations between images cannot be reduced to formal arrangements or categories. In their disavowal of narrative and an original *arkhē*, these archives display a tendency toward entropy, a tendency they share with the medium of photography itself. As Kracauer writes, "however picky the photographer may be, his images cannot deny the tendency towards what is diffuse and unorganized.... That is why they are inevitably surrounded as it were by a border of indistinct ... meanings."[42] The archives discussed above reproduce the border of which Kracauer writes, an element that lies outside of the archive's claim to order and organization and that is, at the same time, its very center.

in the first place.

8

# 8

# THE ARCHIVE AT PLAY

⌐

Michael Fehr
Andrea Fraser
Susan Hiller
Sophie Calle

THRIVING ON WHAT WAS PREVIOUSLY EXCLUDED FROM ARCHIVIZATION—ON TRASH AND MARGINAL, INVISIBLE, PRECONSCIOUS, OR UNCONSCIOUS *RESTE* (REMAINS)—MODERNISM PROMOTES THE IDEA OF AN ARCHIVE THAT DOES NOT SO MUCH COLLECT FACTS AS REVEAL THE CONDITIONS FOR THEIR DISCOVERY, AN ARCHIVE WHOSE PERIPHERAL OBJECTS BECOME VISIBLE OR AUDIBLE TO THE EXTENT THAT THEY CONFORM TO THE ARCHIVE'S OWN PROTOCOLS. Privileging analogue registration—recording as a form of measurement—over representation, the modernist archive suggests the uncovering or accumulation—rather than the collection—of traces as its most essential domain. As we saw, El Lissitzky's Demonstration Rooms too were not so much containers for abstract art as they were standardized armatures designed from the start with that art in mind. The images on the gallery walls become fully recognizable only to the extent that their environment—the archive—allows them to do so. Locking the archive into what it stores, this mechanism is circular to an extent: in the archive, we encounter things we never expected to find; yet the archive is also the condition

under which the unexpected, the sudden, the contingent can be sudden, unexpected, and contingent. Or, differently put, nothing enters the archive that is not in some sense destined to be there from the moment of its inception. Before Foucault, who tied his insight to discourse alone, largely ignoring the technical media on which it relies, no one knew this better than the Surrealists, whose chance encounters were tightly scripted yet accidental to this very extent. Contingency, this archive implies, is not the same as randomness. Chance is organized, yet its precise morphology can be detected only by accident (literally). The archive does not give access to history: it is, or aims to be, the condition of historicity itself. The archive therefore is not simply a departure, a cipher for the condition of innovation; it gives a name to the way in which the new is also a return, an iteration in the true sense of that word.

In this chapter I focus on one curator and three contemporary artists—Michael Fehr, Andrea Fraser, Susan Hiller, Sophie Calle—who have variously questioned the archive's archaeological logic by introducing error—false or fantasmatic inscriptions, purloined objects, fictitious finding tools—into its operations, revealing in the process the mechanism that allows archives to distinguish history from fiction, the authentic record from the false one, the true archival object from its apparently illegitimate counterpart. The common denominator of these procedures is the notion of play, a concept for which there seems to be little room in the nineteenth-century archive with its objectivist pathos and earnest claim to the "presence of the past" and the taming of contingency. The archive at play does not pledge allegiance to the compensatory rationality on which archives are habitually founded, and it may even become, in Irit Rogoff's words, a "construction site for fantasmatic fictions."[1] In an early paper entitled "Structure, Sign, and Play in the Discourse of the Human Sciences" (1966), Derrida proposed two ways of thinking about play. The first includes a stable center or ground that enables play but remains itself ideally exempt from its effects ("a fundamental immobility and a reassuring certitude"), while the second lacks such a stable basis and is no longer invested in either history or hermeneutics.[2] In the context of the archive, the notion of provenance—a principle that orients archival records toward a common origin, reining in the free play of differentiation—clearly corresponds to the first type of play. Crucially, Derrida links this type to a compensatory mode that manages anxiety by presuming itself to be well outside of play's reach, exempted and safe.[3] Such is the position of the historian who enters the archive to confront its fragmentary holdings as if it were testimony to the

paradoxical "presence of the past," a presence that demands interpretation from a stable vantage point—the historian's—that is both inside and outside of the archive at the very same time. (Not coincidentally, Derrida also ties archaeology—a close cousin of the nineteenth-century archive—to the first type of play, explaining that "one perhaps could say that the movement of any archaeology, like that of any eschatology... always attempts to conceive of structure on the basis of a full presence which is beyond play.")[4]

In the archive-based works I consider below, the notion of play is closely linked to our personal traffic with the archive and the (playful) subversion of some of its basic premises, including the principle of provenance. Generally speaking, our interaction with the archive is not supposed to leave any traces; protected by gloves when we handle archival records and shielded from adding to or subtracting from what is already there, we are confined to a posture of observing contemplation. The artists I discuss in this chapter tentatively abandon the archive's immunity from tampering, as they allow visitors to their archives to interact more or less freely with the holdings in ways that fundamentally affect their configuration. The basis of this interaction, I want to suggest, is a form of play that abandons what is perhaps the most fundamental assumption of the modern archive, the assumption that archives function as a kind of technological correlative of memory.

One of the more egregious instances of interference in the archive is the willful alteration of its records, acts of destruction, or the removal of records. Such is the strategy pursued by Andrea Fraser, who has visitors to the information room at the Bern Kunsthalle rummage through its documents to the point of complete disarray. Susan Hiller and Stephanie Calle follow the reverse procedure. In their work, leaving a trace in the archive is not achieved by removing or willfully destroying an item. Instead, both artists create para-archives that juxtapose the archive and its ambition to register the contingent with a set of objects for which there seems to be no assigned place in it, creating a series of supplements that question the foundations of archival hermeneutics.

In the late 1980s, the curator and art theorist Michael Fehr realized two projects focusing on the relationship between the museum and its archives, both at the Karl Osthaus Museum in the German industrial town of Hagen. Fehr was concerned with context and the way it relates to the production of archival objects; with the archive's dealings with desire; and with the boundary that runs between public and private archives. During his first exhibition, "SILENCE" (1988)—conceived

as an artistic intervention, not simply as a curatorial project—Fehr and his helpers cleared the museum of all images, so that nothing remained but the implements used to suspend the pictures—wires, hooks, and rails—from the bare walls: "The exhibition showed a museum that had been emptied out completely. In the afternoon before the opening I had removed ... everything from the showrooms that even remotely resembled an image."[5] Fehr's explicit goal was to address the Hagen museum's checkered local history, its highly eclectic collection, and the resentment and suspicion with which it was greeted by its provincial residents. Besides exposing the museum's previously invisible architectural support, Fehr also handed the museum's material shell over to the visitor, opening up a space for collective memories and speculative play.[6] Confronted with empty walls inside the once familiar space, the visitors at the opening began to reconstruct the museum's topography from memory:

> During the opening of the exhibition the visitors ... began, to the extent that they knew the building, to reconstruct the collection from memory, to talk about the works of art that I had taken away. Moreover, deprived of any decorations and of its function as a background, the architecture of the building entered the visitors' horizon and became the focus of discussions.... In the end everything became focused on the wooden railing on the balcony around the opening on the upper floor of the old building, which I had not been able to remove or hide. In this way I learned for the first time—from the visitors—that this railing was not, as I had believed, a remnant from the old interior furnishing but a reconstruction from the early 1970s when the building had been renovated and expanded.[7]

In the course of this dialogue among the visitors and between the visitors and Fehr, the museum, whose interior had been modified several times, turned from being an abstract, unified space into an assembly of discrete architectural details, many of them with their own history. No longer a closed box or a container filled with pictures, the gallery space was now replete with voices that uncovered, one by one, the layers of local history present in the building's architecture. This difference is reminiscent of Bernhard Dotzler's distinction between a museum gaze and an archival gaze. Where the museum gaze seeks to reconstruct a progressive

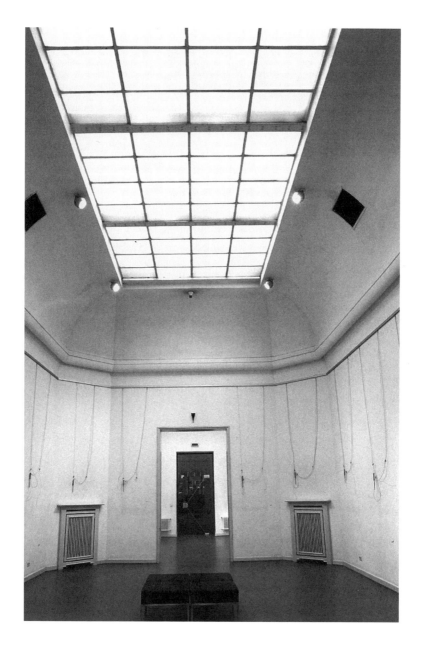

8.1
Michael Fehr, curator, "SILENCE"
(1988). Courtesy Michael Fehr.
© 2007 Artists Rights Society (ARS),
New York.

historical series, the archival gaze—inspired by Foucault—is more dispersive. Focusing on what was said or written, it contradicts "the sheen of presentable [i.e., museum] reconstruction."[8] The archive of voices in the Hagen museum fulfills a similar function; by letting their gazes stray, and by accompanying them with live speech, the visitors not only abandon the mode of numb, voiceless contemplation fostered by the traditional art museum, they also allow the archive to question the museum.

In the mid 1960s, Robert Smithson had focused his critique of the art museum on emptiness and the loss of experience: "The museum undermines one's confidence in sense data and erodes the impression of textures upon which our sensations exist."[9] In terms that closely resemble today's debate, Smithson argued, "now there's a tendency to try to liven things up in the museums, and ... the whole idea of the museum seems to be tending more toward a kind of specialized entertainment. It's taking on more and more the aspects of a discothéque [sic] and less and less the aspects of art."[10] However, far from deploring the museum's increasing "nullity" and inefficacy as an instrument of concrete action, Smithson welcomed this development. The more museums demonstrate their own inefficacy and irrelevance for the representation of history, he reasoned, the more they direct our attention to the empty spaces that are their true structuring element: not the objects, in other words, but the gap that separates one element from another, and not representation but empty surfaces. In Smithson's reading, which is influenced by film, the void serves as the index of the museum's potential as a space where the spectacular representation of history is finally abandoned in favor of a taxonomy of emptiness: "So, I think the best thing you can say about museums is that they really are nullifying in regard to action, and I think that this is one of their major virtues ... I'm interested for the most part in what's not happening, that area between events which could be called the gap. This gap exists in the blank or void regions or settings that we never look at. A museum devoted to different kinds of emptiness could be developed."[11]

At first glance, Fehr's Hagen projects seem to enact what Smithson suggests; by clearing the museum of its contents, and by focusing the visitors' attention on absence and gap, he intensifies the museum's nullity to a maximum. However, in Fehr's reading, Smithson's belief that a museum can be turned from a place into a nonplace, ideally an empty site where nothingness itself can be experienced optically—and hence a site in which vision can ideally see itself see—turns out to be difficult to achieve. Already during "SILENCE," the gallery visitors had reconstructed

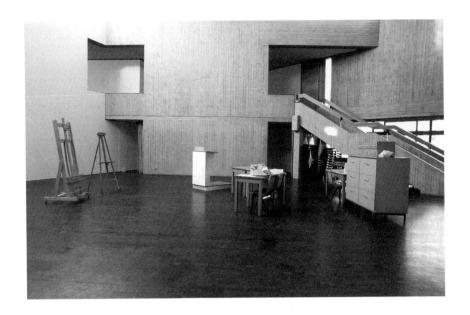

8.2
Michael Fehr, curator, "REVISION"
(1988), view at opening. Courtesy
Michael Fehr. © 2007 Artists Rights
Society (ARS), New York.

from memory what they did not see on the walls, tentatively restoring the museum's contents to its empty architectural shell. In Fehr's second Hagen exhibition, "REVISION" (1988), this effect became the very focus of the installation. Fehr installed his office desk together with filing cabinets containing the museum's inventory lists in the still-empty museum. He then sent an assistant to the store-rooms to fetch a painting of the assistant's choice. The assistant returned with a painting by Christian Rohlfs (*Pine Forest*, 1937) that the Nazis had declared *entartet* (degenerate) and which the Hagen museum had bought back in the early 1980s. He placed it on an easel at the center of the exhibition room. Then, Fehr found the painting's inventory number on one of the lists and hung it on the wall. The painting's position on the wall was determined first by its inventory number and second by an ideal horizontal line that Fehr had drawn on the walls of the museum. After they had completed their task, Fehr and his assistant repeated

the same procedure for about 1,000 of the other images owned by the museum, roughly one-third of the entire collection, beginning with #1 at the beginning of the ideal line. The overwhelming majority of these images had not been shown in the museum on a regular basis.[12] In the end, much of the museum's collection was hanging on the walls of its galleries, in a strict chronological order that chronicled the museum's history from the day of its reopening in October 1945 to the present day.

Once again, Fehr was mostly interested in the public's reaction. Confronted now not with an empty museum but on the contrary with entropic overload, the visitors reacted, as before, by restoring to the walls in front of them the collection they were used to seeing. As Fehr interpreted their response: "To the extent ... that it became evident that the visitors ... gravitated mainly, and not only out of laziness, toward those works that had been shown in the permanent exhibition anyway, it became evident that the often-heard reproach that museums hide their true treasures in the magazine, showing only whatever pleases their directors, is nothing but the expression of a general fear that something important might be forgotten."[13] If the objective of "REVISION" was to lift into visibility the archive behind the museum—all those works in storage that had never been shown in the galleries—the experiment failed. Because the visitors had been exposed to the museum collection for a long time, it was this collection, and not the larger invisible archive of which it formed a part, that determined their reaction. As it turned out, the archive behind the museum was not subject to easy desublimation. While it delimits in a general way the horizon of our perceptions, the general archive—say, a museum's storage of what is not shown in the galleries—cannot simply substitute for the idiosyncratic and selective archive of mental signs that formats our traffic with images. What an archive "is" cannot therefore always be decided in the abstract. For to "see the archive" would mean nothing less than to observe ourselves seeing.

Fehr's experiments demonstrate that the substitution of the archive for the museum—the revelation of the archive behind the museum—is not an easy task; "silence" and "emptiness" are not easily obtained. Ten years after Fehr, Andrea Fraser mounted an installation at the Bern Kunsthalle called *Information Room* (1998) in which she similarly implied that archives are not simply instruments for desublimation, and that our interaction with the archive is more than an afterthought to the administration of information. In Fraser's installation, it was not emptiness that came to the fore but its opposite, clutter and disorder. She

installed the usually inaccessible archives of the Bern Kunsthalle in the institution's new information room. Like Fehr, Fraser played with the archive behind the museum, with its visibility or invisibility, and with the way they relate to each other. Her project began with boxes filled with the Kunsthalle's entire archive of paperwork that were placed on wooden pallets in the middle of the gallery floor. Museum visitors began to rummage through these boxes, taking out material and reading it at a nearby table. This soon resulted in chaos, which was precisely the effect Fraser had hoped for: "After a few weeks it really became a very big mess. It was great. Apparently, people spent quite a bit of time looking through the material there."[14] Fraser's project, which was fully realized only after considerable delay because of internal debates at the Kunsthalle, called for the archive materials to be moved from the boxes to the shelves that lined the information room:

> The program I developed for the information room included installing the entire archive and the entire library in the gallery along with as many of the posters as would fit on the walls. The trick was that all the books and archive boxes were to be installed with their spines to the wall, so that while visitors would have access to the material, they would not be able to pre-select what they pulled from the shelves.... I wanted to make a Cageian information room where all information would be available but access to it would be rendered arbitrary, accidental.[15]

8.3
Andrea Fraser, *Information Room*, Kunsthalle Bern (1998). Courtesy Andrea Fraser.

If the public's interaction with the Kunsthalle's archive successfully turned mere data into information, this transformation had to contend with a concomitant tendency toward entropy and chaos. The fact that it was not possible to scan a folder's contents *before* choosing a document suggests that, despite the archive's claims to rationality and order, information is ultimately random. *Information Room* implies that the shape of information is a result and consequence of the often random ways in which we access it. The relationship between what we see in a museum or gallery and its archive is never one of simple symmetry, and to substitute the archive for the museum is not the same as making it transparent or even visible.[16] Where in Fehr's case the ambition to place the general archive on view had to contend with the particular archives that formed the horizon of its perception, in Fraser's case, it is the threat of entropy that prevents the archive from becoming transparent. There is always a blind spot in our interaction with archives, and it is precisely this blind spot to which the archive at play devotes itself.

8.4
Andrea Fraser, *Information Room*,
Kunsthalle Bern (1998). Courtesy
Andrea Fraser.

**THE BIG ARCHIVE**

In her installation *From the Freud Museum* (1994) at Freud's home in exile in London, Susan Hiller also placed our traffic with the archive at the center of her intervention, adding to it a concern with "unsuitable" archival objects. As part of her installation, Hiller mixed objects from Freud's own collection (things from his archives, his magic lantern slides, etc.) with others collected and indexed by the artist herself.[17] As Hiller writes, "a major factor in all the work I've ever made, it seems to me, is the designation of spaces where viewers and readers can experience their own roles as active participants—collaborators, interpreters, or detectives. Not editing out and forcing strange juxtapositions or unanswered questions to conform to theory is an aspect of my style."[18] As an archive at play, *From the Freud Museum* focuses not on objects but on contexts or, to be more precise, on the process of producing such contexts:

> Taken as a whole, the Freud Museum strikes me as the site of a provocatively poetic accumulation of contexts. Close consideration of its beautiful, utilitarian, tedious, scholarly, macabre, rare, banal, eerie, and sentimental objects produces a picture in which figure-ground relationships seem to constantly shift. Whatever might be said to be the "collection" on display at the Freud Museum is complicated by an overlay of settings where historical, biographical, archaeological, familial, personal, ethnographic and psychoanalytic facts merge to produce representations whose meanings are always in flux.[19]

The archive effect, in Hiller's reading, is one of radical dispersion, a persistent oscillation between different frames of reference (historical/mythical; factual/fictional; subjective/scientific; orderly/chaotic), between organization and entropy.[20] As Denise Robinson has described the project: "Between the first entry and the last—in *From the Freud Museum* and its recording in the book *After the Freud Museum*—is an archive so diffuse that the places from which the fragments of texts, objects and forms come, the kinds of materials and modes of recordings, and the time of their 'burial' and recovery, approach a new threshold."[21] Unlike photomontage where they are largely determined by the design of the artist, the relational patterns, linkages, and overlaps that occur between the different objects in Hiller's installation—all of which seem to her to "carry an aura of memory and

to hint at meaning something"—result from her emotional and cognitive inter-action with them, her (and the viewers') readiness to supply them with a story. In that sense, Hiller's project returns us to what Foucault would refer to as the pre-classical age, an age of magic and proliferating similarities during which archival signs were part and parcel of the objects they named, and an age in which there was no clear distinction between fiction and documentation, between observation and fabulation.[22]

8.5
Susan Hiller, *From the Freud Museum*
(1994). © Tate, London, 2007.

Hiller does not assume that what she collects has never been archivized. On the contrary, she is interested primarily in what has been collected before, indexed, labeled, and described, and in the procedures used to produce such objects. Section 001 of *From the Freud Museum* deals with the name *Nama-ma/mother* and shows pigments used by Papunya artists Hiller visited in 1985. In the text that follows the images (an exhibit in itself, though also linked to the images through its contiguity with them), Hiller explains how such pigments are "usually grouped and classified as 'native earths.'" She then proceeds in an entirely different manner, breaking up the traditional taxonomy and creating her own, homespun version: "Back in London, I ground each chunk by hand and put samples into individual Perspex cosmetic jars. The colours are: yellow ochre,

**THE BIG ARCHIVE**

umber, iron oxide red (dark), iron oxide red (medium), iron oxide red (pale) and white."[23] Thus, rather than simply recontextualizing scientific or anthropological objects that already exist in the archive, Hiller reveals—and playfully alters—the mechanisms that created such objects in the first place. By her own admission, she grapples with "how to show what's out of sight or invisible" and calls this "the dilemma of most contemporary art and all museums."[24]

8.6
Susan Hiller, *001 Nama-ma/mother,*
detail of *From the Freud Museum*
(1994). © Tate, London, 2007.

In another, more recent intervention at the London Freud Museum, *Appointment* (1999), Sophie Calle also engaged "superfluous" things that are redundant from the point of view of the established archive and its legitimizing rules. By placing her own personal belongings and narratives—among them a wedding dress, a wig, letters from a lover, a wedding photograph, a plate with dessert, and pink cards with printed text on them—throughout Freud's house, Calle, like Hiller, questioned the material and symbolic coherence of Freud's museum and archive at 20 Maresfield Gardens. In bringing her objects and stories to Freud's house, Calle reopened what appeared to be a complete collection, underwritten once and for all by Freud's irreversible absence. In English, the word "appointment" may refer to an act of consignment, and consignment is precisely what the artist practiced when she deposited her personal things in the Freud Museum, making it difficult for us to decide which objects are hers and which are Freud's. However, the point to this act of consignment is perhaps less this confusion than the way in which it reflects on psychoanalysis and *its* archive. Draping her wedding dress over Freud's couch as if it were the abandoned skin of one of Freud's female patients, Calle seems to enlist herself as one of them ex post facto. A nearby text printed on a pink card reads:

> I had always admired him. Silently, since I was child.
> On 8 November—I was 30 years old—he allowed me to pay
> him a visit. He lived several hundred kilometers from Paris.
> I had brought a wedding dress in my bag, white silk with a
> short train. I wore it on our first night together.[25]

"He" in this instance is not Freud, though the nature of Calle's caption—if that is how we choose to configure the relationship between this printed text and the dress—seems to hint that the man who lived "several hundred kilometers from Paris" might be Freud himself, and that the fulfillment of Calle's desire came with the gesture of placing her wedding dress on his couch.[26] In this case, Calle's appointment with Freud at his house would be less than sensational or extraordinary; it would be a return, rather than a first visit. This indeed is the impression Calle evokes throughout the installation. When she dons Freud's coat, one of the most revered relics on display at the museum, and even opens the door to would-be visitors, the artist installs herself at 20 Maresfield Gardens as if she were both

the museum's guardian and its long-departed master. Even more scandalous than the obvious act of appropriation—the (female) artist's symbolic usurpation of the master's regalia by wearing Freud's coat—is the way this usurpation touches on the presumed sanctity of Freud's archive. Does Calle's transfer of her personal objects into the Freud Museum taint or compromise that archive's purity by introducing things that blatantly do not belong there? The question may be inserted into a broader debate, the controversy over whether Freud's archive—specifically the Sigmund Freud Collection in Washington, D.C.—faithfully reflects the principles of the nineteenth-century archive, with its emphasis on objectified accumulation and objectifying interpretation. In his plea for the opening of those parts of Freud's archive that will remain closed for decades to come (the so-called *Series Z*), Yosef H. Yerushalmi has argued that it most definitely does not. As he reasons, "the Freud Archives ... were created by Anna Freud, Freud's devoted daughter, and Dr. Kurt Eissler, surely the most zealous guardian of his reputation, for the ... express purpose of preserving Freud's legacy and memory for future generations."[27] Because of this goal, Yerushalmi asserts, the Freud archive is not "naïve" in the way nineteenth-century archives were presumed to be.[28]

What I want to suggest is that Calle's donning of Freud's coat and her gestures of consignment inside the Freud Museum pursue a similar argument, alluding to the possibility that interventions in Freud's archive are less exceptional intrusions than an integral part of its very foundation. Even more important is a second point. *Appointment*, it may be argued, underscores the fact that such intrusiveness and impurity can be seen as characteristics of psychoanalysis in a more technical sense too. For Calle's project may be read as a material realization—and literalization—of a concept central to psychoanalytic practice from the very beginning, *Übertragung* (carrying over), or "transference." Freud first used the term in *Studies on Hysteria*, where it implies a shift onto the psychoanalyst of desires and feelings connected to persons to whom the patient felt particularly close in the past. He maintained that for patients who trust their analyst it is "almost inevitable that their personal relation to him will force itself, at least for a time, unduly into the foreground," and regarded such a transfer as crucial for the success of his treatment.[29] In a literal sense, Calle practices *Übertragung* when she takes ("carries over") her personal belongings to Freud's house. In a clinical sense, too, instances of *Übertragung* appear in many of the stories Calle relates on the printed pink cards, stories that focus on her relationship with men and her

8.7
Sophie Calle, *Appointment* (1999).
Courtesy James Putnam and Sophie
Calle. © Artists Rights Society (ARS),
New York / ADAGP, Paris.

8.8
Sophie Calle, *Appointment* (1999).
Courtesy James Putnam and Sophie
Calle. © Artists Rights Society (ARS),
New York / ADAGP, Paris.

8.9
Sophie Calle, *Appointment* (1999).
Courtesy James Putnam and Sophie
Calle. © Artists Rights Society (ARS),
New York / ADAGP, Paris.

family. For instance, like Freud's patient Dora, Calle was taken by her father to see a psychoanalyst:

> I was thirty, and my father thought I had bad breath.
> He made an appointment for me with a doctor, whom [sic] he
> assumed was a general practitioner. However, when I arrived
> at his office, I immediately realized that he was a
> psycho-analyst. Given the hostility my father always
> expressed towards this profession, I was surprised. "There
> must be some mistake," I said. "My father is convinced I have
> bad breath and he sent me to a GP." The man replied:
> "Do you always do what your father tells you to do?" And so I
> became his patient.[30]

The most striking difference between Calle's stories and Freud's case histories is that Calle allows herself to speak in the first person, in effect giving a voice to those of Freud's patients who speak to us only through his archive. By dispensing with the agency and authority of the (male) analyst who takes charge both of his patients' symptoms and of the methodical steps that led to their discovery, Calle playfully takes charge of Freud's discourse network. That she does so by depositing her belongings in an archive in which they do not belong—Freud's house—is fully in keeping with this strategy.

The fact that Calle's consignment of her archive to Freud's results in a series of more or less awkward juxtapositions—Calle's objects next to Freud's—further underscores the proximity of her project to Freud's understanding of transference. Freud famously explained the mechanism of *Übertragung* as a form of *mésalliance*, an unworkable alliance or relationship between incompatible positions or standpoints. According to Freud, as an unconscious wish from the past arises "in the patient's consciousness without any memories of the surrounding circumstances which would have assigned it to a past time,"[31] this wish is transferred onto the analyst, creating a situation paralleling the one from the patient's past that led to the wish's banishment from consciousness: "As the result of this *mésalliance*— which I describe as a 'false connection'—the same affect was provoked which had forced the patient long before to repudiate this forbidden wish. Since I have

discovered this, I have been able, whenever I have been similarly involved personally, to presume that a transference and a false connection have once more taken place."[32] Freud views misplacement and *mésalliance*—the patient's consignment of a repressed wish to the wrong archive (the analyst's) during transference—not as a calamitous accident but as a crucial prerequisite for the success of his talking cure. Calle's transfer of her wig, cards, dress, pictures, and other items to Freud's house and their placement next to Freud's own objects suggests, brilliantly, that missed connections and erroneous consignments do not simply affect psychoanalysis from without, but that they are, in a sense, the very condition of its successful functioning.

With regard to the archive more generally, Calle—in the spirit of Duchamp and early Surrealism—challenges the nineteenth century's obsession with the registration of time, differentiation, and progress (no object in an archive may be like any other; taken together they represent a temporal series of elements that is ideally opened to the future). When Calle brings her own items to the Freud archive in London, dons Freud's coat for a photograph, and reenacts the case histories of one or several of his female patients, she hints at an archive built not on linear time (progress, innovation) but rather on return and repetition. As we saw, that idea also underlies Freud's own idea of the psychical apparatus as an archive—an archive based not on time or narrative (the unconscious is timeless) but instead on resistance and repetition.

9.1
Thomas Demand, *Archive* (1995).
Cibachrome print, mounted on
Sintra and laminated to Plexiglas,
72³/₈ x 93¹¹/₁₆ in. Courtesy Solomon
R. Guggenheim Museum, New York.
Purchased with funds contributed by
the Young Collector's Council, 1997.
97.4576 © 2007 Artists Rights Society
(ARS), New York.

# EPILOGUE

$\llcorner$

**Thomas Demand**

The archive in Thomas Demand's *Archive* (1995) is empty, stripped of its contents and its ability to reflect another place or time. It is as if Demand wanted to produce a photograph that escapes from its archive. No longer a storehouse of traces, the image shows a wall filled with empty boxes of identical size. Some of the boxes are stacked up on the floor, some of them have been opened. A steely-looking ladder describing a diagonal to the wall leads upward, cut in half by the image's edge. In this archive—whose model interior was built by Demand himself—the only thing that is left is a set of archival hardware that has lost its signatures, its contents, and its ability to authenticate past time. As no finding tools help us distinguish one box from another, we are literally blinded. Demand's archive denies us the indexicality to which archives and photographs lay claim, presenting us instead with an index of its absence. Not an archive of clues, of footprints, or of fingerprints, only organized clutter. Not the past, only phantoms of empty boxes.

# Notes

---

## SIXTEEN ROPES

1 On possible links between the archive and cybernetics, see G. T. Guilbaud, *What Is Cybernetics?* (New York: Criterion Books, 1995), 6.

2 Norbert Wiener, "Homeostasis in the Individual and Society," in *Selected Papers of Norbert Wiener: Including Generalized Harmonic Analysis and Tauberian Theorems* (Cambridge: MIT Press, 1964), 23.

3 In another installation, *The Big Archive,* Kabakov does feed audio voices into the installation, but they are unintelligible.

4 See Alexander Rappaport, "The Ropes of Ilya Kabakov: An Experiment in Interpretation of a Conceptual Installation," in Alla Efimova and Lev Manovich, eds., *Tekstura: Russian Essays on Visual Culture* (Chicago: University of Chicago Press, 1993), 175.

5 Gerhart Enders, *Archivverwaltungslehre* (Berlin: VEB Deutscher Verlag der Wissenschaften, 1967), 17.

6 In *Against Architecture,* Denis Hollier argues that Georges Bataille's efforts as a writer were directed against precisely this type of waste disposal. For Bataille, Hollier reasons, "philosophy's special domain is the trash cans of science. Philosophers, science's garbage men, eliminate or recuperate its refuse, reducing it to nothing or boiling it down to sameness." Denis Hollier, *Against Architecture: The Writings of Georges Bataille* (Cambridge: MIT Press, 1989), 88. The archive I invoke in this book is in the same business of disposing of what falls between its system's cracks. Kabakov's installation dramatizes this recuperative activity—and its utter failure.

---

## 1 INTRODUCTION

1 Allan Sekula, "The Body and the Archive," *October* 39 (1986), 58.

2 The term archive is derived from the Greek *arkhē* (beginning or origin) and *arkheion* (a house or domicile, the home of the guardians of official documents), implying a reference both to a beginning or origin and to the specific place or location where archival documents are kept.

3 Sigmund Freud, "The 'Uncanny,'" in *The Standard Edition of the Complete Psychological Works of Sigmund Freud,* ed. James Strachey, vol. 17 (London: Hogarth Press and the Institute of Psycho-Analysis, 1955), 220. This edition will be referred to subsequently as *SE.*

4 Yosef Hayim Yerushalmi, "Series Z: An Archival Fantasy," http://www.psychomedia.it/jep/number3-4/yerushalmi.htm.

5 Walter Benjamin, "Unpacking My Library," in Benjamin, *Illuminations* (New York: Schocken, 1969), 61.

6 François Lyotard, "Domus and the Megalopolis," in Lyotard, *The Inhuman: Reflections on Time* (Stanford: Stanford University Press, 1991), 193, 192.

7 Ibid., 194.

8 For an attempt to grapple with this situation, see Charles Merewether's *The Archive,* a comprehensive compilation of essays and statements that sheds light on the crowded intersection of archivization and art. In his introduction, Merewether argues that "it is in the spheres of art and cultural production that some of the most searching questions have been asked concerning what constitutes an archive and what authority it holds in relation to its subject." Charles Merewether, ed., *The Archive* (London: Whitechapel; Cambridge: MIT Press, 2006), 10.

9 Nor is an interest in archives confined to art in Western Europe or the United States. I came to the topic through my interest in contemporary art in formerly Communist Eastern and Central Europe, a region

where everyone to varying degrees lived in the shadow of the archive and where the question of archives and their relationship with art was, and still is, anything but academic. Perhaps the most memorable reminder of this is Kabakov's *The Big Archive* (1993), which lent this book its name. Entering the installation and reading the handwritten messages and forms that are posted all over its drab dividing walls, the visitor soon realizes that he or she is in fact part of the archive's inventory. A kind of triage classifies all visitors: "Near the entrance to each booth [into which Kabakov's archive is divided] there is an inscription as to what 'type' of visitor it is intended for: 'sick people,' 'those dissatisfied with their living conditions,' 'those devising plans,' those who 'reside permanently in the country,' those who 'have been in prison.' Each person must own up to something, respond to something, sign up for something." Ilya Kabakov quoted in Amei Wallach, *Ilya Kabakov: The Man Who Never Threw Anything Away* (New York: Harry N. Abrams, 1996), 209. The forms on the archive's desks invite spectators to confirm through their signature that they are ready to accept the position the archive has reserved for them. As an archive, *The Big Archive* comes into being precisely at that point—familiar to anyone who has lived in the Soviet Union and other countries of the former eastern bloc—at which we realize that any perspective on that archive from an exterior vantage point is impossible.

10  James R. Beniger, *The Control Revolution: Technological and Economic Origins of the Information Society* (Cambridge: Harvard University Press, 1986), 37.

11  See also Cornelia Vismann, *Akten: Medientechnik und Recht* (Frankfurt: Fischer, 2000), 274.

12  On the difference between archives and libraries, see T. R. Schellenberg, *Modern Archives: Principles and Techniques* (Chicago: University of Chicago Press, 1956), 22–23.

13  "To be archives, materials must be preserved for reasons other than those for which they were created or accumulated." Ibid., 13.

14  Leopold von Ranke, *Englische Geschichte vornehmlich im siebzehnten Jahrhundert,* in Ranke, *Sämmtliche Werke,* vol. 14 (Leipzig: Duncker und Humblot, 1870), 103.

15  Rosalind E. Krauss, "The Master's Bedroom," *Representations* 28 (1989), 56.

16  Michel Foucault, *The Birth of the Clinic: An Archaeology of Medical Perception,* trans. A. M. Sheridan Smith (New York: Pantheon Books, 1973), 65.

17  "Because what is projected here is a visual field that is not a latency, an ever renewed upsurge of the pure potentiality of the external, but instead a field that is already filled, already—to say the word—readymade." Krauss, "The Master's Bedroom," 65.

18  Walter Benjamin, "Bekränzter Eingang: Zur Ausstellung 'Gesunde Nerven' im Gesundheitshaus Kreuzberg," in Benjamin, *Gesammelte Schriften,* vol. IV.1, 2 (Frankfurt: Suhrkamp, 1980), 556. Translation mine.

19  Similarly, many of Hans Arp's early wooden reliefs abandon altogether the idea of a base.

20 "The revealing that rules throughout modern technology has the character of a setting-upon, in the sense of a challenging-forth. That challenging happens in that the energy concealed in nature is unlocked, what is unlocked is transformed, what is transformed is stored up, what is stored up is, in turn, distributed, and what is distributed is switched about ever anew. Unlocking, transforming, storing, distributing, and switching about are ways of revealing." Martin Heidegger, *The Question Concerning Technology, and Other Essays,* trans. William Lovitt (New York: Garland, 1977), 16. For a recent commentary on Heidegger's concept of *Entbergen,* see Peter Sloterdijk, *Nicht gerettet: Versuche nach Heidegger* (Frankfurt: Suhrkamp, 2001), 287.

21  For an example of such abbreviations as they were used in the organization of office files during the 1920s, see Vismann, *Akten,* 296–297.

22 In her study of contingent time and cinema, Mary Ann Doane contends that "the cinema has worked to confirm the legibility of the contingent." Mary Ann Doane, *The Emergence of Cinematic Time: Modernity, Contingency, the Archive* (Cambridge: Harvard University Press, 2002), 208.

23 Dorothea Dietrich, untitled, in Leah Dickerman, ed., *Dada,* exh. cat. (Washington: National Gallery of Art, 2006), 163.

24 Peter Bürger, *Theory of the Avant-Garde* (Minneapolis: University of Minnesota Press, 1984), 75.

25 "The analysis of the archive, then, involves a privileged region: at once close to us, and different from our present existence, it is the border of time that surrounds our presence, which overhangs it, and which indicates it in its otherness; it is that which, outside of ourselves, delimits us." Michel Foucault, *The Archaeology of Knowledge and The Discourse on Language* (New York: Pantheon Books, 1972), 130.

26 Michel Foucault, *The Order of Things: An Archaeology of the Human Sciences* (New York: Vintage Books, 1973), 297.

27 Ibid., 304.

28 *The Writings of Robert Smithson: Essays with Illustrations,* ed. Nancy Holt (New York: NYU Press, 1979), 287.

———

## 2 1881: MATTERS OF PROVENANCE (PICKING UP AFTER HEGEL)

1 An early predecessor was the *classement par fonds* introduced by the French Ministry of the Interior in 1841. It stipulated that documents were to be classified according to the agencies in which they originated. The French term *fonds* originally referred to a plot of land.

2 Johannes Schultze, "Gedanken zum Provenienzgrundsatze," in Hans Beschorner, ed., *Archivstudien: Zum siebzigsten Geburtstage von Woldemar Lippert* (Dresden: Verlag der Buchdruckerei der Wilhelm und Bertha v. Baensch Stiftung, 1931), 225. On the principle of provenance as a model for the generation and preservation of modern culture, see also Sven Spieker, ed., *Leidenschaften der Bürokratie: Kultur- und Mediengeschichte im Archiv* (Berlin: Kadmos, 2004).

3 T. R. Schellenberg, *The Management of Archives* (New York: Columbia University Press, 1965), 93.

4 John Howard Hodson, *The Administration of Archives* (Oxford: Pergamon Press, 1972), 4.

5 Walter Benjamin, "Excavation and Memory," in Benjamin, *Selected Writings,* vol. 2 (Cambridge: Belknap Press of Harvard University Press, 1999), 576. A better translation of *wahrhaft* might be "truthful."

6 Kant considered the idea that "everything that exists is some place and some time [*Alles was ist, ist irgendwo und irgendwann*]" to be a "false axiom [*ein erschlichenes Axiom*]." Immanuel Kant, "De mundi sensibilis atque intelligibilis forma et principiis" ("Von der Form der Sinnen- und Verstandeswelt und ihren Gründen"), in Kant, *Schriften zur Metaphysik und Logik I, Werkausgabe,* vol. 5 (Frankfurt: Suhrkamp, 1977), 91.

7 On the relevance of the present for Benjamin's concept of remembering, see also T. J. Demos, *The Exiles of Marcel Duchamp* (Cambridge: MIT Press, 2007), 226–228, 41.

8 Rudolf Virchow, "Atome und Individuen," in Virchow, *Drei Reden über Leben und Kranksein* (Munich: Kindler, 1971), 50. Translation mine.

9 Rudolf Virchow, "Die naturwissenschaftliche Methode und die Standpunkte in der Therapie," in Virchow, *Sämtliche Werke,* vol. 4 (Frankfurt: Lang, 1992), 336. Translation mine. See also Sven Spieker "*Cellularbürokratie:* Pathologie als Ordnungswissenschaft, am Beispiel Rudolf Virchow," in Christoph Hoffmann and Caroline Welsh, eds., *Umwege des Lesens: Aus dem Labor philologischer Neugierde* (Berlin: Parerga, 2006), 276–290.

10 S. Muller, J. A. Feith, and R. Fruin, *Manual for the Arrangement and Description of Archives: Drawn Up by Direction of the Netherlands Association of Archivists* (New York: H. W. Wilson, 1968), 19.

11 Adolf Brenneke, *Archivkunde* (Leipzig: Koehler und Amelang, 1953), 22.

12  Friedrich Meinecke, *Erlebtes, 1862–1901* (Leipzig: Koehler und Amelang, 1941), 142–143.

13  Brenneke, *Archivkunde,* 70.

14  Already in the eighteenth century, a great number of administrative agencies had their own *Registraturen.* In 1769 a Prussian minister referred to a properly organized *Registratur* as the "soul of the department." Cited in Ernst Posner, *Archives and the Public Interest: Selected Essays* (Washington: Public Affairs Press, 1967), 89.

15  In a letter to Fliess, Freud argued that the "psychic mechanism" is the result of memory traces being rearranged (retranscribed) as new traces are added. Freud calls these rearrangements "registrations," distinguishing between three different types: consciousness, unconsciousness, and preconsciousness. See *The Complete Letters of Sigmund Freud to Wilhelm Fliess, 1887–1904,* ed. Jeffrey M. Masson (Cambridge: Belknap Press of Harvard University Press, 1985), 207–208.

16  Georg Winter, "Das Provenienzprinzip in den preussischen Staatsarchiven," *Revista de la biblioteca, archivo y museo* 38 (1933), 186. On the relationship between registry and archivist from a British perspective, see A. Jenkinson, *Manual of Archive Administration* (London: Percy Lund, 1965), 189–190.

17  Michel Foucault, *The Archaeology of Knowledge and The Discourse on Language,* trans. A. M. Sheridan Smith (New York: Pantheon Books, 1972), 128–131.

18  Arlette Farge, *Le goût de l'archive* (Paris: Seuil, 1989), 14. Translation mine.

19  On the archival trace as accident, Arjun Appadurai writes that "the central property of the archive in this humanist vision is to be found in the ideology of the 'trace.'... This property is the product of contingency, indeed of accident, and not of any sort of design. The archive is fundamentally built on accidents that produce traces. All design, all agency and all intentionalities come from the uses we make of archives, not from the archive itself." Arjun Appadurai, "Archive and Aspiration," in Joke Brouwer and Arjen Mulder, eds., *Information Is Alive: Art and Theory on Archiving and Retrieving Data* (Rotterdam: V2 Publishing/nai Publishers, 2003), 15.

20  Philipp Ernst Spiesz, *Archivische Nebenarbeiten und Nachrichten vermischten Inhalts mit Urkunden* (Halle: Johann Jacob Gebauer, 1783), 2.

21  Posner, *Archives and the Public Interest,* 95–96. Posner's remark refers to registries in Germany.

22  On such post-Hegelian waste disposal, see Friedrich Kittler, *Eine Kulturgeschichte der Kulturwissenschaft* (Munich: Fink, 2000), 132.

23  Philip Rosen, *Change Mummified: Cinema, Historicity, Theory* (Minneapolis: University of Minnesota Press, 2001), 133.

24  Posner, *Archives and the Public Interest,* 92.

25  T. R. Schellenberg, *Modern Archives: Principles and Techniques* (Chicago: University of Chicago Press, 1956), 13.

26  For a definition of *Akten,* see also Eckhart Franz, *Einführung in die Archivkunde* (Darmstadt: Wissenschaftliche Buchgemeinschaft, 1974), 45–49.

27  The emergence of *Akten* is tied to the transition from orality to literacy in matters of administration, and to the increasing use of paper instead of parchment. For a cultural history of files, see Cornelia Vismann, *Akten: Medientechnik und Recht* (Frankfurt: Fischer, 2000).

28  Leopold von Ranke, "Vorrede zur ersten Ausgabe," in Ranke, *Preussische Geschichte, Werke,* vol. 5 (Lübeck: Vollmer, 1957), 48. Translation mine. Another word for *Akte* is *Vorgang,* which suggests a temporal flow or process.

29  Siegfried Kracauer, "Photography," in Kracauer, *The Mass Ornament: Weimar Essays,* trans. and ed. Thomas Y. Levin (Cambridge: Harvard University Press, 1995), 49.

30  Johann Gustav Droysen, *Historik: Vorlesungen über Enzyklopädie und Methodologie der Geschichte* (Munich: R. Oldenburg, 1937), 47. Translation mine.

31 "To be archives, materials must be preserved for reasons other than those for which they were created or accumulated." Schellenberg, *Modern Archives,* 13. As Yosef H. Yerushalmi has observed, "ideally an archive should be naïve…. Copies of contracts and deeds of property were preserved in archives in case any future disputes should arise, not so that we might write economic history." Yosef Hayim Yerushalmi, "Series Z: An Archival Fantasy," http://www.psychomedia.it/jep/number3-4/yerushalmi.htm.

32 Mary Ann Doane, *The Emergence of Cinematic Time: Modernity, Contingency, the Archive* (Cambridge: Harvard University Press, 2002), 82.

33 Rosen, *Change Mummified,* 115.

34 Droysen, *Historik,* 47.

35 Quoted in Friedrich Jäger and Jörn Rüsen, *Geschichte des Historismus: Eine Einführung* (Munich: C. H. Beck, 1992), 89.

36 Ibid.

37 Walter Benjamin, "The Work of Art in the Age of Its Technological Reproducibility: Third Version," in Benjamin, *Selected Writings,* vol. 4 (Cambridge: Belknap Press of Harvard University Press, 1996), 254.

38 Ibid., 266.

39 Wolfgang Ernst, *Das Rumoren der Archive: Ordnung aus Unordnung* (Berlin: Merve, 2002), 49.

40 Wilhelm Wundt, *Grundriss der Psychologie,* 8th ed. (Leipzig: Engelmann, 1907), 184–185. All translations from this text are mine.

41 Ibid., 172–173.

42 See Darren Wershler-Henry, *The Iron Whim: A Fragmented History of Typewriting* (Toronto: McLelland & Stewart, 2005), 145.

43 Frank B. Gilbreth, *Motion Study: A Method for Increasing the Efficiency of the Workman* (Easton, Pa.: Hive, 1972), 6–7.

44 The story of Simonides, the ancient inventor of mnemotechnics, also begins with a fall.

45 Jorge Luis Borges, "Funes el memorioso," in Borges, *Prosa completa,* vol. 1 (Barcelona: Bruguera, 1980), 484. All translations from this text are mine. Funes's problem is not remembering—he recalls everything effortlessly—but the far more complicated dilemma of how *not* to remember. To limit the scope of his memory he tries to restrict himself to seventy thousand memories a day, but he soon realizes that such an undertaking would be futile.

46 "In effect, Funes not only remembers every leaf of every tree of every forest but also every single time he had perceived or imagined it." Ibid., 482.

47 Ibid., 483.

48 Ernst Mach, *The Analysis of Sensations and the Relation of the Physical to the Psychical,* trans. C. M. Williams (New York: Dover, 1959), 2.

49 Rainer Maria Rilke, *The Notebooks of Malte Laurids Brigge* (New York: Norton, 1949), 14.

50 Clearly, it is the phonograph that inflects the quoted scene. Malte receives the noises from outside like so many discrete signals reaching the surface of a phonographic plate, regardless of their meaning or coherence. Despite all this, remnants of a coherent ego do of course persist in the quoted passage, as the listener does identify the provenance of the sounds he hears.

51 See also Kittler's remark that "the montage of its senseless accumulation of fact made psychophysics into the mental disturbance it was investigating." Friedrich Kittler, *Discourse Networks 1800/1900* (Stanford: Stanford University Press, 1990), 310.

52 Friedrich Nietzsche, "On the Utility and Liability of History for Life," in Nietzsche, *Unfashionable Observations* (Stanford: Stanford University Press, 1994), 116.

53 Ibid., 87.

54 Friedrich Nietzsche, *Daybreak: Thoughts on the Prejudices of Morality,* trans. R. J. Hollingdale (Cambridge: Cambridge University Press, 1982), 286.

55 Hermann von Helmholtz, *Rede zum Geburtstage des höchstseligen Grossherzogs Karl Friedrich von Baden und zur akademischen Preisvertheilung am 22. November 1862* (Heidelberg: Buchdruckerei Georg Mohr, 1862), 4. Translation mine.

56 According to Wolfgang Hagen, the separation of the humanities (*Geisteswissenschaften*) from the natural sciences occurred in the 1870s, shortly before the Prussian archive reforms. Cf. Wolfgang Hagen, "Was heisst und zu welchem Ende studiert man Mediengeschichte?," www.hagen.de/vortraege/antrittsvorlesunghtm/vorlesung.htm, 8.

57 Morelli distinguished originals from copies not with reference to "the most conspicuous characteristics of a painting, which are the easiest to imitate: eyes raised towards the heavens in the figures of Perugino, Leonardo's smiles, and so on," but rather with reference to "the most trivial details that would have been influenced least by the mannerisms of the artist's school: earlobes, fingernails, shapes of fingers and of toes." With the help of this marginal information, Morelli "identified and faithfully catalogued … the shape of the ear in figures by Botticelli, Cosmé Tura, and others, traits that were present in the originals but not in copies," a procedure that helped him identify some of the most famous paintings hanging in European museums. See Carlo Ginzburg, *Clues, Myths, and the Historical Method* (Baltimore: Johns Hopkins University Press, 1989), 97.

58 Helmholtz, *Rede zum Geburtstage,* 14.

59 Ibid.

60 Gustave Flaubert, *Bouvard and Pécuchet, with the Dictionary of Received Ideas,* trans. A. J. Krailsheimer (Harmondsworth: Penguin, 1976), 121.

61 Ibid., 124.

62 Ibid., 132.

63 Ibid., 133.

64 On the archive in Flaubert's novel, see also Marco Codebò, "The Archive and the Novel: Documentation and Narrative in the Modern Age" (Ph.D. diss., University of California, Santa Barbara, 2005), 85–127.

--------

## 3 FREUD'S FILES

1 Derrida asked, "which archive? that of Sigmund Freud? that of the psychoanalytic institution or science? Where does one draw the limit? What is this new science of which the institutional and theoretical archive ought by rights to comprise the most private documents, sometimes secret?" Jacques Derrida, *Archive Fever: A Freudian Impression,* trans. Eric Prenowitz (Chicago: University of Chicago Press, 1995), 20.

2 The term used by Freud to designate the events taking place in the psyche, *psychische Akte* (psychical acts), is the same as the one used for office files (German *Akte* = file).

3 In his letter to Wilhelm Fliess of February 9, 1898, Freud writes that "the dream process is played out in a different psychic territory." *The Complete Letters of Sigmund Freud to Wilhelm Fliess, 1887–1904,* ed. Jeffrey M. Masson (Cambridge: Belknap Press of Harvard University Press, 1985), 299.

4 Heinrich Hertz, *The Principles of Mechanics Presented in a New Form* (New York: Dover Publications, 1956), 12.

5 Hertz subsequently argues that a new law must be found that can encompass all types of motions, those that appear in nature and those that do not. He calls this new law the principle of the conservation of energy. There are no forces that violate the principle (now called the first law of thermodynamics) which says that in any system energy cannot be created or destroyed.

6 Sigmund Freud, *On Dreams, SE,* vol. 5 (London: Hogarth Press and the Institute of Psycho-Analysis, 1953), 641.

7 Ibid.

8  Ibid., 642.

9  The first (and only) time Freud explicitly uses the term "archive" is an early text entitled, significantly, "The Psychical Mechanism of Forgetfulness" (1898; 1901). The focus of this paper is the forgetting of proper names and its relations with repressed memories. Sigmund Freud, "The Psychical Mechanism of Forgetfulness," *SE*, vol. 3 (London: Hogarth Press and the Institute of Psycho-Analysis, 1962), 292–297. This paper is itself an archive of sorts, since in it Freud relates the contents of an earlier piece published in 1898 in the journal *Monatsschrift für Psychiatrie und Neurologie.*

10  Sigmund Freud, "Constructions in Analysis," *SE*, vol. 23 (London: Hogarth Press and the Institute of Psycho-Analysis, 1964), 259.

11  Sigmund Freud, "Fragment of an Analysis of a Case of Hysteria," *SE*, vol. 7 (London: Hogarth Press and the Institute of Psycho-Analysis, 1953), 12.

12  Kenneth Reinhard, "The Freudian Things: Construction and the Archaeological Metaphor," in Stephen Barker, ed., *Excavations and Their Objects: Freud's Collection of Antiquity* (New York: State University of New York Press, 1996), 57.

13  Freud, "Constructions in Analysis," 259–260.

14  Nothing in an archive can fully disappear. Even those files that have been expunged are still registered multiply in the archive's documentary tools. Similarly, what has been inscribed in the psyche can disappear but it cannot be permanently lost.

15  The word *Block* in *Wunderblock* also belongs in the context of the office. In German, *Schreibblöcke* (writing pads) consist of loose sheets of paper held together at one end of the block by a spiraling wire. Technically speaking, the *Schreibblock*—where pages can be torn off and discarded at any time— falls between a stack of loose papers and a (note) book.

16  Jacques Derrida has pointed out that Freud describes the operational mode of the writing pad as essentially discontinuous, since it relies on the continuous interchange of contact between its layers and the interruption of this contact. Jacques Derrida, "Freud and the Scene of Writing," in Derrida, *Writing and Difference* (Chicago: University of Chicago Press, 1978), 334.

17  Sigmund Freud, "A Note upon the 'Mystic Writing-Pad,'" *SE*, vol. 19 (London: Hogarth Press and the Institute of Psycho-Analysis, 1964), 229.

18  Ibid.

19  Ibid.

20  Derrida, *Archive Fever*, 10. In his earlier analysis of the magic writing pad in *Writing and Difference*, Derrida had noted that the similarity between the "dead," mechanical, hand-operated toy and Freud's model of the psyche places finitude at its very center. Derrida, "Freud and the Scene of Writing," 228.

21  Derrida, *Archive Fever*, 10.

22  Ibid., 11.

23  The anarchivic force Derrida elaborates competes with a lawful type of destruction whose regulated functioning is crucial to any archive economy. Traditionally, an archivist has three main tasks: first, the adoption of records; second, their evaluation; and third, their arrangement. The evaluation of materials includes the decision as to whether or not a record should enter the archive. If a decision is made not to include a series of records in the archive, they are often sold or sent to the paper mill so that new paper can be produced from their remains. If this neatly illustrates that the archive may well be the condition under which paper may be blank, it also hints that there cannot be any successful storage without some form of repression.

24  Freud, "Fragment of an Analysis of a Case of Hysteria," 9.

25  Ibid., 10.

26  Ibid., 12.

27 "The difficulties are very considerable when the physician has to conduct six or eight psychotherapeutic treatments of the sort in a day, and cannot make notes during the actual session with the patient for fear of shaking the patient's confidence and of disturbing his own view of the material under observation." (Ibid., 9.)

28 Freud's passive position during treatment is not unlike Ranke's desire to "erase my own Self in order to let only things speak." Leopold von Ranke, *Englische Geschichte vornehmlich im siebzehnten Jahrhundert,* in Ranke, *Sämmtliche Werke,* vol. 14 (Leipzig: Duncker und Humblot, 1870), 103.

29 Emphasis mine. Friedrich Kittler correctly identifies Freud's input here as *durchpausen* (carbon-copying). Friedrich Kittler, *Discourse Networks 1800/1900* (Stanford: Stanford University Press, 1990), 288.

30 Sigmund Freud, "Recommendations to Physicians Practising Psycho-Analysis," *SE,* vol. 12 (London: Hogarth Press and the Institute of Psycho-Analysis, 1958), 115–116.

31 Ibid., 113.

32 Ibid.

33 Freud explains that a full recording of a case history would in fact be "of less value than might be expected" because such records "only possess the ostensible exactness of which 'modern psychiatry' affords us some striking examples. They are, as a rule, fatiguing to the reader and yet do not succeed in being a substitute for his actual presence at an analysis." Ibid., 114.

34 Freud, "Fragment of an Analysis of a Case of Hysteria," 10. On Freud's writing habits more generally, see also Ernest Jones, *The Life and Work of Sigmund Freud,* vol. 2 (New York: Basic Books, 1955), 395–397.

35 Freud, "Fragment of an Analysis of a Case of Hysteria," 16.

36 Michel de Certeau, "The Freudian Novel: History and Literature," *Humanities and Society* 4 (1981), 123.

37 Sigmund Freud and Josef Breuer, *Studies on Hysteria, SE,* vol. 2 (London: Hogarth Press and the Institute of Psycho-Analysis, 1955), 160–161.

38 Dorrit Cohn, *The Distinction of Fiction* (Baltimore: Johns Hopkins University Press, 1999), 44.

39 Ibid., 45.

40 This does not, of course, imply that they may not fruitfully be read as pieces of fiction.

41 Freud, "Fragment of an Analysis of a Case of Hysteria," 16.

**4 1913:"DU HASARD EN CONSERVE": DUCHAMP'S ANEMIC ARCHIVES**

1 On film as archive, trace, and index, see Mary Ann Doane, *The Emergence of Cinematic Time: Modernity, Contingency, the Archive* (Cambridge: Harvard University Press, 2002), 22–24. Doane calls film's ambition to register contingency "self-defeating" since "once the present as contingency has been seized and stored, it ineluctably becomes the past" (23).

2 Gilles Deleuze, *Cinema 1: The Movement-Image* (Minneapolis: University of Minnesota Press, 1997), 31–32.

3 David Joselit, *Infinite Regress: Marcel Duchamp 1910–1941* (Cambridge: MIT Press, 1998), 95.

4 The reappearance of the readymades, in miniature, in the *Green Box* of 1934 marks the archive's *mise in en abîme;* if the readymades themselves have an archival dimension, their inclusion in the archive of the *Green Box* suggests the aporetic figure of an archive within an archive.

5 *The Writings of Marcel Duchamp,* ed. Michel Sanouillet and Elmer Peterson (New York: Da Capo Press, 1989), 32.

6 "An archive is a repository for the future, a starting point, not an end point. While the collector perhaps discriminates between objects, the archivist accumulates with no declaration of what specific value that material may hold for future users." Anna Harding, ed., *Potential: Ongoing Archive* (Amsterdam: Artimo, 2002), 51.

7  Jean Clair, *Sur Marcel Duchamp et la fin de l'art* (Paris: Gallimard, 2000), 242. Translation mine.

8  Duchamp, a trained library assistant, abandoning painting once and for all, called his last painting *Tu m'* (1918) "a kind of inventory of all my preceding works, rather than a painting in itself." Arturo Schwarz, *The Complete Works of Marcel Duchamp* (New York: Delano Greenridge, 2000), 223.

9  *The Writings of Marcel Duchamp*, 33.

10 Walter Benjamin, "Hashish in Marseille," in Benjamin, *Selected Writings,* vol. 2 (Cambridge: Belknap Press of Harvard University Press, 1999), 677.

11 In another narrative involving an unwinding thread, Freud's *Fort/Da* game, the thread similarly functions as a suturing tool for orientation and regained control. Freud's grandson repeats his mother's disappearance by throwing a wooden reel attached to a string into his cot. As long as the string is intact and attached to the reel, the game can be reenacted again and again. See Sigmund Freud, "Beyond the Pleasure Principle," *SE,* vol. 18 (London: Hogarth Press and the Institute of Psycho-Analysis, 1953), 15.

12 Lewis Kachur, *Displaying the Marvelous: Marcel Duchamp, Salvador Dalí, and Surrealist Exhibition Installations* (Cambridge: MIT Press, 2001), 193.

13 On string and threads in Duchamp, especially in his installation *Mile of String* at the "First Papers of Surrealism" exhibition in 1942, see Kachur, *Displaying the Marvelous,* 182–194; T. J. Demos, *The Exiles of Marcel Duchamp* (Cambridge: MIT Press, 2007), 226–228. In a work that is directly related to *3 Standard Stoppages, Chocolate Grinder, #2* (1914), Duchamp sewed threads into the canvas. The threads, which literally puncture the canvas, perforate its surface with the goal of cutting the painting off from the historical trajectory of modern painting, a trajectory Duchamp referred to as "the Cubist straitjacket."

14 It was in fact Duchamp's sister Suzanne who realized this readymade, upon instructions sent to her by Duchamp.

15 Pierre Cabanne, *Dialogues with Marcel Duchamp* (New York: Viking, 1971), 61.

16 Marcel Duchamp, quoted in Schwarz, *The Complete Works of Marcel Duchamp,* 668.

17 On March 26, 1791, the French National Convention had introduced the meter as the nation's legal system of measurement. It was defined as the ten-millionth part of the length of the earth's meridian between the North Pole and the equator. See Wolfgang Trapp, *Kleines Handbuch der Maße, Zahlen, Gewichte und der Zeitrechnung* (Leipzig: Reclam, 2001), 30.

18 In this context, see also Joselit's discussion of *Network of Stoppages* (1914), which includes *3 Standard Stoppages,* as a juxtaposition of a woman's body and a system of measurement. Joselit, *Infinite Regress,* 30.

19 Quoted from Anne d'Harnoncourt and Kynaston McShine, eds., *Marcel Duchamp* (New York: Museum of Modern Art, 1973), 280.

20 Ibid.

21 Walter Benjamin, "Berlin Childhood around 1900," in Benjamin, *Selected Writings,* vol. 3 (Cambridge: Belknap Press of Harvard University Press, 1996), 382.

22 Ibid., 381.

23 Ibid.

24 Walter Benjamin, "Franz Kafka," in Benjamin, *Selected Writings,* 2: 811.

25 Françoise Dragonet, *Etienne-Jules Marey: A Passion for the Trace* (Cambridge: MIT Press, 1992), 149.

26 Marey believed that to the extent that they were intelligible, physiological processes followed mechanical laws.

27 That Marey's apparatuses should be designed to archivize ghosts is not as far fetched as it might seem. With his colleague at the Collège de France, Bergson, Marey regularly attended spiritual séances where

apparently it was his ambition to develop a mechanism that would record if not the spirit itself, then at least the movements of the table on which it manifested itself.

28 Etienne-Jules Marey, *La méthode graphique dans les sciences expérimentales et principalement en physiologie et en médecine* (Paris: G. Masson, 1885), 1. Translation mine.

29 E. J. Marey, *Du mouvement dans les fonctions de la vie: Leçons faites au Collège de France* (Paris: Germer Baillère, 1868), v. Translation mine.

30 The sphygmograph included a clockwork mechanism that moved a strip of paper blackened with soot under the stylus at a uniform speed, so that the pulsations themselves produced the inscription. The fact that it attaches directly to the body makes the sphygmograph different from subsequent machines designed to trace locomotion. See Sven Spieker, "Die Poetik des Anti-Denkmals: Schriftskepsis, Registratur und graphische Methode," in Susanne Strätling and Georg Witte, eds., *Die Sichtbarkeit der Schrift* (Munich: Fink, 2006), 139–152.

31 Marey's machines are part of a broad movement in nineteenth-century science to eradicate interpretation through "the control of the representational process by automatic means." Lorraine Daston and Peter Galison, "The Image of Objectivity," *Representations* 40 (1992), 100.

32 Marey, *Du mouvement dans les fonctions de la vie*, 85. Translation mine. According to Marey, the documents produced by the writing machines, far from accumulating senselessly into infinity, would eventually yield to a numerical law. What Marey proposes here is nothing short of a self-regulating archive, contrasting sharply with the traditional paper archive with its reliance on the evaluating activity of the archivist as the only means to ensure that the archive does not burst its seams.

33 On the nineteenth-century discussion of the point and its relevance for the figuring of time, see Doane, *The Emergence of Cinematic Time,* 214–218.

34 Henri Bergson, *Matter and Memory* (New York: Zone Books, 1991), 138.

35 Here I disagree with David Joselit's otherwise compelling account of Marey's importance for Duchamp. Joselit seems to associate Duchamp with Marey's ambition to develop a "language of [the] phenomena themselves." In my view, Duchamp is squarely *opposed* to the nineteenth-century effort to create a transparent archive of Life. Joselit, *Infinite Regress,* 55.

36 Ibid., 29.

37 The body implicit in Marey's experiments is universally male.

38 See also Joselit's discussion of Duchamp's response, in his painting, to cubism's exchange of the (female) body for various forms of semiotic exchange. Joselit *Infinite Regress,* 34–70.

39 *The Writings of Marcel Duchamp,* 38.

40 Ibid., 31.

41 Schwarz, *The Complete Works of Marcel Duchamp,* 195.

42 *The Writings of Marcel Duchamp,* 175.

43 Schwarz, *The Complete Works of Marcel Duchamp,* 195.

44 *The Writings of Marcel Duchamp,* 71.

45 The check's account is held at "The Teeth's Loan & Trust Company, Consolidated," of New York.

46 Allan Sekula, "The Body and the Archive," *October* 39 (1986), 16.

47 Cf. also Duchamp's frequent references to formal gestures of notarization. For example, he had the subscript he added to his reproduction of the *Mona Lisa* notarized and certified as an "original readymade." On notarization in Duchamp, see Dalia Judovitz, *Unpacking Duchamp: Art in Transit* (Berkeley: University of California Press, 1995), 167.

48 Quoted in Schwarz, *The Complete Works of Marcel Duchamp,* 638.

49 See also Joselit, *Infinite Regress,* 29.

50 This phrase and the correction marks in the text above it are written with the same pen.

51 The German word for striking a key is *Anschlag*, suggesting a violent terrorist attack.

52 Other works by Duchamp in which the typewriter was involved are *Boxing Match* (1912); *Faina (Profile)* (1916); and *Rendez-vous du dimanche 6 février 1916* ... (1916). The latter is discussed in the text below.

53 Schwarz, *The Complete Works of Marcel Duchamp*, 642.

54 E. Remington and Sons originally fabricated guns. See Richard N. Current, *The Typewriter and the Men Who Made It* (Urbana: University of Illinois Press, 1964), 63. The U.S. War Department bought its first typewriter, a Sholes and Glydden, in 1874 for $125. See T. R. Schellenberg, *Modern Archives: Principles and Techniques* (Chicago: University of Chicago Press, 1956), 82.

55 Margaret B. Owen, *The Secret of Typewriting Speed* (Chicago: Forbes, 1917), 59.

56 Ibid., 98.

57 Amelia Jones, *Irrational Modernism: A Neurasthenic History of New York Dada* (Cambridge: MIT Press, 2004), 141.

58 In his manifesto "Futurist Photodynamism" (1913), Anton G. Bragaglia argues that photodynamism, unlike film or chronophotography, is not concerned with breaking down or analyzing movement. http://www.391.org/manifestos/antongiuliobragaglia_futuristphotodynamism.htm.

59 From Latin *pungere/punct-* (pricked).

60 In a letter of April 17, 1917, Duchamp wrote to his sister that one of his female friends had sent a porcelain urinal as a sculpture to the Society of Independent Artists in New York under a male pseudonym. See Schwarz, *The Complete Works of Marcel Duchamp*, 650. The link between motherhood and art is pervasive in Duchamp's work. According to Schwarz (ibid., 161), the Malic Molds in the *Large Glass* are to be understood as matrices, an archaic term for the womb derived from the Latin word *mater.* In 1949, Duchamp stated that "the artist is only the mother of the work." Quoted from Amelia Jones, *Postmodernism and the Engendering of Marcel Duchamp* (Cambridge: Cambridge University Press, 1994),146.

61 Ebbinghaus wrote: "The nonsense material, just described, offers many advantages, in part because of this very lack of meaning. First of all, it is relatively simple and relatively homogeneous. In the case of the material nearest at hand, namely poetry or prose, the content is now narrative in style, now descriptive, or now reflective.... There is thus brought into play a multiplicity of influences which change without regularity and are therefore disturbing." Hermann Ebbinghaus, *Memory: A Contribution to Experimental Psychology* (New York: Dover Publications, 1964), 23. See also Friedrich Kittler, *Discourse Networks 1800/1900* (Stanford: Stanford University Press, 1990), 208–209.

62 The first portable Underwoods entered the market in 1919.

63 Arturo Schwarz reports: "In 1953, when asked his reasons for adopting a typewriter cover as a Readymade, Duchamp replied: 'I thought it would be a good idea to introduce softness in the Readymade—in other words not altogether hardness, porcelain or iron, or things like that.... So that's why the typewriter cover came into existence.'" Schwarz, *The Complete Works of Marcel Duchamp*, 646.

64 This desire was common in the days of the "blind" typewriter. Owen writes, "there was a time when the argument used against the old-style 'blind' typewriter was the habit it encouraged in typists of lifting the carriage many times to see what they had written." Owen, *The Secret of Typewriting Speed*, 99.

65 Arturo Schwarz quotes Ulf Linde's association of the Underwood cover with the Bride. Schwarz, *The Complete Works of Marcel Duchamp*, 196. See also Jones, *Irrational Modernism,* 137, 141.

66 Even before 1890, women, who cost their employers considerably less than men, occupied the majority of secretarial positions. See Current, *The Typewriter and the Men Who Made It,* 177, 119. In typing manuals published in the United States during World War I, the "feminization" of typing was pushed to extremes. Owen's manual, for instance, not only promotes typing as a way of preventing girls from entering business "just to kill time waiting for a Lochinvar to come out of the West"; it also introduces

feminine characters such as "Miss Punctuation" in a chapter dealing with the efficient use of punctuation marks at the typewriter. Owen, *The Secret of Typewriting Speed,* 14, 61.

67 As Richard Polt has pointed out to me in an e-mail, the Underwood was not the first machine to make the text visible, but it was by far the most influential.

68 The Underwood company began in the 1870s as a supplier of ribbons and carbon paper for Remington.

------

## 5 1924 THE BUREAUCRACY OF THE UNCONSCIOUS (EARLY SURREALISM)

1 Friedrich Kuntze, *Die Technik der geistigen Arbeit* (Heidelberg: Carl Winter's Universitätsbuchhandlung, 1921), 2. Not coincidentally, Kuntze was inspired to write his book during an exhibition of office organization technologies.

2 Once the notes have been committed to the card box, they can be arranged in two ways, alphabetically or numerically. Kuntze viewed the alphabetic system as the more traditional one because it was based on the book; he preferred numerical filing systems based on the decimal system.

3 Kuntze, *Die Technik der geistigen Arbeit,* 31.

4 Ibid., 25.

5 Carl Diesch, *Katalogprobleme und Dezimalklassifikation: Eine bibliothekswissenschaftliche Untersuchung und Abwehr* (Leipzig: Otto Harrassowitz, 1929), 24. Translation mine. Containers filled with individual pieces of paper on which data was entered can be traced back at least to the sixteenth century. They were used in roughly two fields, library catalogues and scholarship, where they appeared in the form of collections of excerpts stored on pieces of paper that could be regrouped according to the needs and desires of their users. Already around 1780, the Court Library in Vienna introduced a card-based catalogue. For a concise history of the card index, see Markus Krajewski, *Zettelwirtschaft: Die Geburt der Kartei aus dem Geist der Bibliothek* (Berlin: Kadmos, 2002).

6 Kuntze, *Die Technik der geistigen Arbeit,* vi.

7 Ibid., 27.

8 *The Writings of Marcel Duchamp,* ed. Michel Sanouillet and Elmer Peterson (New York: Da Capo Press, 1989), 77.

9 Ibid.

10 Benjamin reports that the cards in this index were "very small" and that it was impossible to divine what was noted on them. Walter Benjamin, review of Walter de Renéville, *L'expérience poétique* (Paris: Gallimard, 1938), in Benjamin, *Gesammelte Schriften,* vol. 3 (Frankfurt: Suhrkamp, 1980), 555. Translation mine. On Benjamin's own use of the card index, see *Walter Benjamins Archive: Bilder, Texte und Zeichen* (Frankfurt: Suhrkamp, 2006), 30–33.

11 *The Writings of Marcel Duchamp,* 77.

12 Theodor W. Adorno, "Rückblickend auf den Surrealismus," in *Noten zur Literatur* (Frankfurt: Suhrkamp, 1981), 101–105. Translation mine.

13 In his speech at the International Writers' Congress for the Defence of Culture in 1935, René Crevel expounded on Rimbaud's "ingenious stenography." René Crevel, in *Commune* 23 (1935), 1206.

14 Walter Benjamin, *The Arcades Project,* trans. Howard Eiland and Kevin McLaughlin (Cambridge: Belknap Press of Harvard University Press, 1999), 417.

15 On the link between women typists and mechanical writing, see Friedrich Kittler, *Discourse Networks 1800/1900* (Stanford: Stanford University Press, 1990), 352–354. Kittler writes that, with the advent of the Remington in offices, women's main historical handicap in the business world—their insufficient education—was turned to advantage because employers believed that "women [had] the admirable ability 'to sink to the level of mere writing machines'" (352).

16 The machine shown in the photo is a light travel typewriter.

17  Rubén Gallo, *Mexican Modernity: The Avant-Garde and the Technological Revolution* (Cambridge: MIT Press, 2005), 97.

18  As Kittler has observed, "mechanical storage technologies for writing, images, and sound"—including the typewriter—could emerge only after the collapse of the authority associated with writing by hand. Friedrich Kittler, *Gramophone, Film, Typewriter* (Stanford: Stanford University Press, 1999), 188.

19  It was of course Duchamp who provided the precedent for this procedure.

20  Jacques Lacan, "The Function and Field of Speech and Language in Psychoanalysis," in Lacan, *Ecrits: A Selection* (New York: Norton, 1977), 50.

21  Denis Hollier, "Surrealist Precipitates: Shadows Don't Cast Shadows," *October* 69 (1994), 129.

22  In the first "Manifesto of Surrealism," Breton writes: "On fait acte de SURRÉALISME ABSOLU." André Breton, "Manifeste du surréalisme," in *Manifestes du surréalisme* (Paris: Gallimard, 1979), 36. But his rival Bataille saw Breton's ambition to administrate Surrealism as misguided; and Bataille's *Dossier sur l'argument avec Breton* (File on the argument with Breton) concerns, at its most basic level, the correct way of filing documents. In his definition of the "formless" (*l'informe*), Bataille states that the job of the formless would be the lowering and declassification of actions or tasks in order to break up the oppositional economy of classificatory categories: "A dictionary begins when it no longer gives the meaning of words, but their tasks. Thus *formless* is not only an adjective having a given meaning, but a term that serves to bring things down in the world, generally requiring that each thing have its form." Georges Bataille, *Visions of Excess: Selected Writings, 1927–1939* (Minneapolis: University of Minnesota Press, 1986), 31.

23  André Breton and Philippe Soupault, *If You Please,* in Mel Gordon, ed., *Dada Performance* (New York: paj Publications, 1987), 123.

24  See Uwe M. Schneede, *Die Kunst des Surrealismus: Malerei, Skulptur, Dichtung, Fotografie, Film* (Munich: Beck, 2006), 11–12, 72–75.

25  *Permanent* means "the person on duty."

26  "At 5:15 p.m. Gérard is not here, although this is his day of duty." Pierre Naville in *Cahier de la permanence du Bureau de recherches surréalistes, octobre 1924–avril 1925* (Paris: Gallimard, 1988), 95. All translations from this text are mine.

27  Ibid., 26.

28  Mark Polizzotti uses this term: "Despite its intended status as a record of the Bureau's activities, the register in fact became the diary of a failure." Mark Polizzotti, *Revolution of the Mind: The Life of André Breton* (New York: Farrar, Straus and Giroux, 1995), 224.

29  *Cahier de la permanence du Bureau de recherches surréalistes,* 21.

30  Ibid., 63, 49.

31  Ibid., 63.

32  Ibid., 73. The note was likely written by Louis Aragon or André Breton, the two *permanents* on duty that afternoon.

33  Ibid., 83.

34  André Breton in ibid., 36.

35  Unknown author in ibid., 107.

36  The term *permanent* itself references Freud's theory of memory whereby any permanent mnemonic trace (in French, *trace permanente de mémoire*) is the result of a shell shock, an accident, the inability of consciousness to absorb the excitation that speeds toward it with great velocity.

37  Antonin Artaud in *Cahier de la permanence du Bureau de recherches surréalistes,* 122. Artaud's authorship of the circular letter is not certain, but is likely. See the editor's note in ibid., 164 (n1).

38  André Breton, *Manifestoes of Surrealism* (Ann Arbor: University of Michigan Press, 1972), 27.

39 "The Greeks gradually learned how *to organize this chaos* by concentrating—in accordance with this Delphic doctrine—on themselves, that is, on their genuine needs, and by letting those pseudoneeds die out." Friedrich Nietzsche, "On the Utility and Liability of History for Life," in Nietzsche, *Unfashionable Observations,* vol. 2 (Stanford: Stanford University Press, 1994), 166.

40 Breton, *Manifestoes of Surrealism,* 9. Modified translation.

41 André Breton, *Nadja* (Paris: Gallimard, 1964), 19. Translation mine.

42 Quoted from Maurice Nadeau, *Histoire du surréalisme* (Paris: Éditions du Seuil, 1964), 58. Translation mine.

43 Breton, *Manifestoes of Surrealism,* 29.

44 Antonin Artaud, "L'activité du Bureau de Recherches Surréalistes," in *Cahier de la permanence du Bureau de recherches surréalistes,* 129–130.

45 In Artaud's "Déclaration du 27 janvier 1925," written to mark the beginning of his tenure as the Bureau's chief and signed by all members, we read: "3rd. We are quite decided to make a Revolution." In *Cahier de la permanence du Bureau de recherches Surréalistes,* 119.

46 Walter Benjamin noted that the Surrealists exchanged a historical perspective on the past for a political one: "The trick by which this world of things is mastered—it is more proper to speak of a trick than a method—consists in the substitution of a political for a historical view of the past." Walter Benjamin, "Surrealism: The Last Snapshot of the European Intelligentsia," in Benjamin, *Selected Writings,* vol. 2 (Cambridge: Belknap Press of Harvard University Press, 1999), 210.

47 Bakunin, for one, had advocated the "abolishment and burning of all property titles, inheritance records, certificates of sale …, judicial proceedings—in a word, of all that judicial … junk." Mikhail Bakunin, *Gesammelte Werke,* vol. 2 (Berlin: Ullstein, 1975), 877. Translation mine. During the Spanish civil war, Franco's troops followed the opposite strategy. They confiscated all the administrative archives of the cities they conquered and transferred them to the infamous central archive in Salamanca.

48 Breton, *Manifestoes of Surrealism,* 11. Translation modified.

49 *Cahier de la permanence du Bureau de recherches surréalistes,* 123. Polizzotti speaks of the Bureau as being "at least in conception …, far more organized than any of Breton's previous projects." Polizzotti, *Revolution of the Mind,* 220.

50 Tristan Tzara, "pour faire un poème dadaiste," in Tzara, *Oeuvres complètes,* vol. 1 (1912–1924) (Paris: Flammarion, 1975), 382. Translation mine.

51 Benjamin, "Surrealism," 216.

52 André Breton, *Mad Love,* trans. Mary Ann Caws (Lincoln: University of Nebraska Press, 1987), 39.

53 The reproduced *frottage* is part of *Histoire naturelle,* the portfolio of *frottages* Ernst had Jeanne Bucher print in 1926.

54 The term "carbonated paper" was first used when Ralph Wedgwood issued a patent for his "Stylographic Writer" in 1806. However, carbon paper did not challenge press printing until the arrival of the typewriter. See http://www.kevinlaurence.net/essays/cc.php.

55 See also Werner Spies, *Max Ernst: Frottages* (London: Thames and Hudson, 1986), 9.

56 Ulf Linde contends that Duchamp's Bride could be considered a typewriter: "If one considers that the Bride's task is to produce 'alphabetic units,' it might be possible to see her as a typewriter." Quoted in Arturo Schwarz, *The Complete Works of Marcel Duchamp* (New York: Delano Greenridge, 2000), 196. See also *The Writings of Marcel Duchamp,* 36–38.

57 Le Corbusier, *The Decorative Art of Today,* trans. James I. Dunnett (Cambridge: MIT Press, 1987). Most of the book's essays were published during the year 1924 in Le Corbusier's and Ozenfant's journal *L'Esprit Nouveau,* and their publication coincided with the exhibition of Le Corbusier's Pavillon de l'Esprit Nouveau at the Exposition Internationale.

58 On Le Corbusier and his rational management of the irrational, see also Amelia Jones, *Irrational Modernism: A Neurasthenic History of New York Dada* (Cambridge: MIT Press, 2004), 16.

59 Le Corbusier, *The Decorative Art of Today,* 16. In an age when high-quality consumer goods were mass-produced and hence accessible to all, Le Corbusier believed that class antagonisms amounted to little more than a problem of distribution.

60 Ibid., 22.

61 Ibid., 69.

62 Ibid., 77.

63 Ibid., 72.

64 Ibid., 71–72.

65 The German term *geistig* (spiritual; intellectual) implies a reference to ghosts and spirits (*Geister*).

———

## 6 AROUND 1925 THE BODY IN THE MUSEUM

1 See Maria Gough, "Futurist Museology," *Modernism/Modernity* 2 (2003), 327–348.

2 El Lissitzky, "The Catastrophe of Architecture," in *El Lissitzky: Life, Letters, Texts,* ed. Sophie Lissitzky-Küppers (London: Thames and Hudson, 1968), 369.

3 Aleksandr Rodchenko, "O Muzeinom Biuro: Doklad na konferentsii zaveduiushchikh Gubsektsiiami IZO" (n.d.), in Rodchenko, *Opyty dlia budushchego* (Moscow: Grant', 1996), 100. Translation mine.

4 Ibid. As his collapsible *Oval Hanging Spatial Construction, no. 12* (c. 1920) demonstrates, Rodchenko, while scornful of the archive as a static storage place for art, was nevertheless highly sensitive to the problem of archivization in art.

5 Varvara Stepanova, statement in *5 X 5 = 25: Exhibition of Paintings,* translation and facsimile of 1921 catalogue (Budapest: Helikon, 1992), n.p. The passage is quoted by Camilla Gray, *The Russian Experiment in Art, 1863–1922* (London: Thames & Hudson, 1990), 251.

6 Benjamin Buchloh, who quotes Stepanova from Gray, refers to her remark as a "correlative" of Lissitzky's restructuring of the museum in his Demonstration Rooms from the mid 1920s. Benjamin H. D. Buchloh, "From Faktura to Factography," *October* 30 (1984), 91–92. Gough seems to disagree with Buchloh, interpreting Stepanova's statement as the museum's final consignment "to the archive." Gough, "Futurist Museology," 342.

7 Rodchenko, "O Muzeinom Biuro," 99.

8 Lissitzky had already used the term *Demonstrationsraum* for his Berlin Proun Room (1923).

9 The first to argue this point was Benjamin Buchloh: "And the moveable wall panels, carrying or covering easel panels on display, to be shifted by the viewers themselves … already incorporate into the display system of the museum the function of the archive that Stepanova predicted as its social destiny." Buchloh, "From Faktura to Factography," 92.

10 Given that some of the works exhibited in these rooms had never before been shown in a museum setting, one must also not underestimate their role as training grounds for the perception of abstraction in art.

11 El Lissitzky, "Proun Room, Great Berlin Art Exhibition" (1923), in *El Lissitzky: Life, Letters, Texts,* 365. See also Rodchenko's remark that in the traditional art museum "no one pays attention to the saturation of the walls with the works of the same master." Rodchenko, "O Muzeinom Biuro," 99.

12 In a contemporary review of the Cabinet of the Abstracts, Sigfried Giedion likened Lissitzky's gallery walls, to which he attributed a "dematerializing" function, to a Baroque tradition that used a similar system of vertical lines to compose and decompose the images of saints: "Even today you can see in Catholic areas on many farm houses portraits of saints made of painted glass slats that alternately compose and decompose themselves for the passing observer. El Lissitzky adopts, perhaps

unconsciously, the Baroque tradition and translates it into abstraction." Giedion, quoted in Heinz Brüggemann, *Architekturen des Augenblicks: Raum-Bilder und Bild-Räume einer urbanen Moderne in Literatur, Kunst und Architektur des 20. Jahrhunderts* (Hannover: Offizin, 2002), 309. The original review appeared on March 9, 1929, in the *Neue Zürcher Zeitung.*

13   These and other specifications can be found in Monika Flacke-Knoch, *Museumskonzeptionen in der Weimarer Republik: Die Tätigkeit Alexander Dorners im Provinzialmuseum Hannover* (Marburg: Jonas, 1985), 61.

14   The bands, made from Nirosta Krupp steel, were four centimeters deep and only 0.8 centimeters wide. All in all, Lissitzky used 544 of these bands for the Cabinet of the Abstracts. Ibid., 64.

15   See ibid., 64–65, for a discussion of the way in which this coloring may have corresponded to the specific light conditions in the Cabinet of the Abstracts, where the daylight did not, as in Dresden, come from the open ceiling but from the windows along one side of the room.

16   El Lissitzky, "Exhibition Rooms," in *El Lissitzky: Life, Letters, Texts,* 366.

17   Ibid.

18   Ibid.

19   As I show below, the Demonstration Rooms even record, to a limited extent, the interaction of the gallery visitor with their architecture.

20   Rodchenko, "O Muzeinom Biuro," 100.

21   Maria Gough, "Constructivism Disoriented: El Lissitzky's Dresden and Hannover *Demonstrationsräume*," in Nancy Perloff and Brian Reed, eds., *Situating El Lissitzky: Vitebsk, Berlin, Moscow* (Los Angeles: Getty Publications, 2003), 90.

22   Le Corbusier, *The Decorative Art of Today,* trans. James I. Dunnett (Cambridge: MIT Press, 1987), 76 n1. In my reading, the standardized, modular armature of the bands/laths and their interaction with the images on their surface are a crucial prerequisite for the creation of an optical dynamic. For an opposing view see Gough, "Constructivism Disoriented," 102.

23   See also Sven Spieker, "Vom Umhertasten in der Kunst: El Lissitzkys *Demonstrationsräume* zwischen Labor und Büro," in Inge Münz-Koenen and Justus Fetscher, eds., *Pictogrammatica: Die visuelle Organisation der Sinne in den Medienavantgarden 1900–1938* (Bielefeld: Aisthesis Verlag, 2006), 197–217.

24   The illusion of motion created by the phenakistoscope and similar mechanisms was generally explained as being the result of the successful merging of two or more images through the persistence of vision (*Nachbildeffekt*). I thank Hans-Christian von Herrmann for pointing out to me the relevance of nineteenth-century optics for the Demonstration Rooms.

25   Jonathan Crary, *Techniques of the Observer: On Vision and Modernity in the Nineteenth Century* (Cambridge: MIT Press, 2001), 120.

26   Hermann von Helmholtz, "The Recent Progress of the Theory of Vision," in Helmholtz, *Science and Culture: Popular and Philosophical Essays* (Chicago: University of Chicago Press, 1995), 182.

27   Michel Foucault, *The Birth of the Clinic: An Archaeology of Medical Perception,* trans. A. M. Sheridan Smith (New York: Pantheon Books, 1973), 55.

28   While Muybridge was working for Leland Stanford in Palo Alto, Ottomar Anschütz—whose fame rests on his invention of the tachyscope or *Schnellseher*—produced similar work in Central Europe, mostly of military maneuvers and animals. In 1886 Anschütz received a grant from the Prussian minister of culture to put together an "atlas of gymnastic movements" with the help of chronophotog-raphy. Soon afterward, the war ministry sent Anschütz to take series of chronophotographs of the horses and riders at the Military Equestrian Academies in Hannover and Graditz. In Hannover Anschütz utilized a chronophotographic apparatus of his own, involving a battery of 24 cameras with electrically

linked shutters that allowed for 24 exposures taken in from 3 seconds to as little as 0.72 seconds. With this apparatus he captured both moving horses and subjects in various types of activity.

29 Sergei M. Eisenstein, "Yermolova," in Eisenstein, *Selected Works,* vol. 2, *Towards a Theory of Montage* (London: bfi Publishing, 1991), 89. The first shot corresponds with a perspective on Yermolova from above, exposing for instance the hem of her dress in a way that suggests the shot was taken from this position, while shot #4 is framed by the horizontal lines reflected in the mirror. This view allows us to see, among other things, the actress's lower chin, suggesting a shot from below.

30 In Hannover, the movable "shutters" were not perforated but solid black so that nothing could be seen through them.

31 According to Flacke-Knoch, the cassettes in Dresden were filled with moderately modernist paintings, while the structured walls were reserved for the new abstract art. See Flacke-Knoch, *Museumskonzeptionen in der Weimarer Republik,* 62.

32 Lissitzky, "Exhibition Rooms," 366. Partial invisibility as a structural part of a constructed object is also a crucial element in Vladimir Tatlin's counter-reliefs.

33 Ibid.

34 Vertical filing was first introduced in 1868 by the Amberg File and Index Company. In 1893, Dr. Nathaniel S. Rousseau produced a piece of equipment designed to accommodate case files. Their organization was based on a system developed in 1892 by Melvil Dewey's Library Bureau. See T. R. Schellenberg, *Modern Archives: Principles and Techniques* (Chicago: University of Chicago Press, 1956), 83–84. "The introduction of the vertical file marked the utilization of a great efficiency principle, namely, that there is almost always more room for growth in a vertical than in a horizontal direction." William H. Leffingwell, *Textbook of Office Management* (New York: McGraw-Hill, 1927), 415.

35 As JoAnne Yates points out, the new equipment was not by itself enough to render the storage and retrieval of documents more efficient. It was only their organization—which vertical files facilitated—that could accomplish this task. See JoAnne Yates, *Control through Communication: The Rise of System in American Management* (Baltimore: Johns Hopkins University Press, 1989), 57.

36 Walter Benjamin, "The Work of Art in the Age of Its Technological Reproducibility: Third Version," in Benjamin, *Selected Writings,* vol. 4 (Cambridge: Belknap Press of Harvard University Press, 1996), 267.

37 Quoted from Margarita Tupitsyn, "Back to Moscow," in *El Lissitzky, Beyond the Abstract Cabinet: Photography, Design, Collaboration* (New Haven: Yale University Press, 1999), 39. The Russian translation is quoted in Gough, "Constructivism Disoriented," 117 n16.

38 Gough, "Constructivism Disoriented," 111.

39 Through his work at the Vkhutemas, Lissitzky was well acquainted with the context of experimental science. One of the more important reference points here is Soviet reflexology.

40 Francis Bacon, *The New Organon* (Cambridge: Cambridge University Press, 2000), 67. Emphasis mine.

41 Claude Bernard, *An Introduction to the Study of Experimental Medicine* (New York: Macmillan, 1927), 9.

42 "It is on this very possibility of acting, or not acting, on a body that the distinction will exclusively rest between sciences called sciences of observation and sciences called experimental." Ibid., 9.

43 Ibid., 22.

44 Hans Jörg Rheinberger, "Augenmerk," in Norbert Haas, Rainer Nägele, and Hans Jörg Rheinberger, eds., *Liechtensteiner Exkurse III: Aufmerksamkeit* (Eggingen: Edition Isele 1998), 400. Translation mine.

45 Ibid.

46 Ibid., 403.

47 Helmholtz, "The Recent Progress of the Theory of Vision," 195.

48 Sergei Eisenstein, "Perspektives," in Eisenstein, *Selected Works,* vol. 1 (London: BFI Publishing, 1988), 158. The passage is also quoted in Gough, "Constructivism Disoriented," 89.

## 7 1970–2000: ARCHIVE, DATABASE, PHOTOGRAPHY

1 Benjamin H. D. Buchloh, "Warburg's Passages? The End of Collage and Photomontage in Postwar Europe," in Ingrid Schaeffer and Matthias Winzen, eds., *Deep Storage: Collecting, Storing, and Archiving in Art* (Munich and New York: Prestel, 1998), 54.

2 Aleksandr Rodchenko, "Protiv summirovannogo portreta za momental'nyj snimok" (1928), reprinted in Aleksandr Rodchenko and Varvara Stepanova, *Budushchee—edinstvennaja nasha tsel'* (Munich: Prestel, 1991), 232–237. Translation mine. See also Leonid Krasin's remark, in a text called "About Monuments to Vladimir Il'ich," that "in actuality there is no one bust or bas-relief of which one might say: yes, such was V. I. Lenin." Quoted from Leah A. Dickerman, "Aleksandr Rodchenko's Camera-Eye: Lef Vision and the Production of Revolutionary Consciousness" (Ph.D. diss., Columbia University, 1997), 81.

3 With the help of a photographic procedure (*Photogrammetrie*), Meydenbauer determined the position, size, and form of the buildings selected for archivization. They were then photographed with special recording machines (*Messkammern*), while their actual measurements were taken later with special instruments designed for this task. In this way, the measurements of a building could be taken even if its size or form had changed since the photograph had been taken. On the archival aspects of Meydenbauer's project, see also Herta Wolf, "Das Denkmälerarchiv Fotografie," in Herta Wolf, ed., *Paradigma Fotografie: Fotokritik am Ende des fotografischen Zeitalters* (Frankfurt: Suhrkamp, 2002), 349–375. In multiply refracted form, Meydenbauer's project, itself a permutation of Napoleon's universal world archive, returns in photography of the 1960s (the Bechers, Ed Ruscha's *Every Building on the Sunset Strip*, etc.).

4 A. Meydenbauer, *Das Denkmäler-Archiv: Ein Rückblick zum zwanzigjährigen Bestehen der Königlichen Messbild-Anstalt in Berlin* (Berlin: n.p., 1905), 2. Translation mine.

5 If my reading here suggests a somewhat naive belief in the facticity of photography on Rodchenko's part, in other texts from the same period—published in the journal *Novy Lef* and elsewhere—he adopts a more nuanced position, stressing that the power of photography consists not merely in its registration of facts but in the specific technical modalities of their recording. See, for example, Aleksandr Rodchenko, "Predosterezhenie," *Novy Lef* 11 (1928), 36–37. In the "Snapshot" article I discuss here, it is perhaps less the individual photographs that are of interest to Rodchenko than the sheer number of different perspectives on the dead leader opened up in them.

6 Mach is discussing the possibilities for recording periodic movements with the help of the stroboscope and photography. Ernst Mach, "Bemerkungen über wissenschaftliche Anwendungen der Photographie," in Albert Kümmel and Petra Löffler, eds., *Medientheorie 1888–1933: Texte und Kommentare* (Frankfurt: Suhrkamp, 2002), 23. Translation mine.

7 Barthes writes, "In myth there are two semiological systems, one of which is staggered in relation to the other; a linguistic system, the language … which I shall call the *language-object,* because it is the language which myth gets hold of in order to build its own system; and myth itself, which I shall call metalanguage, because it is a second language, *in which* one speaks about the first. When he reflects on a metalanguage, the semiologist no longer needs to ask himself questions about the composition of the language-object …, he will only need to know its total term, or global sign, and only inasmuch as this term lends itself to myth." Roland Barthes, *Mythologies* (New York: Noonday Press, 1990), 115.

8 Ibid., 117.

9 Lev Manovich opposes the database to syntagmatic (narrative) forms of organizing data, defining the database as a cultural form that "represents the world as a list of items, and … refuses to order this list. In contrast, a narrative creates a cause-and-effect trajectory of seemingly unordered items (events). Therefore, database and narrative are natural enemies." Lev Manovich, *The Language of New Media* (Cambridge: MIT Press, 2002), 225.

10 Hans-Peter Feldmann, *Porträt* (Munich: Schirmer/Mosel, 1994), n.p. Translation mine.

11  Hans-Peter Feldmann, *1941* (Düsseldorf: Feldmann Verlag, 2003), n.p. Translation mine.

12  Allan Sekula, "The Body and the Archive," *October* 39 (1986), 16.

13  Theodor W. Adorno, "A Portrait of Walter Benjamin," in *Prisms: Theodor W. Adorno,* ed. Samuel and Shierry Weber (Cambridge: MIT Press, 1981), 239.

14  Susan Hiller, quoted in Tom Godfrey, *Conceptual Art* (London: Phaidon, 1998), 291.

15  Sekula, "The Body and the Archive," 16.

16  Siegfried Kracauer, "Photography," in Kracauer, *The Mass Ornament: Weimar Essays,* trans. and ed. Thomas Y. Levin (Cambridge: Harvard University Press, 1995), 49.

17  Ibid.

18  Ibid., 62.

19  Ibid., 55.

20  Ibid., 56.

21  For example, Kracauer writes: "Now the image wanders ghost-like through the present, like the lady of the haunted castle. Spooky apparitions occur only in places where a terrible deed has been committed." Ibid., 56.

22  Ibid., 62.

23  Barthes calls the *punctum* the photograph's "blind field" and its "subtle *beyond.*" Roland Barthes, *Camera Lucida: Reflections on Photography* (New York: Hill and Wang, 1981), 57, 59.

24  Kracauer, "Photography," 61.

25  Ibid., 62–63.

26  Jacques Lacan, *The Four Fundamental Concepts of Psycho-Analysis* (New York: Norton, 1978), 54.

27  Dache Reeves, *Aerial Photographs: Characteristics and Military Applications* (New York: Ronald Press Company, 1927), 9. Nowhere was the assistance of air photography as crucial as in strategic warfare. During the Franco-Prussian War and the siege of Paris, stationary balloons were used for the surveillance of Prussian troop movements in the encircled Paris region as well as for postal communication with the outside world.

28  After the development of aerial photography, orientation in space was never again simply a matter of left and right. The first attempts at aerial photography were not successful, resulting in images that showed nothing. The sulfurous hydrogen that inflated the balloon sometimes escaped from its lower opening, reacting with the light-sensitive chemicals on the glass plate and clouding it over. After the opening was closed, the problem disappeared. In 1858 Nadar reported that "an image appeared, rather effaced and pale, but clean and certain." Quoted in Jean-François Bory, *Nadar* (Paris: Bookking, 1994), 37. Still, until the introduction of special filters, atmospheric haze especially would continue to trouble air photography for decades to come, often making it impossible to take pictures before 9 a.m. and after 4 p.m. Gerhard Richter's gray paintings may allude precisely to this circumstance.

29  In *Camera Lucida,* Barthes is careful to note the antimonumental nature of photography which, following Kracauer, he sees in close alliance with historicism: "By making the (mortal) Photograph into the general and somehow natural witness of 'what has been,' modern society has renounced the Monument." Barthes, *Camera Lucida,* 93.

30  Based in New York and Beirut, the archive is part of Raad's Atlas Group Foundation.

31  Kassandra Nakas and Britta Schmitz, eds., *The Atlas Group (1989–2004): A Project by Walid Raad, Nationalgalerie im Hamburger Bahnhof—Museum für Gegenwart, Berlin* (Cologne: Walther König, 2006), 68.

32  Ibid., 80.

33  Ibid.

34  Ibid., 108.

35 Raad explains that the reason for this procedure was "to facilitate the work of its staff and to hinder the uses of images by any of the warring parties." Walid Raad, "Sweet Talk, or the Beirut Archive," in Beatrice von Bismarck et al., eds., *Interarchive: Archival Practices and Sites in the Contemporary Art Field* (Cologne: Walther König, 2002), 383.

36 Such imprecision occurs frequently in the Atlas Group Archive. In another document (*My Neck Is Thinner than a Hair: Engines*), Raad collected 100 photographs of car engines that were the only remnants of the countless car bomb attacks that occurred in Lebanon during the civil wars. Here the same caption (date; photographer) is sometimes used for different images.

37 Boris Mikhailov, *Case History* (Zurich: Scalo, 1999), 7.

38 Roman Jakobson with C. G. Fant and M. Halle, "The Concept of the Distinctive Feature," in Jakobson, *On Language,* ed. Linda R. Waugh and Monique Monville-Burston (Cambridge: Harvard University Press, 1990), 244.

39 See also Margarita Tupitsyn, "Photography as a Remedy for Stammering," in Boris Mikhailov, *Unfinished Dissertation* (Zurich: Scalo, 1998), 48, n.p.

40 Ibid.

41 Sigmund Freud, "Fragment of an Analysis of a Case of Hysteria," *SE,* vol. 7 (London: Hogarth Press and the Institute of Psycho-Analysis, 1953), 39.

42 Kracauer, "Photography," 61.

---

## 8 THE ARCHIVE AT PLAY

1 Irit Rogoff, "An-Archy: Scattered Records, Evacuated Sites, Dispersed Loathings," in Beatrice von Bismarck et al., eds., *Interarchive: Archival Practices and Sites in the Contemporary Art Field* (Cologne: Walther König, 2002), 179.

2 Jacques Derrida, "Structure, Sign, and Play in the Discourse of the Human Sciences," in Derrida, *Writing and Difference* (Chicago: University of Chicago Press, 1978), 279.

3 Derrida writes, "On the basis of this certitude anxiety can be mastered, for anxiety is invariably the result of a certain mode of being implicated in the game, of being caught by the game, of being as it were at stake in the game from the outset." Ibid.

4 Ibid.

5 Michael Fehr, "No File, no error: Einige Thesen zum Verhältnis zwischen Museum und Internet," in Fehr, ed., *Open Box: Künstlerische und wissenschaftliche Reflexionen des Museumsbegriffs* (Cologne: Wienand, 1998), 357. Translation mine.

6 On the relationship between the archive and collective memory, see Arjun Appadurai, "Archive and Aspiration," in Joke Brouwer and Arjen Mulder, eds., *Information Is Alive: Art and Theory on Archiving and Retrieving Data* (Rotterdam: V2 Publishing/nai Publishers, 2003), 18.

7 Fehr, "No File, no error," 358.

8 Bernhard Dotzler, *Papiermaschinen: Versuch über Communication & Control in Literatur und Technik* (Berlin: Akademie Verlag, 1996), 38.

9 In Smithson's words, "Visiting a museum is a matter of going from void to void.... Themes without meaning press on the eye. Multifarious nothings permute into false windows (frames) that open up onto a verity of blanks. Stale images cancel one's perception and deviate one's motivation. Blind and senseless, one continues wandering around." Robert Smithson, "Some Void Thoughts on Museums," in *Robert Smithson: The Collected Writings,* ed. Jack Flam (Berkeley: University of California Press, 1996), 41–42.

10 "What Is a Museum? A Dialogue Between Allan Kaprow and Robert Smithson," in *Robert Smithson: The Collected Writings,* 44.

11 Ibid.

12 Fehr, who had frequently been accused by the local press of hiding the museum's treasures from the public eye, wrote at the time: "I advocate the opening of the magazines and their connection with the permanent exhibitions and that 'old,' allegedly not relevant knowledge is made accessible." Fehr, "No File, no error," 366.

13 Ibid., 363.

14 Andrea Fraser, quoted in Karin Prätorius and Anika Hausmann, "Questions for Andrea Fraser," in von Bismarck et al., eds., *Interarchive*, 86.

15 Ibid.

16 For related remarks by the artist with reference to a related project at the University Art Museum at the University of California at Berkeley in 1992, see Andrea Fraser, "Aren't They Lovely? An Introduction," in *Museum Highlights: The Writings of Andrea Fraser*, ed. Alexander Alberro (Cambridge: MIT Press, 2004), 141–145. The exhibition at Berkeley combined objects usually found in museum exhibitions with "hundreds of wall texts and object labels featuring quotations from documents in the museum's archive" (141).

17 The installation at the Freud Museum was about half the size of what is on display at the Tate Modern Gallery today.

18 Susan Hiller, afterword to *After the Freud Museum* (Belfast: Book Works 1995), n.p.

19 Ibid.

20 On the proximity of order and entropy in the archive, see Wolfgang Ernst, "Kunst des Archivs," in *Künstler: Archiv / Artist. Archive. Neue Werke zu historischen Beständen / New Works on Historical Holdings* (Berlin: Walther König, n.d.), 39–40.

21 Denise Robinson, "' ... Scarce Stains the Dust ... ': Freud's Museum—The Work of Susan Hiller," in James Lingwood, ed., *Susan Hiller, Recall: Selected Works 1969–2004*, exh. cat. (Basel: Kunsthalle Basel, 2004), 103.

22 "The division, so evident to us, between what we see, what others have observed and handed down, and what others imagine or naively believe, the great tripartition, apparently so simple and so immediate, into *Observation, Document,* and *Fable,* did not exist." Michel Foucault, *The Order of Things: An Archaeology of the Human Sciences* (New York: Vintage Books, 1973), 129.

23 Hiller, afterword to *After the Freud Museum*, n.p.

24 Ibid.

25 Sophie Calle, *Appointment with Sigmund Freud* (London: Thames and Hudson/ Violette Editions, 2005), 79.

26 The only paper in which Freud discusses wedding rituals at some length is part III of the *Contributions to the Psychology of Love* (entitled "The Taboo of Virginity"), where he focuses on the significance of the bride's defloration as part of the wedding. Sigmund Freud, "The Taboo of Virginity (Contributions to the Psychology of Love III)," *SE,* vol. 11 (London: Hogarth Press and the Institute of Psycho-Analysis, 1953), 196.

27 Yosef Hayim Yerushalmi, "Series Z: An Archival Fantasy," http://www.psychomedia.it/jep/number3-4/ yerushalmi.htm.

28 Ibid. See also Janet Malcolm, *In the Freud Archives* (New York: Knopf, 1984). I thank Rubén Gallo for pointing out to me the critical importance of Yerushalmi's essay for my discussion here.

29 Freud even insisted, "It seems, indeed, as though an influence of this kind on the part of the doctor is a *since qua non* to a solution of the problem." Sigmund Freud and Josef Breuer, *Studies on Hysteria, SE,* vol. 2 (London: Hogarth Press and the Institute of Psycho-Analysis, 1955), 266.

30 Calle, *Appointment with Sigmund Freud*, 43.

31 Freud and Breuer, *Studies on Hysteria,* 303.

32 Ibid.

# Index